CW01019762

The Postconceptual Condition

The Postconceptual Condition

Critical Essays

Peter Osborne

VERSO

First published by Verso 2018
© Peter Osborne 2018

All rights reserved

The moral rights of the author have been asserted

1 3 5 7 9 10 8 6 4 2

Verso
UK: 6 Meard Street, London W1F 0EG
US: 20 Jay Street, Suite 1010, Brooklyn, NY 11201

versobooks.com

Verso is the imprint of New Left Books

ISBN-13: 978-1-78663-420-7
ISBN-13: 978-1-78663-490-0 (LIBRARY)
ISBN-13: 978-1-78663-422-1 (US EBK)
ISBN-13: 978-1-78663-421-4 (UK EBK)

British Library Cataloguing in Publication Data
A catalogue record for this book is available from the British Library

Library of Congress Cataloging-in-Publication Data

Names: Osborne, Peter, 1958– author.
Title: The postconceptual condition : critical essays / Peter Osborne.
Description: Brooklyn : Verso, 2018.
Identifiers: LCCN 2017050552 | ISBN 9781786634207 (paperback)
Subjects: LCSH: Art, Modern – 20th century – Philosophy. | Art, Modern – 21st
 century – Philosophy. | Conceptual art. | BISAC: ART / Conceptual. |
 PHILOSOPHY / Criticism.
Classification: LCC N6490 .O7334 2018 | DDC 709.04/075 – dc23
LC record available at https://lccn.loc.gov/2017050552

Typeset in Minion Pro by Hewer Text UK Ltd, Edinburgh
Printed by CPI Group (UK) Ltd, Croydon, CR0 4YY

For Stella

Contents

Preface

If as Walter Benjamin maintained, 'it is the function of artistic form . . . to make historical content into a philosophical truth',[1] then it is the function of criticism to recover and try to complete that truth. Never has this been more necessary or more difficult than with respect to contemporary art. The word of criticism, of course, is never final. Indeed, it is the passing, historical character of art and criticism alike – their 'necessary abandonment', as Roland Barthes once put it[2] – as much as their immanent suspension of that passing character (in criticism, by writing) that places them into relation with such truth; relations that must thus be constantly renewed.

Today, it is the relations constituting the space of a global capitalist modernity, overdetermining other social relations with an insistent yet disjunctive and crisis-ridden contemporaneity, that must first be understood, as a condition of the renewal of a criticism that is to be at once both historical and emphatic (related to truth), and hence negative in relation to the world as it is. It is in the gap between the passing historical meaning and the truth of a work that the 'untruth' of the present appears.

Contemporary art is a point of condensation of a vast array of social and historical forces, economic and political forms, and technologies of

1 Walter Benjamin, *The Origin of German Tragic Drama* (1928), trans. John Osborne, Verso, London and New York, 1998, p. 182.
2 Roland Barthes, 'Preface', *Critical Essays* (1964), trans. Richard Howard, Northwestern University Press, Chicago, 1972, p. xiii.

image-production, which it treats as artistic materials and subjects to technical procedures in order to wrest these forces, forms and technologies from their everyday functions and re-present them anew. To comprehend such art, one must pass through the many different layers of mediation that are embedded in its materials and encompassed within its forms. Systematically, this would require a fluid process of transdisciplinary reflection and concept construction, which is methodologically complicated and empirically far-reaching, the product of necessarily collective rather than merely individual research.[3] That is a process which, for all the intellectual materials available, scattered across the disciplines, has hardly begun. At the level of criticism, however, one can exploit particular instances and occasions, in order to render the contingent emblematic, a part of the whole, through the more concrete conceptualizations associated with the essay form. This is what I try to do here, in different ways, and at different levels of abstraction, in essays that are very much a part of the afterlife of this book's precursor, *Anywhere or Not At All: Philosophy of Contemporary Art*.

These essays are located at that imaginary crossroads where the discourse of the university meets the speech of the artworld in the hope that the former might acquire greater actuality, while the latter may find a more lasting, critical and theoretical form. All but the first two, more theoretically wide-ranging, essays were initially written for talks at art institutions or as essays for art journals, in Belgium, Brazil, France, Germany, Russia, Spain and Sweden. They aspire to keep open a critical space within the transnationally proliferating discourses of contemporary art: a space that is summed up here by the terminologically difficult idea of a postconceptual condition, which is expounded in Chapter 1. Each essay sets out from a position broadly outlined in *Anywhere or Not At All* and develops it further by exploring its application to a particular occasion, institutional situation or body of artistic work; or by counterposing it to competing theoretical positions.[4]

The essays move from philosophical debates about the 'Time of the

3 See Peter Osborne, 'Problematizing Disciplinarity, Transdisciplinary Problematics', *Theory, Culture and Society* 32(5–6), September–November 2015, *Double Special Issue: Transdisciplinary Problematics*, pp. 3–35.

4 All of the texts assembled here were composed after the completion of the manuscript of *Anywhere or Not At All: Philosophy of Contemporary Art*, Verso, London and New York, 2013.

Present' – the attempt to give historical definition to 'contemporaneity' and its relations to other modes of temporalization, such as modernity and avant-garde – to interpretations of particular works of contemporary art ('Art and Image'), via reflections on cultural-political and institutional forms: in particular, issues of autonomy and activism, in the art–politics relation, and the changing character of art-institutional spaces. There is thus a general – but non-systematic – movement within the book 'from the abstract to the concrete'. The movement through Chapters 8 to 10, for example, charts a single argumentative development, at different levels. In each chapter throughout the book, it is what Hegel called 'the whole' that is the ultimate, determining object of the analyses, yet the whole necessarily appears in each instance only negatively, via different levels of abstraction and mediation.

The texts have been revised to remove a few purely occasional remarks, along with some recapitulations of theoretical content. However, thematic overlaps have been retained, and in some cases developed farther, to maintain that rhythm of allusion and variation characteristic of the essay form; indeed, of form as such. As for the judgements that are inevitably bound up with such analyses: as Lukács famously remarked, the 'value-determining thing' about judgement 'is not the verdict . . . but the process of judging'.[5] Which does not mean that the verdict is otiose.

London, February 2017

5 Georg Lukács, 'On the Nature and Form of the Essay' (1910), in *Soul and Form*, trans. Anna Bostock, Merlin Press, London, 1974, pp. 1–18.

PART I
Time of the Present

1

The Postconceptual Condition:
Or, The Cultural Logic of High
Capitalism Today

Those with long enough memories will no doubt recognize the crossed
syntax of my title. It mimics, first, a text that, while in historical terms
still recent, is nonetheless already antiquated, though perhaps not yet
sufficiently to have acquired those 'revolutionary energies' that André
Breton (and after him, Walter Benjamin) sought in such objects: Jean-
François Lyotard's *The Postmodern Condition: A Report on Knowledge*.
It is approaching forty years since the first publication of that 'seem-
ingly neutral review of a vast body of material on contemporary science
and problems of knowledge or information', which proved to be (in
Fredric Jameson's phrase) 'a kind of crossroads'.[1] Those, like Jameson,
who took the road called postmodernism have long since had to retrace
their steps (surreptitiously or otherwise) or accustom themselves to life
in a historical and intellectual cul-de-sac. The postmodern episode, as
we might call it, an episode in the history of criticism, enlivened theo-
retical debates for little more than twenty years (1979–99) and, retro-
spectively, its fate as a periodizing category had already been sealed by
the time of the fall of communism in Eastern Europe ten years previ-
ously ('1989') and the turn to theories of globalization that followed

1 Fredric Jameson, 'Foreword', in Jean-François Lyotard, *The Postmodern Condition:
A Report on Knowledge* (1979), trans. Geoff Bennington and Brian Massumi, Minnesota
University Press, Minneapolis, 1984, p. vii.

– before Jameson's 1991 magnum opus, *Postmodernism, or, The Cultural Logic of Late Capitalism* (the source of my second borrowing) had even appeared.[2]

Periodizing Capitalism (Contra Jameson)

How very late, it now seems, still to have been periodizing capitalism as 'late' in 1991, at the very moment of its most powerful renewal. In using the term 'late capitalism', Jameson was in part alluding to Adorno's use of it, best known from his 1968 address to the Congress of German Sociology, 'Late Capitalism or Industrial Society?' (*Spätkapitalismus oder Industriegesellschaft?*), where the emphasis falls more heavily on the retention of the concept of capitalism than on its internal periodization. In the meantime, Ernest Mandel's 1972 *Late Capitalism* had provoked a broader revival of the term, originally coined by Werner Sombart as early as 1902 in his *Modern Capitalism*. It is important to remember that capitalism was first declared 'late' quite so long ago – although it was the 1916 edition of Sombart's book that was more influential in this respect, taking the onset of the First World War as its periodizing break between 'high capitalism' (*Hochkapitalismus*) and 'late capitalism'. Mandel would move that break forward again, to the end of the Second World War. By the late 1990s, struggling with the literature on globalization, Jameson would attempt to backdate globalization to 1945, in order to maintain periodizing consistency with Mandel. However, the effective logic of his discussion suggests that 'late capitalism' should have been shifted forwards, yet again, in line with the emergence of the post-communist capitalist 'globalization' that was gearing up in the late 1980s. To acknowledge this, though, would have

2 Fredric Jameson, *Postmodernism, or, the Cultural Logic of Late Capitalism*, Verso, London, 1991. The eponymous article, from which the argument of the book derives, appeared in *NLR* in the same year as the English translation of Lyotard's book: 'Postmodernism, or the Cultural Logic of Late Capitalism', *New Left Review* 146, July–August 1984, pp. 53–92. It had its origins in a lecture at the Whitney Museum, New York, in autumn 1982, published as 'Postmodernism and Consumer Society', in Hal Foster, ed., *The Anti-Aesthetic*, Bay Press, Port Townsend WA, 1983, pp. 111–25. While in no way inaugurating Jameson's contribution, *Postmodernism* was nonetheless a high point in the literature, in part because of its sheer size.

been to acknowledge the *passing* of the postmodern, as previously conceived.[3]

Jameson had called his 1990 book on Adorno *Late Marxism*, with perhaps more irony than he was aware. But then even as liberal a Marxist as Jürgen Habermas was comfortable using the term 'late capitalism' in the 1970s, in the title of *Legitimationprobleme im Spätkapitalismus* (1973), for example – a usage that was effaced by its translation into English three years later, in a manoeuvre presumably designed to avoid frightening the sociological horses, with which Habermas's work was at that time being corralled.[4] Today, apart from in Jameson's work, Sombart's periodizing categories continue to resonate mainly through Benjamin's writings on Baudelaire (*A Lyric Poet in the Era of High*

3 Theodor. W. Adorno, 'Late Capitalism or Industrial Society? The Fundamental Question of the Present Structure of Society', in Adorno, *Can One Live after Auschwitz? A Philosophical Reader*, ed. Rolf Tiedemann, Stanford University Press, Stanford CA, 2003, pp. 111–25; Werner Sombart, *Der moderne Kapitalismus: Historisch systematische Darstellung des gesamt-europäischen Wirtschaftslebens von seinen Anfängen bis zur Gegenwart*, 3 vols, Deutscher Taschenbuch Verlag, Munich, 1987; Ernest Mandel, *Late Capitalism*, 2nd edn, Verso, London and New York, 1998. The final chapter of the 1916 edition of *Modern Capitalism*, ch. 71, is entitled 'The Threat of an End to Capitalism'.

Jameson is characteristically textually vague. In his *NLR* 'Postmodernism' essay, he refers to Mandel for his periodization (pp. 77–8), while in the *Postmodernism* book, he attributes 'the general use of the term' to the Frankfurt School (*Postmodernism*, p. xviii). However, it is likely that it is Adorno's 1949 essay 'Cultural Criticism and Society' (reprinted as the opening essay of his collection *Prisms* (1955; 1963), to which volume it provided the subtitle), in which the 'high'/'late' periodization is operative with respect to culture, that provoked the appropriation. The contrast is concealed in the English translation by the rendering of *Hochkapitalismus* as 'mature capitalism'. Adorno, 'Cultural Criticism and Society', pp. 22 and 25. Cf. Theodor W. Adorno, *Prismen: Kulturkritik und Geselleschaft, Gesammelte Schriften* 10:1, Suhrkamp, Frankfurt am Main, 1997, pp. 15 and 19.

For Jameson's attempt to appropriate the literature on globalization to his concept of the postmodern, suggesting that the 'more interesting' of the former's various formulations is that which 'posits some new or third, multinational stage of capitalism, of which globalization is an intrinsic feature and we now largely tend, whether we like it or not, to associate with that thing called postmodernity', see Fredric Jameson, 'Notes on Globalization as a Philosophical Issue', in Fredric Jameson and Masao Miyoshi, eds, *The Cultures of Globalization*, Duke University Press, Durham NC, 1998, pp. 54–77; and subsequently, Fredric Jameson, 'Globalization and Political Strategy', *New Left Review* 4, July–August 2000, pp. 49–68.

4 Jürgen Habermas, *Legitimation Crisis*, trans. Thomas McCarthy, Heinemann, London, 1976.

Capitalism), reinforcing the association of the 'high' with European capitalism in its mid-nineteenth-century bourgeois form.[5]

Yet Baudelaire's writings resonate as much with life in Hong Kong and Shanghai today as they do with the Paris of the 1850s. In fact, there are good reasons for reviving the term 'high capitalism' as a description of the present, in which capitalism appears far from entering a phase that could usefully be described as 'late', let alone turning into a form of communism all of its own – the so-called 'communism of capital' of which some currently dream. The term 'high' has the virtue of conveying the hubris of a certain peak and hence the imminence of a fall (like a speculative peak in the financial markets), if only a cyclical one, while 'late capitalism' struggles to rid itself of the progressivist illusion of an approaching natural death, along with the ennobling aesthetic connotation of 'late style' (*Spätstil*) – its source as a historical term, dating back to Winckelmann. This is exacerbated in its English usage by the combination of its German sense with that of *Altersstil* (individual old-age style).[6] Jameson drew on these associations in his book on Adorno, trading on Adorno's own well-known interpretation of late Beethoven, but he neglected their implications for his own periodization of capitalism as having entered its 'late' period long ago – a periodization that directly conflicts with Benjamin's recognition, from the 1930s, 'that capitalism will not die a natural death'.[7]

It is interesting to see how, in the last decade, the notion of late capitalism (with its presumption of an imminent end) has been supplanted by debates about the instantiation via a globalized financialization of 'pure' (Balibar) or 'absolute' capitalism (Berardi, Rancière), 'which does not have to deal constantly with heterogeneous social forces that it must either incorporate or repress, or with which it must strike some sort of compromise', but is 'free to deal only with the effects of its own logic of

5 Walter Benjamin, *Charles Baudelaire: A Lyric Poet in the Era of High Capitalism*, trans. Harry Zohn, Verso, London and New York, 1997.

6 Johann Joachim Winckelmann, *History of the Art of Antiquity* (1764), trans. Harry Francis Mallgrave, Getty Research Institute, Los Angeles, 2006. For the combination in the English 'late style' of *Spätstil* and *Altersstil*, see Linda Hutcheon and Michael Hutcheon, 'Late Style(s): The Ageism of the Singular', *Occasion: Interdisciplinary Studies in the Humanities* 4, 31 May 2012.

7 Walter Benjamin, *The Arcades Project*, Belknap Press of Harvard University Press, Cambridge MA and London, 1999, [X11a ,3], p. 667.

accumulation and with those things necessary for its own reproduction'.[8] However, it should not be presumed that 'its own logic of accumulation' and 'those things necessary for its own reproduction' exclude heterogeneous social forces, in either its European or, especially, its non-European dominions.[9]

The naturalistic connotations of late capitalism allowed the prefix of Jameson's 'postmodernism' surreptitiously to anticipate a post-capitalism (that was not to come), at the same time as it functioned as the cultural marker of the end of the social-democratic welfare state and the purported rise of 'a whole new wave of American military and economic domination throughout the world' in the 1980s. The short-lived last gasp of US imperialism, perhaps. This intimation of an end to come was ultimately to be its redeeming, now-utopian feature: that little bit of utopia tucked away in the superstructure of the dystopian capitalism of 'blood, torture, death and horror'. Jameson himself would use it to exit postmodernism (equally surreptitiously), back to a relatively orthodox form of Utopia Studies.[10]

A revival, deepening, multiplication and complication of discourses of the modern – with 'multiple', 'alternative' and 'postcolonial' modernities at the fore – accompanied and followed the decline of the category of the

8 Étienne Balibar, 'Critique in the 21st Century: Political Economy Still, and Religion, Again', *Radical Philosophy* 200, November/December 2016, p. 12.

9 Cf. Harry Harootunian, *Marx After Marx: History and Time in the Expansion of Capitalism*, Columbia University Press, New York, 2015. Harootunian's trenchant critique of the idea of the 'completion' of capitalism is nonetheless itself inconsistent. For which, see my review, 'Marx after Marx after Marx after Marx', in *Radical Philosophy* 200, November/December 2016, pp. 47–51.

10 Jameson, 'Postmodernism, or the Cultural Logic of Late Capitalism', p. 57; Fredric Jameson, *Archaeologies of the Future: The Desire Called Utopia and Other Science Fiction*, Verso, London and New York, 2005. Jameson's Wellek Lectures, delivered in 1991, the same year as the publication of *Postmodernism* (published as *The Seeds of Time*, Columbia University Press, New York, 1994), appear, retrospectively, to mark the onset of the transition. The high period of a critical postmodernism in Jameson's writing was thus actually no longer than a decade.

With regard to the Americanism of Jameson's conception of a 'global yet American postmodern culture' ('Postmodernism, or the Cultural Logic of Late Capitalism', p. 57), it should be recalled that in the early 1980s both the collapse of state communism in Eastern Europe and the rise of capitalism with 'Chinese characteristics' remained largely out of view, hiding the prospect of the broader and complexly distributed cultural-political consequences of the globalization of capital that they would subsequently enable.

postmodern, from the mid-1990s onwards.[11] Yet, revitalizing and illuminating as this process has been in various respects, effectively replacing the concept of postmodernity with that of a singular, complexly internally differentiated global modernity,[12] the renewal of discourses of the modern has not been sufficient, alone, to grasp the most distinctive cultural features (that is, the lived novelty) of the/our historical present. The equivocation here is crucial: *the/our* are two terms whose referents narrative logic dictates be the same, but whose meanings are most definitely not. Indeed, it is here, in the movement of the difference between these two terms (the 'the' and the 'our') – the objective and the subjective sides of the concept of history, or *narrative* and *discourse*, to use Benveniste's terms – that the *problem* of history as a category of modernity resides. 'History', one might say, simply *is* the movement of this difference.[13]

How best, then, after the dissipation of the postmodern illusion, to characterize the cultural form of this condition, the/our historical present, or the cultural logic of high capitalism today?

From Knowledge to Art (Postmodern to Contemporary)

Here, I propose a double displacement of the cultural standpoint of Lyotard's *Postmodern Condition*: from the 'postmodern' to the 'contemp-

11 See Arjun Appadurai, *Modernity at Large: Cultural Dimensions of Globalization*, University of Minnesota Press, Minneapolis, 1996; Lisa Rofel, *Other Modernities*, University of California Press, Berkeley, 1999; Timothy Mitchell, ed., *Questions of Modernity*, University of Minnesota Press, Minneapolis, 2000; Dilip P. Gaonkar, ed., *Alternative Modernities*, Duke University Press, Durham NC, 2001; Shmuel N. Eisenstadt, ed., *Multiple Modernities*, Transaction Publishers, Piscataway, 2002; and Bruce M. Knauft, ed., *Critically Modern: Alternatives, Alterities, Anthropologies*, Indiana University Press, Bloomington, 2002. Jameson accommodated himself to the return to modernity, albeit with some ambivalence (disavowing its repudiation of the postmodern problematic), in his *A Singular Modernity*, Verso, London and New York, 2002.

12 See Arif Dirlik, 'Global Modernity: Modernity in the Age of Global Capitalism', *European Journal of Sociology* 6(3), August 2003, pp. 275–92, subsequently expanded into a book of the same title, Paradigm Publishers, Chicago, 2007; and more recently, Arjun Appaduri, *The Future as Cultural Fact: Essays on the Global Condition*, Verso, London and New York, 2013.

13 Cf. Peter Osborne, *The Politics of Time: Modernity and Avant-Garde* (1995), Verso, London and New York, 2011, pp. 14, 133–4; and on history as the movement of the difference between totality and infinity, p. 61.

orary' and from 'knowledge' to 'art' – taken together, from postmodern knowledge to contemporary art – to accompany the displacement of Jameson's periodizing perspective, from 'late' back to a 'high' capitalism, in which we are perhaps only just beginning to understand the depth of the mutations of social being that capitalism as a social form involves. This shift of focus from knowledge to art does not involve any general claim regarding the relative cultural significances of art and knowledge, or the transformations in their relations and practices – although the so-called 'knowledge economy' undoubtedly involves such changes. The transcendental constitution of 'art' and 'knowledge' as separate 'value-spheres', epitomized in Habermas's Weberian sociologization of neo-Kantianism, appears increasingly historically naive. Rather, it is a question of the standpoint from which to view the whole. There is a greater historical and conceptual intimacy between 'art', in its modern European (post-eighteenth-century) philosophical and institutional sense, and the problems of historical temporality, historical periodization and historical diagnosis – ultimately all 'cultural' problems, insofar as they involve temporal structures of subjectivity – than there is between these problems and 'knowledge' in its main institutionalized, scientific and pedagogical forms, with their tendency to naturalize, if not necessarily history itself, then at least the progress of knowledge. It is an intimacy derived from art's place within the historical culture of Enlightenment, its historico-philosophical association with the affective structure of subjectivity ('aesthetic') and the subjective reflective experience of pure temporal form ('modernity', in its Baudelairean construal).

It has always been a function of literary and art-historical periodization, upon which the intelligibility of works of art depends, to provide models – *ancient* and *modern*, *classical* and *romantic* (naive and sentimental), *neoclassical* and *avant-garde* – for the theorization of broader historical processes of spirit (*Geist*), social forms or subject-formations, of which art itself is only a small yet nonetheless emblematic part. In being generalized in this way, such periodizing categories are transformed, reflect back upon their more narrowly art-historical meanings and change them in turn. In this respect, *postmodern* and *contemporary* have similar critical origins and could, hypothetically, be similarly opposed:

ancient	modern
classical	romantic
neoclassical	avant-garde
postmodern	contemporary

One has only to align the categories like this (in a crude and tendentious manner) for the political meanings of their temporal roles in the philosophy of history to jump out as 'conservative' and 'progressive' (from left to right), respectively. This does not mean that these pairs of terms are not dialectically imbricated in any particular instance or that the historical relations between the core critical-temporal meanings of each term are not considerably more complicated than their serial presentation suggests, reading downwards from the past towards the present. In historical terms, the lineages might perhaps be better represented as in Figs 1.1 and 1.2.

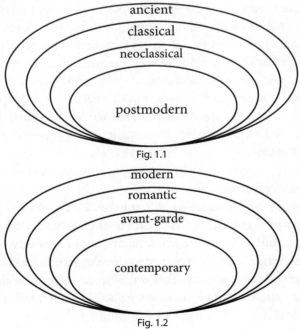

ancient
classical
neoclassical
postmodern

Fig. 1.1

modern
romantic
avant-garde
contemporary

Fig. 1.2

As the semantic range of these terms indicates, the connections between art as historical-cultural form and historical temporalizations of the present more generally are neither historically nor conceptually

arbitrary; and nor is the proposed critical displacement of the postmodern by the contemporary as at once a periodizing category and, more fundamentally, a form of historical time.[14] For what 'contemporaneity' signifies most deeply is a new form of historical time. A 'report on art' (to continue the Lyotardian conceit) may thus have more to tell us about the changing structure of historical experience than might be supposed.

The displacement of the postmodern by the contemporary as the fundamental category of the historical present follows not merely from the discrediting of the postmodern as a temporal and critical concept – and the need to fill the conceptual space it vacated – but, more importantly, from the globalization of the resurgent concept of modernity in response to the actual historical process that underlay postmodernism's critical demise: namely, world capitalism after 1989. In a nutshell, if modernity is the temporal culture of capital (as Jameson discerned), within its current form, contemporaneity is the temporal structure that articulates the unity of global modernity.[15] Here, I shall expound this speculative idea in a compressed serial form through summaries of: (1) globalization as the movement of the difference between globe and world; (2) contemporaneity as the historical temporality of the worlding of the global; (3) postconceptuality as the culturally symptomatic condition of contemporary art.

Globe and World

What is called 'globalization' is primarily the effect of the relative global deregulation of capital markets, or, more specifically, the relative denationalization of the regulation of markets in finance capital (at least as important, at this moment, it would seem, as the mobility of variable capital – migration – that drove postwar accumulation), after the passing of historical communism. This process has been grounded on the destruction of the geopolitical conditions that underpinned previous

14 For an artistic appropriation of these diagrams (taken from the publication of the earlier version of this chapter), in which they turn into targets as part of a dream in which they are revealed to function as a proxy or stand-in – and hence screen – for the impact of the processes to which contemporary art refers, see Hito Steyerl, 'Duty-Free Art', *E-Flux Journal* 63, March 2015, ch. 5, 'A Dream'.

15 See Chapter 2.

notions of the world-historical present (those of the Cold War). The notion of 'globalization' has come to articulate debates about the meaning of the historical present in their place. The term 'globalization' thus occupies a conceptual space for which there is no available *social* occupant, insofar as the subject position that unifies the process of globalization (that of a globally mobile capital) is not that of a possible socially actual agent, or subject of action.[16] Hence the sober negativity of Gayatri Spivak's judgement: 'Globalization takes place only in capital and data. Everything else is damage control.'[17]

There are numerous, extremely rich accounts of globalization focused upon and making competing claims about various different aspects of the process: economic, technological, cultural, political, legal, geographical and so on. Yet, as Giacomo Marramao among others has argued, the term 'globalization' does not yet stand for anything like an adequately theorized *concept*, capable of unifying the objects of the various discourses in which the term is found.[18] This lack of conceptual unity is apparent in Jameson's attempt to demonstrate the 'ultimate cohesion' of 'five levels' of globalization in his 'Globalization and Political Strategy'. This takes the simple form of a posited 'dedifferentiation' of the levels, which, it is claimed, 'characterizes postmodernity and lends a fundamental structure to globalization'. It is doubtful, though, that such a vaguely generalized dedifferentiation can provide anything as definite as a 'fundamental structure'.[19] A more basic theorization is required. And it is on the terrain of the concept of the

16 For the philosophical history and relevant meanings of the term 'subject', see Alain de Libera, *Archeologie du Sujet: 1 La naissance du sujet*; *2: La quête de l'identité*, Vrin, Paris, 2007 and 2008; Étienne Balibar, Barbara Cassin and Alain de Libera, 'Sujet', in Barbara Cassin, ed., *Vocabulaire européen des philosophies: Dictionnaire des intraduisibles*, Seuil/Le Robert, Paris, 2004, pp. 1233–54, trans. as 'Subject', in Barbara Cassin, ed., *Dictionary of Untranslatables: A Philosophical Lexicon*, Princeton University Press, Princeton NJ, 2014, pp. 1069–91; Alain de Libera, 'Subject (Re-centred)', *Radical Philosophy* 167, May/June 2011, pp. 15–23; Étienne Balibar, *Citizen Subject: Foundations for Philosophical Anthropology*, trans. Steven Miller, Fordham University Press, New York, 2016.

17 Gayatri Chakravorty Spivak, *An Aesthetic Education in an Era of Globalization*, Harvard University Press, Cambridge MA and London, 2012, p. 1.

18 Giacomo Marramao, *The Passage West; Philosophy and Globalization* (2003 in Italian), trans. Matteo Mandarini, Verso, London and New York, 2012, ch. 1.

19 Jameson, 'Globalization and Political Strategy', p. 55. The sociological terminology of de-differentation is borrowed from the critique of Luhmann, for which see William Rasch, *Niklas Luhmann's Modernity: The Paradoxes of Differentiation*, Stanford University Press, Stanford CA, 2000.

historical present (in the singular) as an aspect of the concept of 'history' (in the collective singular), which emerged in Europe towards the end of the eighteenth century, that the concept of globalization functions in both its broadest and its deepest diagnostic sense. As such, globalization represents a new spatialization of historical temporality: a mapping of planetary wholeness as 'globe' on to the irreducibly phenomenological concept of 'world' that emerged in the course of European colonialism to provide the geographical space of the concept of history.[20]

This conception of world is given a founding philosophical expression in Kant: 'I call all transcendental ideas, insofar as they concern absolute totality in the synthesis of appearances, *world-concepts* (*Weltbegriffen*)'.[21] Globalization is a transcendental idea, in this sense. It is given an existential-ontological exposition by Heidegger, in the famous bad poetry of the formulation 'the world worlds' (*die Welt weltet*):

> The world is not the mere collection of the countable or uncountable, familiar and unfamiliar things that are just there. But neither is it a merely imagined framework added by our representation to the sum of such given things. The *world worlds*, and is more fully in being than the tangible and perceptible realm in which we believe ourselves to be at home.[22]

The conceptual independence of the notion of the planet as a globe, registered in the separate semantic histories of *mundus* and *globus*, which Marramao expounds, indicates that 'globalization' is in no way a mere spatial extension of a once-colonially restricted geographical conception of the world to its planetary limit – as is often thought – but is rather to be understood as a projected 'worlding' of the globe. Hence Jean-Luc Nancy's preference for the French *mondialisation* over 'globalization' to register this conceptual point terminologically.[23] There

20 See Chengxi Tang, *The Geographic Imagination of Modernity: Geography, Literature, Philosophy in German Romanticism*, Stanford University Press, Stanford CA, 2008.

21 Immanuel Kant, *Critique of Pure Reason*, trans. Paul Guyer and Allen W. Wood, Cambridge University Press, Cambridge, 1997, A408/B434, pp. 460–61.

22 Martin Heidegger, 'The Origin of the Work of Art', in Heidegger, *Poetry, Language Thought*, Harper & Row, New York, 1971, p. 44.

23 Marramao, *The Passage West*, pp. 6–16; Jean-Luc Nancy, *La Création du monde ou*

are subtle issues to do with finitude and infinity inherited from the philosophical history of these terms. *Mundus*/world is associated with finitude and mortality – as opposed to the otherworldly divine – while *globus*/globe carries the geometrical associations of infinity and perfection.[24] My point here, however, is that it is the difference between globe and world that grounds globalization as the process of the 'worlding' of the planet as a globe. This process is extensionally based on a multidimensional 'global' expansion of forms of social dependence and interdependence, often enforced but also in some forms freely embraced. But it is not reducible to it, since it depends upon multiple, intensive, communicational constructions of these forms as 'world'; that is, upon a multiplicity of claims on a common subject position. This is the 'our' of 'our historical present'.[25]

There is thus *a fundamental, constitutive ambiguity within the concept of globalization* between its 'objective' planetary aspect (the integration of particular geographically localized social sites into global networks of various sorts) and what we might call its (collectively) 'subjective' worldly aspect, through which these practices and processes of 'integration' are lived as part of a transformation of 'the world'; manifest existentially in a necessary plurality of interconnecting 'worlds', each of which speaks as though on behalf of all. What appears as 'ambiguity' in the semantics of 'globalization' manifests itself socially as tension and antagonism, and logically as immanent or dialectical contradiction, between its two main aspects: functional social process and its worldly appropriation. This contradiction is expressed spatially as a contradiction between the abstractly ideal and literally uninhabitable 'absolute' or infinite subject position of the globe (which is a kind of Romantic absolute) and the necessarily 'located' multiple subject positions of its worldings. The main way in which it appears within the structure of the 'artworld' – note the phenomenological connotation of that term in this context – is as a structural contradiction between its cultural-economic (or 'cultural-industrial') global aspects and its individualizing

mondialisation, Galilée, Paris, 2002, self-defeatingly translated into English as *The Creation of the World or Globalization*, State University of New York Press, New York, 2007.

24 Cf. Peter Sloterdijk, *Spheres, Volume 1: Bubbles: Microspherology*, trans. Wieland Hoban, semiotext(e), Los Angeles, 2011.

25 See Paul Ricœur, *Memory, History, Forgetting*, trans. Kathleen Blamey and David Pellauer, University of Chicago Press, Chicago and London, 2004, p. 305.

cultural-artistic functions. Within the artwork itself, this structural spatial contradiction appears as a new artistically global form of what the US artist Robert Smithson called the Site–Nonsite dialectic.[26]

Today, over forty years after Smithson's death, this Site–Nonsite dialectic appears as an art-institutional specification of a more general dialectic of places and non-places that has become global in its logic and extent.[27] Number nine in Smithson's list of paired elements of the Site–Nonsite dialectic in his 'Spiral Jetty' essay reads: 'Some Place (physical) – No Place (abstract)'.[28] Smithson's initial use of 'non-site' to refer to the location of physical material displaced from a site to a place at which that site is represented (an art institution) here becomes transformed, via the mechanism of representation, to denote the function of representation itself. Hence the subsequent derivation of the concept of the 'functional site' from the spatial generality of the non-site,[29] giving Smithson's dialectic a further axial turn. This socio-spatial dialectic, immanent within the artwork under the economic and communicational conditions of globalization, derives its temporality from the novel historical temporality of 'contemporaneity'.

Contemporaneity as Historical Time

Insofar as globalization involves a fundamental transformation in the spatio-temporal matrix of *possible* experience, these changes do not simply happen 'within' historical time, in the famous 'homogenous empty' sense of time diagnosed by Heidegger, Benjamin and Althusser alike as 'historicism'. Rather, they represent a new form of historical temporalization, opening up the possibility of new temporalizations (new temporal structures) of 'history'. This new form of temporality

26 Robert Smithson, 'A Provisional Theory of Non-Sites', in *Robert Smithson: The Collected Writings*, University of California Press, Berkeley and Los Angeles, 1996, p. 364.

27 See Peter Osborne, 'Art Space', in *Anywhere or Not At All*, ch. 6.

28 Robert Smithson, 'The Spiral Jetty' (1972), in *Robert Smithson: The Collected Writings*, note 1, pp. 152–3.

29 See James Meyer, 'The Functional Site; or, The Transformation of Site Specificity', in Erika Suderberg, ed., *Space, Site, Intervention: Situating Installation Art*, Minnesota University Press, Minneapolis, 2000, pp. 23–37.

produced by the globalization of the social processes grounding the temporality of modernity is best grasped not simply as the spatial extension of the temporality of modernity (the logic of the new), the aforementioned 'global modernity', but by the term 'contemporaneity': that is, as a new, internally disjunctive global historical-temporal form, a totalizing (but not thereby 'total', since it is open to no more than a *distributive* unification), radically disjunctive, contemporaneity. There is a fracturing of the identity between the *the* and the *our* by the multiplication of *wes that are not-I* and that *I cannot become* – to use the terminology of Hegel's famous 'I that is we and we that is I' (*Ich, das Wir, und Wir, das Ich ist*), which remains the speculative political horizon posited by all phenomenology. The consequence is that (as Adorno insisted) universal history must be both 'constructed and denied (*leugnen*)'.[30] What is new here, since Adorno's day, is that this process of construction and denial is no longer a purely speculative, intellectual task (the task of the philosopher – Kant's personification of the 'world concept' of philosophy),[31] but is the increasingly manifest form, or rhythm, of the historical process of capital accumulation itself.

In short, historically construed, contemporaneity is the temporality of globalization: a new kind of totalizing but immanently fractured constellation of temporal relations. This new historical temporality interacts with the temporality of modernity – the differential temporality of the new – in fiendishly complicated ways. There is no replacement of the one with the other, no replacement of the logic of the modern by the contemporary – that is the mistake of the kind of stagist, historicist periodization we find in mainstream history and art history alike. Rather, as a historical temporality, global contemporaneity is an accompaniment to the more abstract temporality of modernity, and a consequence of its spatial expansion. A clue to its structure – conjunctively disjunctive – can be found in the modern philosophical conception of temporality as the process of temporal production through which time is lived as a self-differentiating set of relations of unification.

30 Theodor W. Adorno, *Negative Dialectic* (1966), *Gesammelte Schriften* 6, Suhrkamp, Frankfurt am Main, 1996, p. 314; *Negative Dialectics*, trans. E.B. Ashton, Routledge & Kegan Paul, London, 1973, p. 320, translation amended.
31 Kant, *Critique of Pure Reason*, A838/B866, p. 694.

The English and French vernacular terms 'contemporary' and *contemporain* (derived from the medieval Latin *contemporarius* and the late Latin *contemporalis*) emerged around the middle of the seventeenth century, but a philosophical thinking of contemporaneity that exploits the etymological resource of the togetherness signified in the prefix (lacking in its German-language equivalents) is a distinctively post-Hegelian phenomenon.[32] It is associated, in the first instance, with the thinking of 'sametimeness' (*samtidighed* in the Danish) in Kierkegaard's existential theology of the 1840s. However, it emerges as a critical, social and historical concept only in the course of the 1990s.

The structure of contemporaneity as the product of an *act* of conjunction emerges in Kierkegaard's use of 'sametimeness' in his *Philosophical Fragments* in opposition to the everyday historicist meaning of contemporary as 'living, existing, or occurring together' in the same chronological time. It is used there to denote the *act of conjoining times* to produce an immediate (paradoxically de-temporalized) temporal unity. As Gadamer put it: 'Sametimeness for Kierkegaard does not mean existing at the same time . . . [It is] not a mode of givenness in consciousness, but a *task* for consciousness and an *achievement* that is required of it.' More specifically, according to Gadamer, for Kierkegaard sametimeness is 'a formulation of the believer's task of so totally *combining* one's own presence and the redeeming act of Christ, that the latter is experienced as something present (not as something in the past)'. It thus consists in 'holding on to the object in such a way that . . . all mediation is dissolved in total presentness [*Gegenwärtigkeit*]'. This appears, superficially, to be similar to the simultaneity of aesthetic consciousness. But, as Gadamer goes on to argue, 'aesthetic consciousness depends on the *concealment* of the task that sametimeness sets', while Kierkegaardian sametimeness, despite its existential immediacy, is nonetheless to be understood philosophically as an achievement and not as given – hence, a Hegelian would say, precisely as mediation.[33]

32 None of the standard synonyms for 'contemporary' in German – *Heutigkeit, Gegenwärtigkeit, Gleichzeitigkeit* or *Zeitgenosse* – comes close to conveying the dual (conjunctive and disjunctive) connotation of the term 'con-temporary', although *Zeitgenosse* is perhaps least distant.

33 Søren Kierkegaard, *Philosophical Fragments*, in *Kierkegaard's Writings*, vol. 7, trans. Howard V. Hong and Edna H. Hong, Princeton University Press, Princeton NJ,

This philosophical notion of sametimeness as a task and achieve-
ment of temporal combination (of a particular past and present, within
the present itself) remained confined to religious existentialism until,
first, being taken up into Benjamin's conception of now-time (*Jeztzeit*)
– where it retains its other-worldly immediacy – and, more recently,
becoming associated with the semantics of the contemporary. The
term 'contemporary' first acquired a historical meaning in the after-
math of the Second World War, in the context of art and (especially)
design, through its use to denote a new periodization in contrast to
'the modern'. (The phrase *l'art contemporain* was in use in Paris at the
time of the First World War, but without specific conceptual intent.) In
fact, in the 1950s and 1960s, it still acted mainly as a qualification of
(rather than a decisive immanent counter to) a more extended sense of
the modern: the contemporary was the most recent modern, but a
modern with a moderated, less ruptural futurity than that associated
with the avant-garde.

In this respect, 'contemporary' was still not enough of a critical
concept in its own right by the 1970s to be included in Raymond
Williams's *Keywords: A Vocabulary of Culture and Society* (1976), for
example.[34] It was only with the decisive discrediting of postmodernism
as a coherent critical concept, at the end of the 1990s, that 'contempo-
rary' began to emerge into the critical daylight from beneath its
commonplace function as a label denoting what is current or up to
date, by which time it had definitively separated itself out from the
modern in art-historical periodization, with the invention of a new
subdisciplinary specialism: history of contemporary art. At the same
time, the structure of contemporaneity itself was changing. In fact, the
very idea of contemporaneity as a *condition* is historically new.

The coming together of different but equally 'present' temporalities

1985, ch. 4; Hans-Georg Gadamer, *Wahrheit und Methode, Gesammelte Werke 1,
Hermeneutik 1*, J.C.B. Mohr, Tübingen, 1986, p. 132; *Truth and Method*, Sheed & Ward,
London, 1975, pp. 112–13, translation amended to render *Gleichzeitigkeit* more literally
as 'sametimeness'. Gadamer translates Kierkegaard's *samtidighed* into the German
Gleichzeitigkeit, which is usually rendered into English as 'simultaneity'. In order to
preserve the opposition of *Gleichzeitigkeit* to *Simultaneität*, Gadamer's translator inter-
estingly renders the former into English as 'contemporaneity'. I am grateful to Lucie
Mercier for drawing my attention to Gadamer's German in this passage.
34 Osborne, *Anywhere or Not At All*, p. 16.

in temporarily totalized but disjunctive unities, which characterize historical contemporaneity today, is not the individual combinations of existential presents with particular pasts (religious or otherwise) characteristic of Kierkegaard's concept of sametimeness, or even Benjamin's now-time, although the purported collectivity of the subject of experience always remained a central issue for Benjamin, however unresolved. Rather, these conjunctions involve geopolitically diffuse multiplicities of temporalities (each carrying its own history) combined within social structures that produce geopolitically totalized presents that are constitutively problematic: unified only in *images* of ideal, speculative or fictional 'subjects' purporting to occupy the same kind of historical space as the alienated ideality of the value form of capital, in its seemingly self-determining movement.[35]

Globalization *subjects us* to these new contemporaneities, in all of the multiple and contradictory senses that phrase has acquired in French philosophy since Foucault. These problematically disjunctive conjunctions are covered over by the everyday historicist use of 'contemporary' as a periodizing term, derived from mainstream art history, with its simple opposition to modern art. However, within this discourse, as a repressed register of the historical turbulence of the present, we nonetheless find several competing periodizations of contemporary art, overlapping genealogies or historical strata and differently extended senses of the present, within the wider time span of a Western conception of modern art. Each is constructed from the standpoint of the present as a historical contemporaneity with regard to the rupture of a particular historical event, and each privileges a particular geopolitical terrain.[36] The competition between these conceptions registers their politically as well as their epistemologically constructive character, contributing to the discursive production of 'the present' as a cultural form.

35 On the ontology of the alienated ideality of the value form, with its seemingly self-determining movement, see Christopher J. Arthur, 'The Spectral Ontology of Value', *Radical Philosophy* 107, May/June 2001, pp. 32–42.

36 See Osborne, 'Three Periodizations of Contemporary Art', in *Anywhere or Not At All*, pp. 18–22.

The Postconceptual Condition of Contemporary Art

A critically philosophical art-historical periodization makes a claim upon, or operates at the level of, the historical ontology of the artwork, along with what we might call (in an odd phrase) the *temporal ontology* of the fundamental social and cultural forms that condition it: here, the intertwining of modernity and contemporaneity as temporal forms. Today, 'contemporary art', critically understood, is a postconceptual art. What this claim means is that, if we try to construct a critical concept of contemporary art from the dual standpoint of a historico-philosophical conception of contemporaneity and a rereading of the history of twentieth-century art – in its established sense as that art that is produced, circulated, exchanged, consumed and preserved within the art institutions of the global network of capitalist societies – the idea of postconceptual art appears as the most intelligible and coherent way of critically unifying this field, historically, within the present.

Three clarifications regarding the use of the term 'postconceptual' are required. First, the term is not to be understood in either a merely chronological sense or even exclusively from the standpoint of temporal continuity, although its referents can be chronologically charted. (In this respect, its semantics are different from the term 'postmodern'. Since 'modern' is itself a temporal term that conceptually incorporates the temporality of the 'post', the paradoxical self-referentiality of that relation is immediately at issue, in a way that does not arise with *post*'s qualification of *conceptual*.) In this construction, postconceptual art is not a traditional art-historical or art-critical concept at the level of medium, aesthetic form, style or movement. It denotes an art premised on the complex historical experience and critical legacy of conceptual art, broadly construed in such a way as to register the fundamental mutation of the ontology of the artwork carried by that legacy. As a historical ontology, such an artistic ontology is thus not a purely philosophical one, in any disciplinary sense of 'philosophy'. It is a transdisciplinary ontology constructed in such a way as to cross the multiplicity of disciplinary and institutional discourses and practices necessary for the adequate constitution of the concept of art. 'Art' is a transdisci-

plinary concept, and it is from this that the profound difficulties and paradoxes of the thinking of art's autonomy derive.[37]

Second, the term 'postconceptual' is used here to refer to the *condition* of such art in the dual sense inherent in the ordinary usage of the term 'condition', which allows it to refer both to that which conditions something – and hence may be viewed as standing outside of it, logically speaking – and to the internal state of being of the thing that is conditioned. This ambiguity refers us, dialectically, to the internality of the conditioning to the conditioned (or the 'internalization' of the one by the other), such that to speak of the 'condition of art' is to speak *at once* of the state of being of art and of the totality of conditions that determine it as 'art'. Hence: the idea of a postconceptual condition is double-coded. It is determined at once as an artistic situation and that which conditions it – primarily, that interplay of communications technologies and new forms of spatial relations that constitute the cultural and political medium of economic processes of globalization, the experience of which (when successful) it artistically condenses, reflects and expresses. Such a condition is historical, but it functions transcendentally (as a 'condition of possibility') from the standpoint of interpretation, as a condition of certain unpredictable possibilities that are embedded within, and come constructively to express, a particular historical actuality.

The unity of such a concept of art is the necessarily retrospective product of its construction within the present. That is, it is genealogical. This is a unity that is therefore 'not abstract', but as Adorno put it, 'presupposes concrete analyses, not as proofs and examples but as its own condition'. The idea of art is given through each work, but no individual work is adequate to this idea, however 'preponderant' that idea becomes. This ongoing retrospective and reflective totalization is necessarily open, fractured, incomplete and therefore inherently speculative:

> The definition of art is at every point indicated by what art once was, but it is legitimated only by what art became with regard to what it wants to be, and perhaps can, become . . . Because art is what it has

37 For the problematic of transdisciplinarity in the humanities, see preface, p. 10, note 3.

become, its concept refers to what it does not contain . . . *Art can be understood only by its laws of movement*, not according to any set of invariants. It is defined by its relation to what it is not . . . Art acquires its specificity by separating itself from what it developed out of; *its law of movement is its law of form*.[38]

It is for this reason that the proposition 'contemporary art is postconceptual art' is a speculative one, in Hegel's technical sense of that term. Its artistic meaning is ultimately determined by the reflective totality of its applications to the interpretation of individual works. This is the specific, post-Hegelian mediation of nominalism and realism that we find in Adorno's work.[39]

Third, in this respect, postconceptual art stands to conceptual art not as postmodern art was thought to stand to modern art, but rather as poststructuralism may be taken to stand to structuralism: namely, as its philosophical comprehension and the elaboration of its consequences. In Hegelian terms, postconceptual art is the 'truth' of conceptual art. I have summarized the critical legacy of conceptual art, upon which postconceptual art rests, elsewhere, in terms of a combination of six features, which thus appear here as elements or aspects of its postconceptual condition.[40] The second three of these six features, namely,

- that art's fundamental conceptuality expands to infinity its possible material means;
- the radically *distributive* – that is, irreducibly relational – unity of the individual artwork across the totality of its multiple material instantiations, at any particular time; and
- the open and historically malleable borders of this unity,

38 Theodor W. Adorno, *Aesthetic Theory*, trans. Robert Hullot-Kentor, Athlone Press, London, 1997, pp. 2–3; *Ästhetische Theorie, Gesammelte Schriften* 7, Suhrkamp, Frankfurt am Main, 1996, pp. 11–12, emphases added.

39 On a technically 'speculative' concept of contemporary art as postconceptual art, see Osborne, *Anywhere or Not At All*, pp. 51–3. Misconstruing the concept of nominalism in Adorno's *Aesthetic Theory* is one of the ways in which Jameson draws Adorno into the orbit of the concept of postmodernism. See Peter Osborne, 'A Marxism for the Postmodern? Jameson's Adorno', *New German Critique* 56, Spring/Summer 1992, pp. 171–92.

40 Osborne, *Anywhere or Not At All*, p. 48.

indicate the manner in which the ontology of postconceptual works is *transcategorial*. More specifically, it is a transcategorial *ontology of (transmedial) mediations*. So understood, the successful postconceptual work traverses (crosses, back and forth) the internal temporal disjunctions that constitute the contemporary, constructing them in such a way as to express them at the level of the immanent duality – conceptual and aesthetic – constitutive of its postconceptual form, internal to the structure of the image. Each a condensed fragment, worlding the globe.

2

Global Modernity and the Contemporary: Two Categories of the Philosophy of Historical Time

What is the relationship of contemporaneity to modernity as forms of historical time? In particular, how does the notion of the contemporary involve a transfiguration of the phenomenological subject of 'the modern'. My title here mimics a well-known essay by Reinhart Koselleck, ' "Space of Experience" and "Horizon of Expectation": Two Historical Categories' (1976),[1] as a mark of both acknowledgement and difference. Acknowledgement of the fact that it is in large part a result of Koselleck's historical semantics of the basic temporal concepts of modernity – *Neuzeit*, history, progress, revolution, expectation, crisis, the new – that the problematic of 'the modern' has been established in its philosophical meaning as part of a philosophy of historical time; or more precisely, as a temporalization of history; indeed, as the *founding* form of such temporalizations. Difference, because the restriction of Koselleck's analysis of these concepts to, on the one hand, the horizon of their founding period (from late eighteenth- to late nineteenth-century Europe) and, on the other hand, the philosophical framework of phenomenological ontology, registers the narrowly or *merely historical* character of his work. That is to say, 'space of experience' and 'horizon of

1 Reinhart Koselleck, ' "Space of Experience" and "Horizon of Expectation": Two Historical Categories', in *Futures Past: On the Semantics of Historical Time*, trans. Keith Tribe, MIT, Cambridge MA, 1985, pp. 267–88.

expectation' cannot be treated as transcendental categories of historical analysis (as Koselleck presents them, from within their own absolutized historical domain), for both historical and philosophical reasons – philosophical reasons that the passage of time has itself made clearer.

It was always conceptually incoherent, for example, to delegate 'experience' solely to the present, in counterpoint to the futural horizon of expectation; and to restrict 'the new' to such a purely futural horizon, suppressing both its element of ambiguous externality and its ruptural quality with regard to the phenomenological subject.[2] Rather, today, these categories appear relative to historical and philosophical conditions that are in the process of being fundamentally transformed. The two main conceptual registers of this process of transformation, and the emergence of new structures of temporalization of history that it involves, are (1) the 'globalization' of the (historically, 'Western' colonial) concept of modernity, and (2) the becoming-world-historical of the concept of the contemporary, as a more adequate way of grasping certain relational aspects of the spatio-temporal structure of a now-global modernity.

Here, I offer a schematic account of some of the main aspects of this dual process, through an elaboration of the concepts 'global modernity' and 'the global contemporary' as categories of the philosophy of historical time. As should already be clear, I do not understand these concepts to denote successive 'regimes of historicity',[3] but rather integrally connected structures of historical temporalization: objectively produced subjective structures, subject to reflexive theorization, which perform a heuristic but nonetheless constitutive interpretative function.[4] These concepts grasp discrete aspects of the historical process, corresponding to qualitatively different subject positions, and they pose correspondingly different theoretical and practical challenges. Only when they are

2 For a critique of Koselleck's essay, see Peter Osborne, 'Expecting the Unexpected: Beyond the "Horizon of Expectation"', in Maria Hlavajova et al., eds, *The Horizons Reader*, BAK, Utrecht, 2011, pp. 112–28; and in a revised version in *Anywhere or Not At All: Philosophy of Contemporary Art*, Verso, London and New York, 2013, pp. 202–8.

3 François Hartog, *Regimes of Historicity: Presentism and the Experience of Time* (2003), Columbia University Press, New York, 2015.

4 The destabilization of Kant's transcendental distinction between the constitutive and regulative function of pure concepts, relative to the objects of experience, is a condition of rendering experience historical.

thought *together*, however, can the complex and disjunctive temporality characteristic of the current historical process be grasped in something like its unity, in outline at least.

'Modernity!': From the Colonial to the Global

The concept of global modernity may be expounded via five, brutally reductive theses on the development of modernity as a historical form:

1. As a historical concept, 'modernity' designates the social forms and conditions of the *self-absolutizing* and thereby *structurally contradictory* temporality of the modern: the temporality of the new.
2. This concept is further contradictory, insofar as it involves the territorialization – or spatial delimitation – of an *infinite* process of temporal differentiation. (Temporal infinite, spatial finitude.) This contradiction is the dialectical motor of modernity as a distributed series of historical forms.
3. This second, spatio-temporal contradiction is epitomized by – but by no means restricted to – the historical relationship of modernity to the colonial and postcolonial (or decolonizing) imaginaries. It also applies to the historically discrete case of socialist modernities, for example, that is crucial to the comprehension of current developments in China.
4. Postcolonial relations are in the process being qualitatively transformed by their immanence to now-global processes of transnational capital accumulation, as a result of which a new kind of postcolonial temporality is emerging. This temporality is antiquating the spatial framework that the earlier form of postcoloniality inherited (through inversion) from the colonial modern: essentially, the spatial framework of anti-colonial nationalisms.
5. The transnational globalization of processes of capital accumulation and exchange, recoding relations of colonial difference, raises the question of modernity as a global form. However, insofar as this is understood as the projection of anthropological and national senses of cultures on to a single global plane, the idea of global culture is *vulgar* – in Marx's sense of offering an 'imaginary

satisfaction' which disavows the insatiable temporal logic of the modern.[5] Any global modernity will, rather, be internally self-differentiating. The spatially relational aspects of this internally self-differentiating global modernity are better grasped by the idea of the global contemporary.

Allow me to elaborate.

Thesis 1. As a historical concept, modernity designates the social forms and conditions of the self-absolutizing and thereby structurally contradictory temporality of the modern. Indeed, 'modernity' is still best written (as it often was early in the twentieth century) in exclamatory form: 'Modernity!' This exclamation mark conveys modernity's peculiar triple status of being, at once, a *declaration*, a *demand* and a *command*. There is the *declaration* of a state of affairs – 'modernity' (negation of the temporality of tradition) – and hence a description of an always-still-emergent situation. There is a *demand* that one recognize this state of affairs: an appeal to some other or others for its recognition, and everything that is implied, politically, by that. And there is a *command*, implicit in that recognition, to further actualize this state of affairs, to fulfil or complete its description. That is to say, there is a *performative logic* to the declaration of modernity that combines *description, desire* and *compulsion* (indeed, *subjection – l'assujettissement –* in the multiple senses which that term has come to acquire),[6] in a way that is familiar from the retrospectively self-validating logic of claims for recognition more generally. In the case of the exclamation 'Modernity!' however, this general performative logic of description, desire and compulsion takes on a peculiar and paradoxically absolutizing form. Herein lies both its *irresistibility* and its specifically *philosophical* significance.

To quote the French poet Arthur Rimbaud from 1873, writing at the moment of the opening up of a new stage of capitalist colonialism, consequent upon the increased competition between European powers

5 Karl Marx, *Grundrisse: Foundations of the Critique of Political Economy (Rough Draft)*, trans. Martin Nicolaus, Penguin, Harmondsworth, 1973, Notebook V, January/February, 1858, p. 488: 'the modern gives no satisfaction; or, where it appears satisfied with itself, it is *vulgar*'. Cf. Peter Osborne, 'Marx and the Philosophy of Time', *Radical Philosophy* 147, 2008, pp. 15–22, p. 17.

6 Étienne Balibar, Barbara Cassin and Alain de Libera, 'Subject', in Barbara Cassin, ed., *Dictionary of Untranslatables*.

stimulated by the emergence of Germany as an industrial force, in the final 'Farewell' sequence of his poem *A Season in Hell*: '*il faut être absolument moderne*' – 'it is necessary to be absolutely modern', or '*one must* be absolutely modern'. This is a strange and compulsive existential-categorial imperative, this declaration of a necessity not to act but *to be* in a certain way.[7] Writing a decade earlier, in the wake of Baudelaire's founding formulation, of the time-consciousness of *modernité* as a quality of temporal experience, Rimbaud was the first to articulate the paradoxical universality of the existential demand imposed upon the historical process by the self-absolutizing temporal logic of the modern as the logic of the new. This is a demand coterminous with the increasing semantic density of 'the new' marked by an intensification, differentiation and growing reflexivity of temporal meanings.

To grasp the significance of this absolutization, it is necessary to recall that 'modern', 'modernity' and 'modernism' are phenomenological-temporal concepts that, during the nineteenth century, came to be extended to the level of the concept of history (in the collective singular), at once displacing and rearticulating the category of 'history' itself. In this respect, the discourses of modern/modernity/modernism have no direct conceptual connection to 'reason' in an Enlightenment sense (although they are contingently historically associated with it) – an identification that has wrought havoc in the literature – but they are structurally tied to the philosophical concept of *the subject* (and its predecessors and successors). As Paul Ricœur put it, in his belated few pages on the category of modernity in his final major work, *Memory, History, Forgetting*: the 'full and precise formulation' of the concept of modernity is achieved only 'when one says and writes "our" modernity'.[8] That is to say, as a form of historical experience – and more precisely an experience of 'history' in the collective singular – modernity posits Hegel's 'I that is We and We that is I' as its ideal addressee. Modernity involves the construction of 'the subject', as such, as the action of the contradictory temporal structure of 'the new'.[9]

7 Cf. Pierre Macherey, '*Il faut être absolument moderne': La modernité, etat de fait ou Imperatif?*, stl.recherche.univ-lille3.fr, accessed 14 November 2016.

8 See Chapter. 1, note 25

9 Cf. Peter Osborne, 'Modernism and Philosophy', in Peter Brooker et al., eds, *Oxford Handbook of Modernisms*, Oxford University Press, Oxford, 2010, pp. 388–409, p. 397. This is possible because 'the subject' – as philosophically invented by Kant

It is the phenomenologico-temporal comprehensiveness of the Augustinean threefold present (the presence within the soul – we might say, to 'consciousness' – of the objects of memory, attention and expectation, respectively) that is the conceptual basis of the tendency towards absolutization inherent within the time-consciousness of the modern.[10] It is the fluidity of temporal differentiation and its indifference to the chronological time in which it is retroactively measured that constitutes historical time as the medium of historical meaning and political action alike.

The tendency towards absolutization inherent within the time-consciousness of the modern conjoins and condenses three phases in the development of its concept. First, at its root, the modern designates the valorization of the present *as new* over the past, thereby splitting the present itself from within and *antiquating* those aspects of the present that are not new. Second, the *generalization* of this antiquating dynamic necessarily involves its application to the new itself, at any particular time, thereby instituting a self-transcending temporal structure that opposes itself not merely to what is received by any particular tradition, but to tradition as such, as a structure of temporalization. (This is the moment of the coinage of *Neuzeit*, in Koselleck's account.) Finally, this affirmation of the new as such, in its transitoriness, across the totality of its manifestations (modern*ism*) reveals the new to have become 'ever-same' (Walter Benjamin); to have itself become a new kind of 'tradition'. The new thereby contradictorily represses the very temporality it affirms, by instituting a new temporal structure of differentiated repetition.[11]

– simply *is* the action of a particular structure of time-determination. 'The modern' codes and inflects this structure of time-determination as 'the new'. See Immanuel Kant, *Critique of Pure Reason*, pp. 271–7 (A137/B176–A147–B187); Jacques-Alain Miller, 'Action of the Structure' (1968), in Peter Hallward and Knox Peden, eds, *Concept and Form, Volume 1: Key Texts from the Cahiers pour l'Analyse*, Verso, London, and New York, 2012, ch. 2.

10 See Éric Alliez, 'The Time of *Novitas*: Saint Augustine', in *Capital Times: Tales From the Conquest of Time* (1991), trans. Georges Van Den Abbeele, University of Minnesota Press, Minneapolis, 1996, pp. 77–137.

11 Osborne, 'Modernism and Philosophy', pp. 389–92. This narrative situates Deleuze's *Difference and Repetition* (1968) – taking off from the reception of Nietzsche's eternal return – at the (current) endpoint of the philosophical history of the new.

This is not the only contradiction that infects the concept of modernity as a result of its self-absolutizing, performative temporal logic.

Thesis 2. As a historical process, this temporal absolutization is further contradictory insofar as it necessarily involves the territorialization (or spatial de-limitation) of an infinite process of temporal differentiation. The application of the concept of modernity at the level of the concept of history, which constitutes it as a historical concept, carries with it the spatialization or territorialization of the phenomenological concept of 'world'. What is now called 'globalization' appears from this point of view as the planetarily expanded process of social actualization of the phenomenological concept of world.[12] And, as Marx foresaw, the medium of this social actualization is the universalization of relations of exchange. The idea of global modernity thus posits a (virtual) absolute 'we' of universal exchange. Ultimately, it is the value form (in Marx's specific sense) that is 'the' subject of modernity.[13] At the level of the actual historical process, however, geopolitically, irreducible (embodied) elements of spatial finitude (place) accompany the electronic actualization of this virtual 'we' in the (cyber)space of capital 'flows'.[14] The contradiction here between the temporal infinite of a self-absolutizing modernity carried by the tendential universalization of exchange relations and the spatial finitude of actual historical subjects is the dialectical motor of modernity as a distributed series of historical forms. In the first ('anthropological' and 'sociological') phases of historical modernity, these forms were primarily constituted through relations of colonial difference, transcoding socio-economic differences internal to European

12 This is more clearly grasped by the French term *mondialisation*, which Jean-Lucy Nancy, for example, explicitly opposes to the 'indistinct integrality' implied by the English 'globalization'. This is a distinction that is nonetheless negated by his English-language publishers in their translation of the title of the very book dedicated to its exposition, *La Création du monde ou mondialisation*, Galilée, Paris, 2002, translated as *The Creation of the World or Globalization*, SUNY Press, New York, 2007. See, in particular, the author's prefatory note on the untranslatability of *mondialisation*, pp. 27–9.

13 I elaborate this claim in detail in my forthcoming book on the categories of subject, time and crisis in Marx's *Capital*, forthcoming in 2018.

14 See, for example, Saskia Sassen, 'Electronic Space and Power', in *Globalization and its Discontents: Essays on the New Mobility of People and Money*, New Press, New York, 1998, pp. 177–94; *Territory, Authority, Rights: From Medieval to Global Assemblages*, (2006), Princeton University Press, Princeton NJ and London, 2008. I discuss these spatial issues in *Anywhere or Not At All*, ch. 5, 'Art Space'.

societies: 'feudal' versus 'capitalist' relations of production, 'religious' versus 'secular' worldviews.

Thesis 3. This second, spatio-temporal contradiction is epitomized in the historical relationship of modernity to the colonial and postcolonial or de-colonizing imaginaries. The first, still-abiding historical form of modernity was the colonial modern. In its generalized historical sense, the category of modernity was constituted in the course of the eighteenth-century European Enlightenments through a dual process of the transcoding of immanently European temporal differences ('revolution') and colonial spatial differences ('the colonies') to produce a geopolitical spatialization of temporal differences and a temporalization of spatialized colonial differences. In this respect, as colonial difference, the colonial is constituted *internal to* the conceptual dialectics of the modern as a historical concept, in a much more fundamental manner than its mere attribution to the modern, as one possible attribute among others, in a phrase like 'the colonial modern' (which suggests a variety of kinds of the modern), is able to convey.

Indeed, the phrase 'the colonial modern' may even function to *disavow* the constitutive character of colonial difference; in particular, when used to refer to only one side of the colonial relation – the colonies – rather than the spatialization of the relation itself, which includes the territorial sites of the colonial powers. On this understanding, the colonial modern is a historical *a priori*, in Foucault's sense: a historically particular spatialization of the modern that was nonetheless *constitutive* of the modern itself as a historical concept, in the full sense. As such, it includes an investment of state power in a distinctive temporalization of the variety of political-territorial differences of the colonial relation constitutive of the first phase of historical modernity. This applies as much to non-European examples, such as Japanese colonialism in northern China, as it does to the paradigmatic instances of the capitalist colonialism of the European powers. More precisely, the colonial functions here as what we might call the historical modern's first spatial *reserve*.

As a geohistorical category, the modern can never be actual (as opposed to imaginary – which is also real, albeit in a different way) 'without reserve'. And this reserve must necessarily be, in part, spatially conceived, since every temporal designation ('the medieval', for example) has spatial presuppositions, be they explicit or implicit, which resist

the *pure* temporalization of social differences. Categories like 'the Middle Ages' make no sense outside a restricted 'Western' topography. To use the terms of Jacques Derrida's famous 1967 essay on Georges Bataille, the colonial modern is a particular 'restricted economy' of the modern, a Hegelianism *with* reserve.[15] Colonial spatialization is a 'reserve' here in each of the contradictory senses of the term 'reserve': the sense of (1) a reservation, a spatial delimitation that puts something aside; but also (2) something that is held in reserve, as an as-yet-unrealized potential, something 'beyond' the actual, in the sense of the beyond of Bataille's conception of an expenditure beyond meaning. At its most general, this reserve is the *future*. In Blanchot's phrase, the modern affirms a future that 'obstinately holds itself in reserve'.[16] This is the contradictory double coding of the colonial reserve. On the one hand, it is that which is held back, delimited, segregated, enclosed; but on the other hand, it is also that which contains the future within itself, the postcolonial. It is in the postcolonial that the colonial modern actualizes its futurity, that is, its temporal status as 'reserve'. This is a dialectical reversal internal to the problematic of modernization, in which colonies, initially figured as sites of the past, appear anew as the sites of the future, antiquating their colonial masters.

However, the future that the colonial both holds back and projects, the future that the modern affirms – the postcolonial as the new – will always itself involve another (spatial) reservation, another holding back in the sense of a delimitation, another spatialization of temporal differentiation that cannot but contain another metaphorical 'colonialization' of that which is produced as 'the antiquated/old' by 'the new'. This leads to the questions: What is the new today, geopolitically speaking? And what is the postcolonial today? Are postcolonial structures of difference still running on the modern's colonial reserve? Or have they acquired new, immanently self-differentiating temporal powers? The answers to both these last two questions must surely be 'yes'.

Thesis 4. Postcolonial relations are currently being transformed by their immanence to now-global processes of capital accumulation, as a result of

15 Jacques Derrida, 'From Restricted to General Economy: A Hegelianism Without Reserve', in *Writing and Difference*, trans. Alan Bass, University of Chicago Press, Chicago, 1978, pp. 251–77.

16 Maurice Blanchot, 'The Final Work', in *The Infinite Conversation* (1969), trans. Susan Hanson, Minnesota University Press, Minneapolis, 1993, p. 289.

which a new kind of postcoloniality is antiquating the futures of the colonial modern. Yes, postcolonial structures of difference are still running on the modern's colonial reserve, insofar as the relations between territorially defined nation-states continues to regulate capital accumulation (including, crucially, the flows of variable capital, that is, migration). But yes, also, these postcolonial structures of difference have acquired new, immanently self-differentiating temporal powers, insofar as the deterritorializing logic of capital accumulation is leading to new and genuinely transnational (rather than international) reterritorializations or socio-spatial forms. That is to say, capital markets have developed transnational dynamics that have transformed the economic, political and cultural significance of nationality beyond the purview of the problematic of postcolonial nationalisms and metropolitan multiculturalism, which nonetheless retains significant *residual* meaning and power. This is what Gayatri Spivak in her 2004 Wellek Lectures, *Death of a Discipline* – the discipline being Comparative Literature – called the 'new post-coloniality'.

On this argument, 'demographic shifts, diasporas, labour migrations, the movements of global capital and media, and processes of cultural circulation and hybridisation' have rendered the twin geopolitical imaginary of a culturalist postcolonial nationalism and a metropolitan multiculturalism at best problematic and at worse redundant.[17] *That* geopolitical imaginary may now be retrospectively periodized as belonging to a 'first stage' of postcolonialism, insofar as the world is currently in transition from postcolonial nationalisms to transnational postcolonialities, that is, a new *kind* of postcoloniality. However, this is by no means capitalism or modernity 'without reserve', but rather the modern's *new* postcolonial reserve: a dialectics of 'old' and 'new' postcolonialities that is respatializing social relations, geopolitically, at a global level, as an effect of the immanently temporalizing modernity of capital. The globalization of processes of capital accumulation and universal exchange thus raises anew the question of the structure of modernity as a cultural form.

17 Gayatri Chakravorty Spivak, *Death of a Discipline*, Columbia University Press, New York, 2003, p. 3, citing Toby Alice Volkman, *Crossing Borders: Revitalizing Area Studies*, Ford Foundation, New York, 1999, p. ix. Cf. Osborne, *Anywhere or Not At All*, pp. 26–7.

Thesis 5. Insofar as it is understood as the projection of anthropological and national senses of cultures on to a single global plane, the idea of global culture is vulgar, in Marx's sense of offering an 'imaginary satisfaction' which disavows the insatiably self-differentiating temporal logic of the modern. The spatially relational aspects of this internally self-differentiating global modernity are better grasped by the idea of the global contemporary. Global networks of communicative action are more radically de-nationalizing and de- and re-culturing than the idea of global culture can sustain. 'Cultures' of modernity are constituted, first, at the point of intersection of received cultural practices with the logic of the value form (what Marx called 'formal subsumption') and, second, in the enculturation of that form itself (which he called 'real subsumption').[18] This can be as much a matter of *currencies* as it is of 'cultures'. (Think, for example, of the imperial significance of the US dollar, or more recently the euro, as economic-culture forms.)

We need to distinguish here between at least three rather different senses of the global or 'total' application of the logic of the modern in the construction of the concept of global modernity under the condition of transnational capital. First, it could mean something like the paradoxical spatial totalization of modernity at the level of the planet, into a *single* internally temporally self-differentiating global cultural modernity – an absolute modernity, if you will. This is a powerful fantasy of capital. Yet the social unification of the global through universal exchange has not yet reached anything like this point of abstract, *purely self-generating* temporal differentiation. There is no actual global culture in this sense (however 'vulgar'). For even on the implausibly singular interpretation, the form of unity – namely exchange – abstracts radically from the 'meaningful wholes' of the plural 'cultures' in either their anthropological or nation-state senses,

18 Karl Marx, *Capital: A Critique of Political Economy*, vol. 1: *The Process of Production of Capital* (1867/1873), trans. Ben Fowkes, Penguin/NLR, Harmondsworth, 1976, Appendix, 'Results of the Immediate Process of Production', pp. 1019–38. For an account of the importance of the category of formal subsumption to the understanding of uneven development in non-European capitalist societies, see Harry Harootunian, *Marx After Marx: History and Time in the Expansion of Capitalism*, Columbia University Press, New York, 2015. For a critique of Harootunian's overextension of the concept, see Peter Osborne, 'Marx after Marx after Marx after Marx', *Radical Philosophy* 200, November/December 2016, pp. 47–51.

which, however imaginary, retain a social actuality. 'Global modernity' may have everything to do with 'culture', in the sense of the social processes of formation of subjectivity and meaning, but it has little to do with culture in the conventionally particularistic anthropological and national senses. Yet it is precisely these senses that are kept alive through the multiple culturalisms through which various regional and state forms are currently *represented* within transnational cultural spaces.

Second, the concept of global modernity could refer to something more empirically particularistic, namely, the empirical totality or *global aggregate* of the spatial multiplicity of modernities, each with their own relatively territorially contained unities (Japanese modernity, Moroccan modernity, Argentine modernity, etc.): multiple modernities – even, for some, 'alternative' ones, although that term is implausible when used in a generalized manner, since socialist modernity has been, to date, the only *historically* genuinely 'alternative' modernity to those generated by the temporal logic of capital accumulation ('expanded reproduction') driving the capitalist system of production. The problem with this second notion is that it gives no credence to the relative unity of the world capitalist system, or its overdetermining systemic effects on particular territories – and so remains within an essential national-colonial spatial imaginary.

Third, one might understand global modernity more processually as a play of forces between the abstractly unifying and temporally self-differentiating power of the universalization of exchange relations at the level of the planet and the persisting complexly interacting multiplicity of relatively territorially discrete, immanently self-differentiating modernities. This is the most realistic and also the most messy option, which can only be adequately addressed concretely, through theoretically informed, lower-level historical analysis. The comprehension of modernity in China (which is by no means the same thing as 'Chinese modernity') is particularly important in this regard, given the role of the development of capitalism in China in unifying the world economy since 1989. At a theoretical level, however, the relational aspects of this third conception are, in certain respects, better grasped by the idea of the global contemporary, as the speculative positing of the living, disjunctive unity of a multiplicity of social times. This is a temporality emergent from global coevalness, a massively complex set of practical

articulations and mediations of different temporalities within a present constructed by these articulations themselves.[19]

The Global Contemporary

In its most basic form, the concept of the contemporary is simply that of the coming together – hence the unity in disjunction, or better, the *living disjunctive unity* – of multiple times.[20] More specifically, it refers to the coming together of the times of human lives within the time of the living. Contemporaries are those who inhabit (or inhabited) the same time. As a historical concept, the contemporary thus involves a projection of unity onto the differential totality of the times of lives that are in principle, or potentially, present to each other in some way, at some particular time – in particular, 'now', since it is the living present that provides the model of contemporaneity. That is to say, the concept of the contemporary projects a *single temporal matrix of a living present* – a common, albeit internally disjunctive, 'living' historical present. As I have argued elsewhere, such a notion is inherently problematic but increasingly inevitable.

It is theoretically problematic, first, because it is an idea, in Kant's technical sense: its object (the total conjunction of present times) is beyond possible experience.[21] This is so not merely for narrowly Kantian reasons about finitude and totality (which are themselves problematic, as the Romantics showed), but also, more fundamentally, for temporal-philosophical reasons of an early Heideggerian kind. 'The present', in its presentness, cannot be understood as 'given' with experience, even transcendentally, as a fixed temporal form with its own objects (the objects

19 For the concept of the coeval as a form of chronological coexistence that is temporally overdetermined by the social dimension of spatial relations, producing complex temporalities of encounter, see Johannes Fabian, *Time and the Other: How Anthropology Makes Its Object*, Columbia University Press, New York, 1983, pp. 156–65. In *The Politics of Time* (pp. 27–9), I distinguished the coeval from the temporal unity of 'a contemporaneous present'. Here, however, in contrast, I attempt a new construction of the historical temporality of 'the contemporary' *on the basis of* a globalization of the coeval. For a further development of this argument, see Chapter 7.

20 This section reproduces, in condensed form and with a slightly different inflection, material that appears in Osborne, *Anywhere or Not At All*, pp. 22–7.

21 Kant, *Critique of Pure Reason*, pp. 394–408.

of attention), since it exists only as the differentiation or fractured togetherness of the other two temporal modes (past and future), under the priority of its futural dimension.[22] From this standpoint, the concept of the contemporary projects into presence a temporal unity that is in principle futural, 'horizonal', or better, *anticipatory*, and hence *speculative*. Furthermore, the relational totality of the currently coeval times of human existence (however theoretically comprehended in their present-ness, and however increasingly interdependent) remains empirically, fundamentally, structurally and socially disjunctive. There is no actual shared subject position from the standpoint of which its relational total-ity could be lived *as* a whole, in whatever futural, temporally fragmented or dispersed a form.

Nonetheless, the idea of the contemporary functions *as if* there is. That is, it functions as if the speculative horizon of the unity of human history had been reached, as a phenomenologically actualizable stand-point. In this respect, the contemporary is a utopian idea, with both negative and positive aspects. Negatively, it involves a disavowal; posi-tively, it is an act of the productive imagination. It involves a disavowal – a disavowal of its own futural, speculative basis – to the extent to which it projects an *actual* conjunction of all present times. This is a disavowal of the futurity of the present by its very presentness. Essentially, this is a disavowal of politics. It is a productive act of imagination to the extent to which it performatively projects a non-existent unity onto the disjunctive relations between coeval times. In this respect, in rendering present the absent time of a unity of times, all constructions of the contemporary are *fictional*. More specifically, the contemporary is an *operative* fiction: it *regulates the division* between the present and the past (the 'non-contemporaneous') within the present. Epistemologically, one might say, the contemporary marks that point of indifference between historical and fictional narrative which, since the critique of Hegel, has been associated with the notion of speculative experience itself.[23]

22 Martin Heidegger, *Being and Time* (1927), trans. John Macquarrie and Edward Robinson, Blackwell, Oxford, 1962, p. 374.

23 See Paul Ricœur, 'Poetics of Narrative: History, Fiction, Time', in *Time and Narrative*, vol. 3, trans. Kathleen Blamey and David Pellauer, Chicago University Press, Chicago, 1988, pp. 99–240. Despite the volume of his writings on time and history, Ricœur nowhere thematizes the concept of the contemporary. This is perhaps a sign of

It is the *fictional* 'co-presentness' of the contemporary that distinguishes it from the more structural and dynamic category of modernity, the inherently self-surpassing character of which identifies it with a permanent transitoriness, familiar in the critical literature since Baudelaire. In this respect, the contemporary involves a kind of internal retreat of the modern to the present. If the primary value of the modern is 'the new', in its distinction from 'the old' (which it produces), the primary value of the contemporary is its *actuality*, in distinction from the fading existential hold of what is still present but 'out-of-date' – that is, no longer articulating *living* relations between a multiplicity of spatially distributed standpoints.[24] If modernity projects a present of permanent transition, the contemporary fixes or enfolds such transitoriness within the actuality of spatially distributed conjunctures, or at its broadest, the envelopes of lives. This is the second aspect of the theoretical problem of the contemporary: the problem of the disjunctive unity of present times is the problem of the unity and disjunction of social space – that is, in its most extended, global form, the problem of the *geopolitical*. In its current, global variant, the idea of the contemporary thus poses the problem of the disjunctive unity of the *geopolitically historical*: temporal unity/spatial disjunction – in contrast to modernity's temporal differentiation within a unified space.

The temporal dialectic of the new, which gives qualitative definition to the historical present (as the standpoint from which its unity is constructed), but which the notion of the contemporary cuts off from the future, displacing it into the actuality of a shared present, must be mediated with the complex global dialectic of spaces if any kind of sense is to be made of the notion of the historically contemporaneous. Or to put it another way, *the fiction of the contemporary is necessarily a geopolitical fiction*. This considerably complicates the question of periodization: the

its own contemporaneity. As argued in Chapter 1, the contemporary emerges as a *critical* concept in cultural and art theory only during the 1990s.

24 This emphasis on the value of actuality places the concept of the contemporary within the ambit of Foucault's idea of a 'critical ontology of the present'. For some reflections on this connection, see Giorgio Agamben, 'What is the Contemporary?', in *What is an Apparatus? and Other Essays*, Stanford University Press, Stanford CA, 2009, pp. 39–54; John Rajchman, 'The Contemporary: A New Idea?', in A. Avanessian and L. Skrebowski, eds, *Aesthetics and Contemporary Art*, Sternberg Press, Berlin and New York, 2010, pp. 125–44.

durational extension of the contemporary 'backwards' into the recent chronological past. For the backwards extension of the contemporary (as a projected unity of the times of present lives) imposes a constantly shifting periodizing dynamic that insists upon the question '*When did the present begin?*' This question has very different answers depending upon *where* you are thinking from, geopolitically, which depends upon one's answer to the question '*Where is the now?*'[25]

Despite these theoretical problems of the fictive character of unity and spatial standpoint, however, constructions of the contemporary increasingly appear as inevitable, because growing global social interconnectedness gives historical content to these fictions, filling out their speculative projections with empirical material ('facts'), thereby effecting a transition from fictional to historical narrative. Such histories are as performative as they are empirical (i.e. they are constructions), but they nonetheless aspire to a hypothetical empirical unity of the present, beyond pure heteronomy or multiplicity. In this respect, the concept of the contemporary ('contemporary history') has acquired not merely the totalizing scope of a Kantian idea but its regulative necessity too. Increasingly, 'the contemporary' has the transcendental status of a condition of the historical intelligibility of social experience.

Today, the fiction of the contemporary is without doubt primarily a global or a planetary fiction. Fictions of global transnationality have recently displaced the 140-year hegemony of the internationalist imaginary, 1848–1989, which came in a variety of political forms. These are fictions – projections of the temporary unity of the present across the planet – grounded in the contradictory penetration of received social forms ('communities', 'cultures', 'nations', 'societies' – all increasingly inadequate formulations) by capital, and their consequent enforced interconnection and dependency. In short, today, the contemporary

25 Cf. Peter Osborne, 'To Each Present, its Own Prehistory', in Ruth Noack, ed., *Agency, Ambivalence, Analysis: Approaching the Museum with Migration in Mind*, Mela Books, Politecnico di Milano, Dipartimento di Progettazione dell'Architettura, 2013, pp. 20–32. For a critique of the *de*-historicizing reification inherent in the despatialization that structures categories of historical periodization, see Katheleen Davis, *Periodization and Sovereignty: How Ideas of Feudalism and Secularization Govern the Politics of Time*, University of Pennsylvania Press, Philadelphia, 2008. It is a virtue of the concept of the contemporary that it *undoes* periodization as conventionally conceived. See also Dipesh Chakrabarty, 'Where is the Now?', *Critical Inquiry* 30(2), 2004, pp. 458–62.

(the fictive relational unity of the spatially distributed historical present) is transnational because our modernity is that of a tendentially global capital. Transnationality is the putative socio-spatial form of the current temporal unity of historical experience.

It is at this point that the historical concept of the contemporary connects up to Spivak's 'new postcoloniality', which, as we saw, marks a movement beyond the colonial modern, associated with the notion of global modernity. This 'return of the demographic, rather than territorial, frontiers that predate and are larger than capitalism',[26] in response to large-scale migration, is made possible by the new communicational forms that are establishing a virtual dimension to social reality. These transversal relations of a transnational contemporaneity are overlaid upon the immanently self-differentiating temporal dynamic of the new that characterizes the now tendentially global capitalist modernity.

The question thus arises as to how we are to think about the relationship between the two forms. Might the historical time of the present (*this* present, *now*) be best thought in terms of the articulations mediating these two temporalities of global modernity and contemporaneity, as an unstable coexistence of these two distinctive forms of time? More specifically, might we not think of their mediation, primarily, as that of temporalities of *crisis*?

As the coming together, disjunctively, of different temporalities expressing conflicting tendencies or 'contradictions' at the level of a tendentially systematic, self-reproducing whole, global contemporaneity is a temporality of crisis. Contemporaneity is the overarching temporal form of global crisis – it carries the temporality of crisis immanently within itself – because crises are expressed as forms of temporal disjunction. All structural crises of capitalism are at root crises of the realization (or overproduction) of value grounded in *disjunctions between moments in the circuit of money-capital*, of one sort or another: a lack of balance, or 'unbalancing', as they say, between the circuits of different kinds of capital, between sectors, or between regions of the system. The crisis itself is the expression of these temporal disjunctions.

The primary difference of a globally extended contemporaneity from the temporality of a global modernity is that while the latter projects a collective subject of utterance (Ricœur's '*our* modernity') 'of which it is

26 Spivak, *Death of a Discipline*, p. 15.

full' (as Meschonnic put it),[27] the *trans*nationally disjunctive coding of the global contemporary projects a multiplicity of subjects, constituted by relations of temporally coded spatial difference, within a self-consciously *coeval* time: the 'contemporary' itself. In this respect, the phenomenology of the contemporary exceeds the categorical framework of phenomenology itself, as a philosophical movement. We can see this in, for example, the contrast between the 'heroism' of the Baudelairean quest to 'conquer' modernity – what Laforgue called Baudelaire's 'Americanism'[28] – and the constitutively *unconquerable*, because radically distributed, character of the contemporary. The contemporary is not to be conquered, even paradoxically via self-dissolution (Baudelaire's solution); it can only be *engaged*.

27 Henri Meschonnic, 'Modernity, Modernity', *New Literary History* 23, 1992, p. 419. Cf. Osborne, *The Politics of Time*, p. 14.
28 Walter Benjamin, 'Central Park', in *Selected Writings, Volume 4: 1938–1940*, ed. Howard Eiland and Michael W. Jennings, Harvard University Press, Cambridge MA and London, 2003, p. 161.

3

Temporalization as Transcendental Aesthetics: Avant-Garde, Modern, Contemporary

'Aesthetics and politics' has been a set – too often, a settled – topic for discussion for over forty years now, since the rubric was popularized as the framework for a set of debates with their origins in Germany in the 1930s.[1] It returns each year, like a kind of intellectual second nature, refreshed by the failure of the world to move beyond the oppositions it is dedicated to theorizing: expression and knowledge, form and commitment, art and non-art, art and life. These debates are at once invigorating and blocked. Keeping the independent discourses of aesthetics and politics alive, at their limits, by the contradictions of their conjunction, the seemingly endless reproduction of these oppositions figures something of the restless stasis at the heart of the social relations of capitalist societies themselves: the temporality of 'expanded reproduction'.[2] At once a reflection of and a reaction to these conditions, the opposition between aesthetics and politics functions in a quasi-transcendental manner, as a historical *a priori*, producing something akin to an aesthetico-political condition in its own right – a kind of intellectual

1 Ernst Bloch et al., *Aesthetics and Politics: Debates Between Ernst Bloch, Georg Lukács, Bertolt Brecht, Walter Benjamin, Theodor Adorno*, New Left Books, London, 1977.

2 Karl Marx, *Capital: A Critique of Political Economy, Volume 2*, trans. David Fernbach (1978), Penguin/NLR, London, 1992, ch. 17, Pt 2, 'Accumulation and Expanded Reproduction [*erweiterte Reproduktion*]', pp. 418–24.

scratching of the itch of the commodity culture and the instrumentalization of politics alike.

How are we to make of it something more than a symptom of divisions that are all-too-readily at once bemoaned and prospectively (but always only prospectively) surpassed – and thereby, on occasion, wished away: divisions between models of un-alienated activity, given the lie by being alienated from each other?[3]

The problem lies more deeply within the concept and condition of politics than it does within our understandings of either aesthetic or art (which are themselves to be strictly distinguished), although the *internality* of aesthetic to politics – what we might call *the aesthetic dimension of political subjectivation* – is an essential aspect of politics, in its classical sense as a collective practice of the reproduction or transformation of social relations as a whole.[4] Art contributes to the aesthetic dimension of political subjectivation by reflecting upon and re-presenting it for further reflection, although art itself is rarely of direct political significance. (One should not inflate the political significance of art – as some protagonists in these debates so often do.) One way in which art does this is through the *forms of historical temporalization* (the temporalizations of history) that it enacts, which are conditions of its intelligibility: pre-eminently, over the last two centuries, the temporalities of *avant-garde, modern* and *contemporary*.

'Temporalization' functions here as a metacritical term of transcendental aesthetics, applicable to 'politics' and 'art' alike, as it is to other forms of social practice and experience. Following Heidegger, we may think of temporalization as the process of production of the structure of temporal differences, in their dynamically differentiated unity.[5] Departing from Heidegger though, we must think of this not as an individually, existentially generated process (based in a primordial 'mineness' of death), but as the temporal aspect of practices that are constitutively relational and which produce (and reproduce) subjects in social

3 See Chapter 4.

4 Jürgen Habermas, 'The Classical Doctrine of Politics in Relation to Social Philosophy' (1963), in *Theory and Practice*, trans. John Viertel, Heinemann, London, 1974, pp. 41–81. This aesthetic dimension is what Rancière calls 'the distribution of the sensible'. Jacques Rancière, *The Politics of Aesthetics: The Distribution of the Sensible*, trans. Gabriel Rockhill, Continuum, London and New York, 2004.

5 Heidegger, *Being and Time*, pp. 349–423.

processes of subjectivation. Such processes constitute 'subjects' not merely as the epistemological correlate, or point of consciousness, of 'objects' (the epistemological problematic with which both Marx and Heidegger definitively broke), but as the retrospectively projected occupants of the 'empty place' of the actions of structures.[6] 'Subject', in its modern (post-Kantian) philosophical sense, is primarily *that which acts* and which *becomes that which acts in the course of its action*; but it is also, socially, that which is 'subjected' (in the sense of being placed in a subordinate position) to the power and authority of others in the course of these same actions.[7]

From the standpoint of the aesthetic dimension of processes of subjectivation, we may say that *temporalization is a practice of transcendental aesthetics*, both in Kant's basic sense, in which transcendental aesthetic concerns the spatial-temporal conditions of experience, conceived as elements of the subject (the first *Critique*), and in the second, extended Kantian sense of referring to a specific domain of feeling and judgement arising from the internal relationship between the faculties, and hence concerning the subject's felt relationship to its (to 'our') unity and disunities (the third *Critique*). As a practice of transcendental aesthetics, temporalization is a process at the heart of subjectivation: the process of production of subjects. Different processes and practices of temporalization inscribe subjects within different forms of historical time. As such, they determine the forms of possibility of actions of different kinds. The extension of the scope of transcendental aesthetics to historical time incorporates both a certain critical art history and certain political temporalities, within the discourse of

6 See Miller, 'Action of the Structure'. For an account of the dual (retrospectively prospective) temporality of the subject, associated with this conception, see Alain Badiou, 'Subjectivizing Anticipation, Retroaction of the Subjective Process', in *Theory of the Subject*, trans. Bruno Bosteels, Continuum, London and New York, 2009, pp. 248–53.

7 Cf. Michel Foucault, 'The Subject and Power', in *Power: Essential Works of Foucault, 1954–1984, Volume 3*, Penguin, London, 2000, pp. 326–48; *The Hermeneutics of the Subject, Lectures at the Collège de France, 1981–1982*, trans. Graham Burchell, Picador, New York, 2005. For the broader historical framework of philosophies of the subject, see Étienne Balibar, Barbara Cassin and Alain de Libera, 'Subject', in Barbara Cassin, ed., *Dictionary of Untranslatables*. I offer a condensed summary of this intricate history of the intermingling and mutual transformation of multiple philosophical concepts of the subject at the outset of Part 1 of my new book on Marx, forthcoming in 2018.

'aesthetics', thereby providing a basis for rethinking the 'aesthetics and politics' relation.[8]

To echo Baudelaire, one may say that art functions here as a kind of cultural 'distillation' or 'purification' of historical-temporal forms. These forms of temporality function as models for the historical dimension of politics. Indeed, these forms of temporality are themselves political forms, of a sort, insofar as politics continues to be thought within an imaginative space delineated by the terms of the Enlightenment philosophy of history, however aporetic such a historical conception of politics may ultimately be.[9]

That politics should continue to be thought within an imaginative space mapped out by the terms of a philosophical concept of history is currently fiercely contested. Indeed, the whole post-Althusserian and post-Foucauldian revival of a philosophical thinking of emancipatory politics (in the writings of Alain Badiou and Jacques Rancière, in particular – but also in Gilles Deleuze) is premised, precisely, on the rejection of any such notion of history – as, indeed, is the self-consciousness of most contemporary art. (There is, in certain respects, a surprising affinity between the two fields here.) Nonetheless, within art as in politics, as I have argued elsewhere, the *problem* of historical temporalization continues to be posed, if only implicitly, as a condition of the intelligibility of social experience. In this respect, history is a problem in the Kantian sense: the sense in which 'ideas' (regulatively necessary concepts of objects beyond possible experience) are inherently 'problematic'. It cannot be escaped.[10] In the case of art today, the problem

8 The idea of a *practice* of transcendental aesthetics is, I am aware, a controversial one. After all, is not 'transcendental' form precisely that which conditions the possibility of practices of all sorts, and thereby has logical priority over practices themselves? Only if we maintain a strictly logical or 'purely rational' construal of transcendental form. If we understand such forms as historically produced, then they must themselves be possible objects of practices, to the extent that a notion of *historical practices*, in the full sense of that term inherited from the Enlightenment philosophy of history, can be sustained. Given the increasing global interconnectedness of practices, such practices are becoming historically possible, for the first time, at the very moment their idea is being discarded. The uneasy relationship here between languages of *practices* and *processes* is a symptom of the practical and historical, as well as the philosophical, problematicity of the issue.

9 See Reinhart Koselleck, *Critique and Crisis: Enlightenment and the Pathogenesis of Modern Society* (1959), Berg, Oxford/New York/Hamburg, 1988.

10 See Peter Osborne, *The Politics of Time*, Chapter 2.

imposes itself, first and foremost, in the question of the critical meaning of the temporality carried by the term 'contemporary' in the phrase 'contemporary art'.

In the wake of the swift disposal – one might almost speak of a blessed obliteration – of the belatedly discredited concept of the postmodern and the revival of an interest in avant-gardes (and thereby in the critical legacy of Peter Bürger's 1974 *Theory of the Avant-Garde*), art-critical discourse has begun to have recourse to a threefold historical schema to encompass the art of the last 200 years: *avant-garde*, *modern* and *contemporary*. One interesting thing about this schema is that, while it is in certain respects periodizing, nonetheless, at base, in their fundamental conceptual meaning, its categories denote not forms, movements or styles, but the prevalence of particular forms of historical temporality, each of which has implications for our understanding of periodization itself. However, when these temporalities are narrated as occurring successively, in a straightforwardly periodizing manner (as successive 'regimes of historicity', for example, in François Hartog's Rancièrean, post-Foucauldian terminology),[11] such a narrative tends itself to take place within a homogenous meta-temporality, or historicist 'empty time', which suspends – as historicism always suspends – the critical question of the temporality of the present of the analysis itself and its constitutive role in the temporality of periodization.[12]

In what follows, I offer some brief reflections upon these three historico-temporal forms – *avant-garde*, *modern* and *contemporary* – the relations between them and, in particular, their *conflictual coexistence* as *transcendental aesthetic* aspects of processes and practices of *subject constitution*. My narrative is not that of a simple epochal replacement of one form of historicity by another, but rather of an overlaying of one by another, in a deepening *contradictory complication* of temporal forms. I do not believe, as John Rajchman has recently asserted, that ' "avant-garde" is itself history',[13] in the pejorative sense intended there, where 'history' is used to refer to that which is definitively of the past, in

11 Hartog, *Regimes of Historicity.*
12 For a critique of the temporality of conventional historical periodization, see Kathleen Davis, *Periodization and Sovereignty.*
13 John Rajchman, 'The Contemporary: A New Idea?', in Avanessian and Skrebowski, eds, *Aesthetics and Contemporary Art*, pp. 125–44; 126.

the sense of no longer being of the present. Rather, I propose that ' "avant-garde" is itself history' in the fullest philosophical sense of the term 'history', in which history is not just *also* about the present and the future (as well as the past), but is primarily so. If, in Heidegger's phrase, 'temporality has the unity of a future that makes present in the process of having been', the articulation of the relations between the three temporal *ecstases*, at the level of history, is nonetheless considerably more complicated and varied than the structure of repetition through which Heidegger himself theorized it.[14]

In particular, I propose two theses, each of which poses problems for the aesthetic dimension of political subjectivation, both at the level of social relations and, more particularly for art, as a critically reflective social practice.

Thesis 1. The modern stands to the avant-garde as the *negation of its politics by the repetition of the new* (the infamous experience of the new as *the ever-same*).

Thesis 2. The contemporary stands to the modern as *the negation of the dialectical logic* (and hence specifically developmentalist futurity) *of the new by a spatially determined, imaginary co-presencing.*

This latter thesis is not that of the negation of time by space, as some advocates of the 'spatial turn' have imagined (this is an incoherent notion: there is only space-time), but the negation of a specific temporality – a specific futurity – by a specific spatiality. The question it raises (too large to address here, although I have begun to address it elsewhere)[15] is: what is the form of futurity of the contemporary? Here, I shall restrict my focus to some particular aspects of the two theses themselves. However, one should bear in mind that the relationship between the temporalities of avant-garde and modern is now complicated by their mutual relations to the emergent temporality of a global contemporaneity, within which the temporalities of 'avant-garde' and 'modern' are increasingly mediated by the spatial relations between national and transnational social forms.

14 Heidegger, *Being and Time*, p. 374; and 'Temporality and Historicality', Division Two, Part V, pp. 424–55.
15 Osborne, *Anywhere or Not At All*, ch. 1; and also Chapter 1 in this volume.

Avant-Garde and Modern: Formal Subsumption

'The trick by which this world of things is mastered', Walter Benjamin famously wrote in his 1929 essay on surrealism, 'consists in the substitution of a political for a historical view of the past.'[16] Contained within this sentence, when taken together with the materials in Convolute N of *The Arcades Project*, is the seeds of an account of avant-garde as a philosophical concept: specifically, a certain *political temporalization of history*.[17] (The opposition of 'political' to 'historical' here is actually the counter-position of a non-historicist, interruptive conception of history to the chronologically based continuity of historicism that forms the temporal ground of historiography.) The distinctiveness of this political temporalization, which requires the explicit affirmation of a *particular* historical future (be it 'left' or 'right' – there are fascist avant-gardes, of course), can be seen in its difference from the modernism to which it was 'reduced' by Greenberg and others – indeed, by the institutional culture of the artworld as a whole – after 1939. This is the difference between destruction or negation as (1) the condition of specific, politically defined constructions ('Construction presupposes destruction' was Benjamin's formulation),[18] the positivities of which derive from the free appropriation of the givenness of certain social and technological conditions; and negation as (2) a logical moment in the abstract temporal formalism of the new *qua new*: the fate of the modern under the conditions of the commodification of culture, or the new as 'the aesthetic seal of expanded reproduction', as Adorno put it, 'with its promise of undiminished plenitude.'[19]

The social instantiation of this latter abstract temporal formalism in fashion – which Benjamin associated with the dialectic of the new

16 Walter Benjamin, 'Surrealism: The Last Snapshot of the European Intelligensia', in *Selected Writings, Volume 2: 1927–1934*, Belknap Press of Harvard University Press, Cambridge MA and London, 1999, p. 210.

17 See Peter Osborne, 'Small-scale Victories, Large-scale Defeats: Walter Benjamin's Politics of Time', in Andrew Benjamin and Peter Osborne, eds, *Walter Benjamin's Philosophy: Destruction and Experience*, Routledge, London and New York, 1994, pp. 59–109.

18 Benjamin, *The Arcades Project* [N7, 6], p. 470.

19 Adorno, *Aesthetic Theory*, p. 21.

and the ever-selfsame ('the new in the ever-selfsame, and the ever-selfsame in the new'), and about which Adorno wrote that 'the longing for the new represses duration'[20] – makes it as *actual* (despite its abstraction) as the development of the value form from which it ultimately derives: the expansion of consumption as a condition of the expanded reproduction of capital and the consequent commodification of novelty as the means for the capitalistic appropriation of desire. The political problem here concerns the character of the 'subjects' produced by such abstract temporal processes of subjectivation. These are neither just 'citizen subjects' (Étienne Balibar's political model for the modern subject)[21] nor, primarily, labouring subjects (contradictory amalgams of the individual, collective and formal, objectified subject-structures of human labour and capital), but equally consumer subjects and subjects of debt – in both the active and the passive senses of 'subject'; that is, as both imaginary sources of free action and beings 'subjected' to the processes and conditions of the accumulation of capital. As individuals, we are the *felt sites* of these contradictory processes of subjectivation (and many other ones too) – this is our primary 'aesthetic dimension'. Such at least is the outcome of the structuralist recasting of the existential analytic of Dasein, through which the concept of subjectivation achieves its most consistent development.

Outside of *politically defined* and *sustained* cultures of production and consumption (for which the historical model remains the brief early years of the Soviet Union), the two temporalities of avant-garde and modern coexist; or rather, the latter (the modern as the *abstractly new*) becomes the social form through which the former (the avant-garde as the politically produced *qualitatively historically new*) achieves a generalized social appearance, in the wake of its failure to be actualized politically. We could think of this coexistence as a temporal-cultural version of what Marx called formal subsumption: the subsumption of an existing labour process to the social relations of the production

20 Walter Benjamin, 'Central Park', in *Selected Writings, Volume 4*, p. 175; Adorno, *Aesthetic Theory*, p. 27.

21 Étienne Balibar, 'Citizen Subject', in Eduardo Cadava et al., eds, *Who Comes After the Subject?*, New York and London, 1991, pp. 33–57. See also the Introduction to Étienne Balibar, *Citizen Subject*, pp. 1–31.

of value.[22] Here, the concrete historical novelty of the avant-garde is subsumed to the abstract and formal temporality of the new character- istic of 'the modern' as a temporal schema. There is a contradiction within avant-garde practices that are culturally 'formally subsumed' to the temporality of the modern between the temporal logic of their production process (that is, *construction* as a politicized historical temporalization, a making of the future) and the temporal forms under which they are consumed (the temporal determinations of the commodity form: the new as the ever-same). Furthermore, the effect of the sustained repetition of the abstract temporal formalism of the new (the primary temporal determination of the *distribution* of the art commodity) has been to reduce further whatever qualitative historical novelty it retains, in any particular instance, to its relations of differ- ence to other works with which it shares the common time of its space of exhibition. This represents a further reduction: an over-coding of the logic of the modern by that of the contemporary – a togetherness in time produced by the appearance of works with different temporalities appearing with the same, *de*-temporalized, abstract art-space (the famous 'white cube').[23]

There has thus been a dual retreat within the temporalizing function of the artwork from a historical conception of the future: first, a subsumption of the temporality of the avant-garde to the temporality of the modern as the abstractly new (Benjamin's later thought is located at the crisis point of that transition); second, and subsequently, the attempt to save the qualitative aspect of the temporality of the modern from its immanent degeneration through repetition, via the more punctual concept of the contemporary. However, this spatializes novelty by making co-presence the condition of the conjunction of the different times it holds together. Furthermore, under the conditions of global capital (in which 'globalization' is shorthand for 'global capitalization'), this is a primarily imaginary, speculative or *fictional* co-presence.[24]

Just as political debates about social emancipation and the resistance to capital have tended to focus on what is beyond the scope of

22 Karl Marx, *Capital, Volume 1*, Appendix, 'Results of the Immediate Process of Production', pp. 1019–38.

23 See Osborne, *Anywhere or Not At All*, ch. 6, 'Art Space'.

24 Ibid., ch. 1.

subsumption to the value form – either in historically received non-capitalist social forms or inherently (for some, 'ontologically') non-capitalistic forms – so debates about artistic avant-gardes have shifted from a constitutive identification with a post-capitalist future immanent in the potentiality of the productive forces developed by capitalism, to the potentiality of practices developed outside, or on the regional margins of, the now globally transnational art market. However, rather than being prospectively projected as actualized in a *historical* future, the anticipation of which will historically transform the present, such regional avant-gardes are instead projected as realizing their artistic value within the chronological near-future of the international artworld itself. That is to say, they function as a kind of pre- or non-capitalist anthropological reserve, which achieves its avant-garde status not via its anticipation of a prospective post-capitalist future, but rather from its prospective subsumption to the art institution itself (ultimately, the art market). Indeed, it is precisely formal subsumption that preserves the possibility of the constitutively contradictory structure of the artwork as at once 'autonomous' and 'social fact', from which its critical status derives.[25]

The formal subsumption of the temporality of the avant-garde to that of the modern performed by art institutions in capitalist societies was accompanied, from the outset, by an insistent spatial coding in terms of metropolitan, national or regionally delimited territorial forms.[26] This is a different kind of repetition: not the economically driven, abstract repetition of the new (the new as 'the aesthetic seal of expanded reproduction'), but the cultural-political repetition of the national and (at a greater distance) the regional, which increasingly functions as the compensatory correlate of its destruction as an economic form, under the conditions of a tendentially global transnational capital – 'after 1989', and after the opening up of capitalist manufacturing in China subsequent to its joining the World Trade Organization in 2001 in particular. In the context of the history of avant-gardes (and the history of the

25 See Adorno, *Aesthetic Theory*, pp. 225–8.
26 The Ur-scene of this particular scenario of spatial belonging was, of course, Paris, from which New York famously 'stole' the idea of modern art during the 1940s. Serge Guilbaut, *How New York Stole the Idea of Modern Art: Abstract Expressionism, Freedom and the Cold War*, trans. Arthur Goldhammer, University of Chicago Press, Chicago, 1985. French artists – Duchamp, in particular – had been trying to sell the idea to New York since the outbreak of the First World War.

theory of the avant-garde, especially), one exemplary form of this repetition has been the recent *repetition of the Russian*.

Avant-Garde, National, Historical: The Repetition of the Russian

The theoretical understanding of avant-garde art practices in Russia in the immediately post-revolutionary period has by now turned full cycle, through a succession of stages, returning us to its starting point in the idea of a Russian avant-garde. Initially conceived as an extension of the pre-revolutionary national-bourgeois artistic avant-garde, with Malevich as the central, defining figure of its 'revolutionary' artistic continuity, by the early 1920s the explicitly *communist, internationalist* and *anti-'art'* ideas of its Constructivist-Productivist trajectory had redefined the logic of future-orientated artistic production according to the dual – formal and functional – parameters of the concept of construction. Subsequently, however, in the 1940s and 1950s, in the West, with reference to its main émigré figures (such as Gabo), this heritage was stripped of its functionalism to produce a politically dissident formalist Constructivism, reintegrated into a history of specifically artistic avant-gardes, as part of a broader modernism – the ideological content of Soviet Constructivism having been conflated with the Stalinist cultural policy that usurped it.[27] This was followed, in the 1960s and early 1970s, by attempts to recover the critical social logic of Soviet Constructivism, culminating in its repositioning as part of a broader, anti-art-institutional 'historical' avant-garde in Peter Bürger's 1974 *Theory of the Avant-Garde* – a work that condensed two decades of renewed reception, from the standpoint not of social revolution, but its refraction in the 'anti-art' of Dada and Surrealism.[28] Finally, after 1989 and the apparently definitive closure of a seventy-year episode in Russian and world history, the avant-garde of the 1920s once again began to appear as distinctively

27 See Benjamin H. D. Buchloh, 'Cold War Constructivism', in Serge Guilbaut, ed., *Reconstructing Modernism: Art in New York, Paris, and Montreal, 1945–1964*, MIT Press, Cambridge MA and London, 1990, pp. 85–112; Hal Foster, 'Some Uses and Abuses of Russian Constructivism', in Richard Andrews, ed., *Art into Life: Russian Constructivism, 1914–1932*, Rizzoli, New York, 1990, pp. 241–53.

28 Peter Bürger, *Theory of the Avant-Garde*, trans. Michael Shaw, University of Minnesota Press, Minneapolis, 1984.

Russian, harking back to the terms of the *pre-internationalist* nine-neenth-century, dissident bourgeois, national avant-gardes from which the description originated. And this despite the fact that from the stand-point of the emerging post-Soviet nationalisms, Malevich appears as a Ukrainian artist – and not a 'Russian' one at all.

The sequence of dominant Western understandings of the avant-garde in Russia from the beginning to the end of the twentieth century thus runs as depicted in Fig. 3.1.

Early twentieth century	Russian
1920s	Communist/Soviet
1940s/1950s	Dissident formalist
1960s/1970s	'Historical'
1990s–	Russian

Fig. 3.1 Western recodings of the 1914–1933 avant-gardes in Russia

If not a spiral of forgetting, this is at least a spiral of recoding: a recod-ing of the communist (via the Soviet) as the Russian. If there is repeti-tion here, in this sequence of designations, it is not the repetition of what has become known as the 'repetition paradigm', from 'historical' to 'neo' avant-gardes and beyond, as set out by Benjamin Buchloh and later Hal Foster in the 1980s and 1990s, as the enabling condition of the historical legitimation of a retroactively declared institutional critique as the continuation of the historical avant-garde under the conditions of the 'neo'.[29] Nor is it the 'repetition of revolution' – the repetition of revo-lution as *counter*-revolution, in Boris Groys's formulation, whereby political revolution appears as artistic counter-revolution.[30] Rather, it is the repetition of the Russian as a national coding, within a globally

29 Benjamin H.D. Buchloh, 'The Primary Colours for the Second Time: A Paradigm Repetition of the Neo-Avant-Garde', *October* 37, Summer 1986, pp. 41–52; Hal Foster, 'Who's Afraid of the Neo-Avant-Garde?', in *The Return of the Real*, MIT Press, Cambridge MA and London, 1996, pp. 1–34; Benjamin H.D. Buchloh, 'Conceptual Art, 1962–1969: From the Aesthetic of Administration to the Critique of Institutions', *October* 55, Winter 1990, pp. 105–43.

30 Boris Groys, 'Repetition of Revolution: Russian Avant-Garde Revisited', paper to the conference Russian Avant-Garde Revisited, Van Abbe Museum, Eindhoven, 13 March 2010, part of the Former West project, formerwest.org.

expanded art market, in which it is the financial strength of Russian buyers, more than the significance of contemporary Russian art, which has imposed a sense of 'the Russian' on the market.[31]

In the development of this series, the concept of the 'historical' avant-garde performs a complex and subtly double-coded role. On the one hand, it acts as an agent of political neutralization, by consigning the political conception of avant-garde definitively to the *past*, via the restricted connotation of 'historical' meaning 'of the past'. The historical avant-garde is 'historical' in this sense because it is *over*; more particularly, it is supposedly over because it 'failed' (just as conceptual art was later said to have failed). And the political avant-garde failed because Soviet communism failed – quite early on, by the end of the 1920s, let us say (albeit not, *pace* Groys, by 1925). It thus became, retrospectively, 'utopian'. Its utopianism is the effect of its failure. Indeed, it is deemed to have failed so fundamentally that on Bürger's schema the term 'historical' displaces the term 'communist'. (This is not, I think, merely an effect of Bürger's guiding reference to Dada and Surrealism, but a fundamental part of the book's political unconscious.) The term 'historical' covers over the politics of the avant-gardes of the 1920s by its very mode of acknowledging them, preparing the way for the subsequent preservation as the 'treasure' of their revolutionary heritage. (This is the paradigm of cultural history to which Benjamin, for example, was explicitly opposed.)[32]

However, the so-called historical avant-garde was also 'historical' in a second, deeper sense: it was historical by virtue of its investment in history, as a whole, in the collective singular – not as 'the past' alone, but, in order to complete that whole, by representing *the future*. The 'historical' avant-garde was socially and politically (and not merely artistically) avant-garde; hence, precisely *not* 'artistically' if the sense of this latter term is restricted to the predominant modern conception of art as

31 'Moscow Conceptualism' is the exception here, although it too cannot escape the logic of retroactive appropriation to a now-globalizing Western art history. For which, see Chapter 12.

32 'Barbarism lurks in the very concept of culture – as the concept of a fund of values which is considered independent not, indeed, of the production process in which these values originated, but of the one in which they survive. In this way, they serve the apotheosis of the latter . . . barbaric as it may be.' Benjamin, *The Arcades Project*, [N5a, 7], pp. 467–8.

autonomous. When the First Working Group of Constructivists (Aleksei Gan, Rodchenko, Stepanova) announced 'IRRECONCILABLE WAR AGAINST ART', in 1922, it was because 'A CONSTRUCTIVE LIFE IS THE ART OF THE *FUTURE*' (1921).[33] This sense of the 'historical' in the historical avant-garde kicks against the neutralization of its politics involved in Bürger's narrower usage by retaining a sense of its politics as a *collective construction of life* at the level of history ('THE COMMUNIST EXPRESSION OF MATERIAL CONSTRUCTIONS', as the First Working Group put it),[34] as a permanent possibility – immanent with the historical ontology of the social. This is the philosophical core of the Constructivist avant-garde. However, ironically, it is the very permanence of this possibility – and thereby the abstraction of its basic terms, 'construction' and 'life' – that allows for its imagistic freezing, not merely as an 'instantaneous picture of a process' (Lissitzky), but as an eternalized form, waiting, as in a fairytale, to be reawakened. Benjamin's 'dialectical fairytale', the subtitle of his initial version of *The Arcades Project*, is in this respect a better description of the current fate of historical communism than of nineteenth-century capitalism. Recent ontologizations of communism as 'idea' attest to this fate.[35]

In fact, with regard to Bürger's historical avant-garde, the very expression 'art into life' harbours an *aestheticist misrepresentation* of the communist avant-garde's replacement of one art (the art of composition) by another (the art of construction = 'the organization of elements') that is *always already engaged* with 'life'; and hence does not need to go 'into' life. It is already there. This marks the critical primacy of the avant-garde of the 1920s over those of 1914–19. Aestheticism had already projected the generalization of the aesthetic aspect of the artwork into the sphere of life as a whole. (Think here of Benjamin's formulation: the avant-garde was the 'cargo' of art for art's sake, 'a cargo that could not be declared because it still lacked a name'.)[36] Constructivism is no

33 'Who We Are: Manifesto of the Constructivist Group', in Aleksandr Rodchenko, *Experiments for the Future: Diaries, Essays, Letters, and Other Writings*, Museum of Modern Art, New York, 2005, p. 145; 'Slogans', 22 February 1921, in Rodchenko, *Experiments*, p. 142.

34 'Who We Are', in Rodchenko, *Experiments*, p. 145.

35 Costas Douzinas and Slavoj Žižek, eds, *The Idea of Communism*, Verso, London and New York, 2010.

36 Benjamin, 'Surrealism', p. 212.

generalized aestheticism. It is the generalization of the principle of construction. This is a generalization that is necessarily, in part, *mimetic* as well as constructive, and hence (as Gan, Rodchenko and Stepanova said) *expressive*. This is a side of constructivism that is rarely discussed: that speculative identity of construction and expression to which both Adorno and the later Deleuze point as the telos of the non-organic work of art or machinic art assemblage.[37]

Peter Bürger's *Theory of the Avant-Garde* leads us astray here, in figuring its early twentieth-century 'historical' avant-garde from the institutional standpoint of the neo as its future negation. This may apply to Dada, but Constructivism was effectively (rather than rhetorically) indifferent to art-*institutional* negation, since, in the period immediately after the Revolution, there were very few actual institutions left to negate. In fact, institutions needed *building*, alongside the application of the principle of construction to the reorganization of everyday life. Hence the proliferating collective art organizations of the early Soviet years, from the Art Department of the Moscow Council of Soldiers' Deputies (of which Malevich was the President as early as September 1917) to the UNOVIS collective ('Affirmers of the New') at the art academy in Vitebsk. Constructivism contained Productivism within itself as one of three elements: 'laboratory' formalism, reorganization of everyday life, and organization of production. There was no necessary contradiction there. At the level of theory, that conflict was a phoney war. The invocation of institutional critique as the 'good' political repetition of the avant-garde of the interwar period, as opposed to the 'bad' formalist one of the neo-avant-garde, is thus largely spurious; doubly so, in fact, since institutional critique is *more* concerned with art's institutionality than the autonomous works of laboratory constructivism, the formalism of which was produced in anticipation of life-functional applications, rather than for their own sake; unlike the predominantly, albeit negatively, *art-functional* applications of institutional critique.

The issue rather concerns construction as the expression of a particular historical form of the social; hence, alternative constructions as expressions of alternative forms, levels and aspects of the social:

37 See Éric Alliez and Peter Osborne, 'Philosophy and Contemporary Art, After Adorno and Deleuze: An Exchange', in Robert Garnet and Andrew Hunt, eds, *Gest: Laboratory of Synthesis*, Bookworks, London, 2008, pp. 35–64.

'*communist* expressions of *material constructions*' and *capitalist* expressions of material constructions. In theoretical terms, 'the Russian' is relegated here to no more than a mediating cultural-historical form, and a form, moreover, which carries with it the permanent danger of the illusion of an autonomous 'cultural history'.[38] Historically, though, this illusion has been the mediating condition of the global extension of the art market, organizing meaning according to interacting national narratives. The temporality of the contemporary finds itself critically suspended here between understandings of it as a kind of recently spatially expanded chronological co-presence, making possible exchanges between *all* nations, on the one hand, and a radically disjunctive field of relations, on the other, in which a multiplicity of different times are at play which have to be *actively conjoined*. Only the latter is adequate to the concept of temporalization and thereby to a properly historical form of transcendental aesthetics: a transcendental aesthetics of historical contemporaneity.

Contemporaneity: An Active Conjunction

This active conjunction is no longer that of a particular individual, existential present with a particular (religious) past, of Kierkegaard's founding philosophical concept of contemporaneity as a task and an achievement;[39] rather, it is a geopolitically diffuse multiplicity of social times that are combined within the present of constitutively problematic, speculative or fictional 'subjects' of historical experience. This problematically disjunctive conjunction is covered over by the straightforward, historicist use of 'contemporary' as a periodizing term, in the manner in which it is encountered in mainstream art history, for example, in its stabilization of the distinction between modern and contemporary art. However, within this discourse, as a register of the continual historical movement of the present, we nonetheless find several competing periodizations of contemporary art, overlapping genealogies or

38 Cf. Walter Benjamin, 'Eduard Fuch, Collector and Historian', in *Selected Writings, Volume 3: 1935–1937*, Belknap Press of Harvard University Press, Cambridge MA and London, 2002, pp. 267–8.
39 See Chapter 1, 17–19, above.

historical strata, differently extended senses of the present, within the wider time span of a Western modern art – each of which is constructed from the standpoint of the rupture of a particular historical event and each of which privileges a particular geopolitical terrain.[40] The competition between these conceptions registers their epistemologically constructive and politically overdetermined characters. Each is itself cut across by complex imbrications within the present of the abiding, interlaced temporal forms of the avant-garde and the modern outlined above.

The extension of transcendental aesthetics into the field of historical temporalization thereby transforms the question of the relationship of aesthetics to politics in a theoretically fundamental manner. It is no longer a question of actualizing positions within a field defined by a relatively stable set of conceptual oppositions and relations inherited from philosophies of the late eighteenth century. It has become the conjointly philosophical, empirical and political task of grasping and constructing the possible political meanings of new and internally complex sets of temporal relations in uneven and rapidly changing spatial distributions. For now, 'art' remains the emblematically privileged site of such relations; for how much longer, is unclear.

40 See 'Three Periodizations of Contemporary Art', in Osborne, *Anywhere or Not At All*, ch. 1.

PART II
Art and Politics

Theorem 4. Autonomy: Can It Be True of Art and Politics at the Same Time?

It is a distinctive feature of much recent critical discourse that 'autonomy' has become increasingly derided in art, while being increasingly valued in politics. Indeed, autonomy is frequently claimed to be the very basis of politics, and hence of a politics of art – 'art activism' – dedicated to the production of non-autonomous art. Yet it is not clear that the senses in which some art may be claimed, critically, to function autonomously is well understood, or that the theoretical intimacy of relations between claims for autonomy in art and in politics is fully appreciated. It may thus be useful to approach these relations from a historico-philosophical point of view. This chapter sets out from four common misconceptions of the autonomy of art. It proceeds to outline what is taken to be a less inadequate conception, derived from Adorno's writings, before sketching the political limits of that conception and the dialectical entanglement of its critique with artistic autonomy itself.

How Not to Think About the Autonomy of Autonomous Art

Aesthetic autonomy

The autonomy of art is not – although it has often been thought to be – the same thing as the 'autonomy of the aesthetic'. Nor can the autonomy of the aesthetic provide a conceptual basis for the autonomy of art. It is a widespread historico-philosophical myth that it is the *logical* autonomy of

aesthetic judgements of taste from other types of judgement (as theorized by Kant in his 1790 *Critique of the Aesthetic Power of Judgment*) that is the conceptual basis of the autonomy of art from other types of social practice. Over the last 200 years, this myth has been perpetuated to the level of a philosophical commonplace, in part, through the use of the term 'aesthetic' to mean 'of art'. The phrase 'aesthetic autonomy' has thereby come in most places to be used synonymously with 'autonomy of art'. However, with regard to autonomy, this identification of 'art' with 'aesthetic' is both philosophically incoherent and art-historically implausible. Philosophically, Kant's *Critique of the Aesthetic Power of Judgment* cannot, in principle, provide the conceptual ground for a philosophical account of the artwork – this was actually the contribution of Jena Romanticism – since it has no account of (nor any interest in) the ontological distinctiveness of the work of art. Indeed, the whole of Kant's transcendental philosophy is systematically orientated towards the avoidance of all ontology. This is its methodological distinctiveness. Kant's thought on aesthetic requires objects that can 'occasion' the possibility of pure aesthetic judgement, for which his model is *nature*. The 'produced' and hence purpose-based character of the artwork means that *no* judgement of 'artistic beauty' can be a pure aesthetic judgement of taste, in principle, for Kant (genius notwithstanding). Indeed, what Kant called 'aesthetic art' – an art appropriate to pure aesthetic judgements of taste – precisely *cannot* be viewed as autonomous qua 'art', or as an instance of any particular art, but only 'as if' a part of nature. *Aesthetic autonomy is indifferent to the art/non-art distinction.* This makes it interesting, in itself, of course, but not as an account of the autonomy of art. Correspondingly, historically, *autonomous art has largely been indifferent to the aesthetic/non-aesthetic distinction*, for fifty years at least; and in important cases much longer.

Is there, then, no 'aesthetic regime of art' – to use Jacques Rancière's now established phrase? Well, there is no strictly Kantian one; although there appears to be a Schillerian one. However, this Schillerian regime is *not strictly aesthetic*, in either of Kant's two main senses ('of sensibility' and pertaining to a 'critique of taste'), since Schiller's aesthetics involves the application to Kant's transcendental analysis of aesthetic judgement-power of a principle from Kant's philosophy of pure *practical* reason – namely, what in his 1788 *Critique of Practical Reason*, Kant called 'Theorem 4': autonomy of the will. Theorem 4 is the source of all

productivity and all problems of autonomy in this tradition. Schiller's application took place precisely in order to solve the problem for Kantianism that it *cannot* account for the beauty of art, other than by abstracting from, or negating, the artefactual, art-status of the artwork. It is here, historically – in Schiller's early, 1793 *Kallias Letters* (his letters to Gottfried Körner, 'Concerning Beauty') – that 'autonomy' first became philosophically associated with the work of art. The autonomy of the artwork is thus, in this German tradition, philosophically mortgaged to Kant's *practical*, as opposed to his aesthetic, philosophy. This genealogy poses a political problem for nearly all accounts of autonomous art, Adorno's included; as it does also (albeit in a more subterranean, disavowed manner) for supposedly quite different accounts of the autonomy of *politics* – the supposedly Spinozist politics of autonomia, in particular. (Where is the *theorization* of autonomy in autonomia?) For this genealogy rests upon the myth of a *purely rational* determination of the will, the *in*applicability of which was to be mitigated by Schiller via the aesthetic mediations of the play and form drives. The residue of this history appears within the autonomia tradition of political autonomy in its dependence on a Kantian *negative freedom* of autonomy *from . . . autonomy from* economics, capital, the state, the party, and ultimately, perhaps, the social itself. Refusal – exodus – escape.

But what, then, of the aesthetic tradition: the historical manifestation of the Schillerian 'aesthetic regime of art'? Two things may be said about this. First, there *is*, certainly, historically, a Kantian *self-understanding* of the Schillerian 'aesthetic regime of art' – an 'aesthetic ideology' as it has been called. In its conventional form, it runs from 'art for art's sake' (in early nineteenth-century France), through aestheticism (in late nineteenth-century England), formalism (in late nineteenth-century Germany and early twentieth-century England and Russia) and formalist-modernism (in the mid-twentieth-century USA). Second, however, insofar as this 'aesthetic regime' exists as the practical enactment of a philosophical misunderstanding, it is *not the same thing as* the 'regime of autonomous modern art', or indeed, even the basis of the autonomy of the particular 'aesthetic' art that it theorizes. For once 'purposiveness without a purpose' becomes *the* purpose of art, as it did in 'art for art's sake' (as proposed by Benjamin Constant as early as 1804), such art's beauty is *no longer* 'free', on Kant's own terms – no longer actually 'without a purpose'. This is its dialectical dilemma.

Conceptualization of art's autonomy, or of autonomous art, must be sought elsewhere. The second most widespread misconception concerns self-referentiality.

Self-referentiality

The autonomy of art is not – as it is often thought to be – the autonomy of self-reference. The idea of an autonomy of self-reference is the product of the transposition of the concept of aesthetic autonomy into a linguistic register in literary modernism (T. S. Elliot was the main influence on Greenberg here): a new way of conceiving of being 'without purpose'. This in turn became the basis for a reinterpretation of aesthetic autonomy in the visual arts in Greenberg's transformation of the concept of self-referentiality into that of medium-specificity ('medium-specificity' *means* medium self-referentiality): aesthetic autonomy was thereby transformed into the *task* of *medium self-definition through purification.* Historically, this did achieve an (ideological) 'regime' of autonomy, for practices recognized as medium-based – not 'autonomous art', that is, but autonomous arts – but it arbitrarily denies autonomy to other art practices ungrounded in the history of a medium. The institutional history of art practices, since at least the 1960s, embodies the widespread rejection of this foreclosure, as it does of the earlier, generalized 'aesthetic' variant.

The third common misconception (this one is more tricky, and also more 'living') is freedom of the artist.

The freedom of the artist

The autonomy of art cannot – as has often been thought – be reduced to the expression of the autonomy of the artist, although it is conditioned by whatever *elements* of autonomy (in the sense of rationally, subjectively willed components) are involved in art practices. This is the difficult bit: theorizing those 'elements', other than by purely retrospective attribution to an artist-subject of the action of the structure articulating the process of which he or she is a part; i.e. other than by retroactively confusing the 'artist-function' with the individual human being(s) seeming to inhabit its place in the structure. (In fact, according to Alain Badiou's *Theory of the Subject,* this confusion precisely *is* 'the subjective

process' in its distinction from 'subjectivation'.)[1] Yet the burden of the idea of autonomous art (its metaphysical distinctiveness and experiential and political productivity) rests on the ontological primacy of the artwork, sedimenting the process of its production, as a whole, into an immanent structure with its own, *apparently independent*, productivity (*Schein*: actuality of the illusion of the work's autonomy). As an organizing principle and component of the production process, the artist (and his or her intentions and intentionalities) drops out; his/her/their creativity is literally consumed by the work. The artist cannot be treated as the ground of the action of the work, which *appears* as the only relevant 'subject' at stake.

However, finally, this does not mean that art is free from social determinations.

Freedom from social determinations

The autonomy of art is not – as it is often thought to be – a freedom of art from social determination. Historically (so the familiar story goes, and Bourdieu tells it well in *The Rules of Art*), the autonomous work required the production of a special social space in which it could be received as autonomous from the standpoint of its art-character. This first requires, of course, famously, the development of a market in art (the commodification of the artwork), and second, the transformation of art-institutional spaces into spaces of exhibition for autonomous art. The social history is familiar. From the standpoint of the concept of autonomous art, however, the by-now-well-established dialectical point is that autonomous art requires (ideally) the social determination of a space *free from social determinations of meaning based on non-artistic functions.* Separation. Artistic autonomy is thus – in part – a social form, an institutional form, as Peter Bürger famously argued, taking his cue from Adorno.

So, if the autonomy of art is not best conceived as any of these four things – *aesthetic autonomy, self-referentially, expression of the autonomy of the artist alone,* or *freedom from social determination* – how is it best conceived?

1 Badiou, *Theory of the Subject*, part V.

A Better Account (Or, a More Dialectical Adorno)

A better account starts out from the notion of a socially determined autonomy: not viewed in a 'causal' sociological manner (although there *is* social determination/conditioning of that kind), as some kind of explanatory external determination, but rather, immanently construed, as art's taking up of its social conditions into itself, as part of its constitution as art, (historico-)ontologically speaking. Otherwise, the idea of social determination simply negates any 'actual' or 'effective' autonomy (which is the problem with so much of Bourdieu's early work in this area). Adorno famously writes, in conjoint Dostoevskian–Marxian vein, of art's 'double character' (*Doppelcharakter*) as autonomy and social fact (*fait social* – alluding to Durkheim's sociological notion, as one element) in order to express the *contradiction* at its core.[2] This contradictory double character is best expressed dialectically, in the idea of the artwork as being internally structured by dialectical relations between its autonomous and dependent elements. On this conception, rendered more formally dialectically explicit than it is in *Aesthetic Theory* (oddly, it is more so in *Dialectic of Enlightenment*, generally a less dialectical text), and adopting the language of a dialectic in which contradictions are 'structured in dominance': autonomous art is an art in which autonomous or immanent determinations of meaning 'dominate' heteronomous or dependent ones. Dependent or heteronomous art is art in which heteronomous or dependent determinations 'dominate' autonomous ones. (These are 'determinations' in the logical/conceptual – not causal – sense.) In other words, there is dependence in autonomous art, and there is autonomy in dependent art – of course! The history of autonomous art is the history of the development and increasing complication of this dialectic. *Adorno subjects the social concept of autonomous art to the history of capitalism.* This is the distinctiveness and rigour of his critical art history. The history of modern art thus becomes for him, in large part, the history of art's relationship to/struggle with the commodity form – a dimension as absent from Rancière's account of the aesthetic *regime* of art as it is from much autonomia and post-autonomia writing on art activism.

2 Adorno, *Aesthetic Theory*, p. 225.

But what are the 'autonomous determinations' enabled by this social form? At this point, we need to look back to Schiller's taking up of Kant's philosophy of practical reason into his attempt to supplement Kant's aesthetic with an 'objective' concept of beauty.

The first half of 'Theorem 4' of Kant's *Critique of Practical Reason* reads as follows:

> *Autonomy* of the will is the sole principle of all moral laws and of duties in keeping with them; *heteronomy* of choice, on the other hand, . . . is instead opposed to the principle of obligation and to the morality of the will [i.e. to all universality] . . . the sole principle of morality consists in independence from all matter of the law (namely from a desired object) and at the same time in the determination of choice through the mere form of giving universal law that a maxim must be capable of. That independence, however, is freedom in the *negative* sense, whereas this *lawgiving of its own* on the part of pure and, as such, practical reason is freedom in the *positive* sense. Thus, the moral law expresses nothing other than the *autonomy* of pure practical reason, that is, freedom.

This is not the autonomy of 'the subject' – note – but the autonomy of 'pure practical reason' itself, or the autonomy of pure reason in its practical deployment, as Kant describes it, transcendentally. The subject's relation to the causality of this freedom, whose act it *is*, is problematic.

In the *Kallias Letters*, Schiller transposes this problematic from the domain of practice to the domain of the *appearance* of objects, viewing objects from the standpoint of pure practical reason – what he calls the 'adaption' or 'imitation' of 'the *form* of practical reason'. 'The analogy of an appearance with the form of pure will or freedom', he writes, 'is *beauty* (in its most general sense). Beauty is thus nothing less than freedom in appearance', or 'autonomy in appearance'.[3] (Freedom and autonomy are synonymous in this tradition.) Beauty, then, for Schiller is the *appearance* of the free or 'autonomous' *determination of form*. 'Autonomous art' – which gets its first philosophical definition here – is

3 Friedrich Schiller, 'Kallias or Concerning Beauty: Letters to Gottfried Körner', in J.M. Bernstein, ed., *Classical and Romantic German Aesthetics*, Cambridge University Press, Cambridge, 2003, pp. 145–83, 151–2.

an art that so *appears*. This is what Adorno is repeating when he refers to the autonomous artwork as *exhibiting* a *self-legislating* 'law of form'. It does not mean that the artwork actually *is* 'autonomous', in some positive ontological sense, but that it *appears* to be so: it has the capacity to produce this illusion. Or, to put it another way, *the artwork is autonomous to the extent to which it can generate the appearance or illusion of autonomy*. As Peter Bürger argued, over forty years ago now, autonomy operates at two discrete levels: both as a set of institutional conditions and as the achievement of an individual work, in each individual instance (this involves, but is not reducible to, the individuating moment of the aesthetic *aspect*). Certain social conditions (the market and art institutions) help make this possible, and can also hinder or negate it, but they can only *facilitate* what *appears as* a self-legislation immanent to the individual work.

Adorno's argument is that the appearance of self-legislating form positions the work critically in relation to the demand for social functionality – including its own functional aspects, which it must somehow internally 'resist' or counter in order to achieve autonomy (which = the illusion of autonomy), thereby allowing it to *figure* freedom. This is the 'truth' of art, in this tradition: the figuring of freedom, or what Adorno refers to as a free praxis. In this respect, *autonomous art is not part of an 'aesthetic regime of art', it is part of a 'supra-aesthetic artistic regime of truth'* (of which 'aesthetic art' is one restricted and historically passing variant). From this point of view, the historical development of modern art is a development in the social forms and dynamics of the dialectics of autonomy and dependence that constitute this *supra-aesthetic artistic regime of truth*. Politics is inscribed within the structure of this dialectic in three main ways.

First, as I have said, the political meaning of autonomous art resides in its *image* of freedom: the prefiguration of a free praxis, or praxis in a free society. As such, it is taken to be a criticism of the existing state of unfreedom: hence, the work of art, *any* work of art, 'criticizes society by merely existing', Adorno somewhat hyperbolically claimed (or at least, a work that has achieved autonomy does).[4] This is a politics of form – an affirmation of freedom as self-legislating form; not a 'distribution of the sensible'.

4 Adorno, *Aesthetic Theory*, p. 226.

Second, the political meaning of the dialectical unity of autonomy and dependence within the work is as a model of reconciliation. The unity of the work functions as a 'promise of happiness' by offering a model of reconciliation, a non-coercive identity, via the 'belonging together' of the one and the many. In both cases, the political meaning inherent in art is prefigurative, and hence 'imaginary'. Yet it is also, thereby, in danger of being affirmative, in the bad Marcusean sense – affirmative of the society in which such prefiguration is possible – and hence socially functional in a conservative way. This complicates the critical criteria for the achievement of autonomy.[5] Furthermore, subsequent to the recognition of the socially affirmative function of autonomous art (in the early twentieth century) and the subsequent so-called 'failure' of both the historical avant-garde's and institutional critique's assault upon the institution of autonomy, there is an additional critical requirement for the achievement of autonomy. Under these conditions, autonomous art critically requires an element of anti-art – the contradictory incorporation of an unintegrated, dependent element, for which collage and the ready-made are the historical models – but 'politics' is another way – in order to mark (i.e. to render self-conscious) the illusory character of the autonomy of the artwork by staging its connection, indexically, to the world.

This points to a third way in which politics appears within the dialectic of autonomy and heteronomy within the work: namely, as the major mode of heteronomy as external determination, necessity or constraint. Politics is *one form* of dependence – either *within* autonomous art (as a subordinate aspect) or as a type of dependent art, political art, which itself still has a (subordinate) autonomous aspect. However, when a political art (a dependent, non-autonomous art) is taken out of its practical political context by historical change or geographical displacement, and ceases to function politically, autonomous (formal) aspects come to the fore, and the character of the work changes. This is what happened when, for example, classically, works of Soviet Constructivism and Productivism were first displayed within Western art institutions as part of the history of the artistic avant-garde. Here, politics appears as an

5 Herbert Marcuse, 'The Affirmative Character of Culture' (1937), in *Negations: Essays in Critical Theory*, Beacon Press, Boston, 1968, pp. 88–133. For Adorno's critically modified adoption of this position ('its thesis requires the investigation of the individual artwork'), see *Aesthetic Theory*, p. 252.

external condition that is nonetheless incorporated into the work as one
of its conditions, remaining partly heteronomous, but nonetheless
thereby, in its very anti-formalism, becoming form-determining in a
new way, and hence 'autonomous' at a structural level.

As a paradigm of a dependent element, politics is thus one paradig-
matic, if paradoxical, way of rendered art critically *autonomous*, that is,
of *maintaining* its autonomy but in a political sense. (This is one way of
reading Thomas Hirschhorn's or Andrea Fraser's work, for example.)
However, this critical function, internal to autonomous art, only oper-
ates so long as the anti-art (dependent) element in question resists
incorporation into the art institution's conception of art. Once it is
incorporated, the originally anti-art element will itself become affirma-
tive of 'art' – and hence art's affirmative function – contradicting its
initial critical function. (This is another way of reading Thomas
Hirschhorn's or Andrea Fraser's work, for example.)

In this regard, autonomous and dependent elements of the work of
art do indeed turn into their opposites: dependent becomes autono-
mous; autonomous becomes dependent. This is the reason a dialectical
thought is still needed to grasp these dynamics. This is a great strength
of Adorno's position: despite his personal artistic preferences, his posi-
tion refuses the red herring of having simply to choose between mono-
lithically conceived blocs of 'autonomous art' and anti-institutional
'avant-garde activism'. First, because the relationship is structurally
dialectical; and second, because *the institution changes* in response to
this dialectic. Contra Bürger, the issue is thus not anti-art-institutional-
ism as such, but *socially alternative modes* of the institutionalization of
art (which was the problematic of the productive phase of the Soviet
experience in the first place).

This leads to the limits of this conception of autonomous art – namely,
its basis in the analogical application of Kant's concept of autonomy:
autonomy of the will in its 'positive' guise as *self-determining universal
form*.

The Limits of Adorno and Art Activism Alike

The conceptual and political limits of Adorno's conception of autono-
mous art derive from the individualistic assumptions behind Kant's

application of the concept of pure rational will. Adorno's notion of autonomy continues to pertain to *individual subjects*; autonomous art thus provides no more than an immanent criticism of liberal capitalist societies, through which figures the possibility of a free *individual* praxis.

Now, Adorno's is not a 'straight' Kantianism, to be sure, but a certain kind of Marxian one. He is a Marxian Kantian. He thinks that the development of capitalism has destroyed/demobilized collective subject formation, leaving a retreat to individual freedom the sole remaining progressive option. But this does not get around the conceptual issue that for him *the artwork images the political freedom of the ideal liberal individual*: this is its 'enigmatic', subject-like, singular object status. Despite the historical argument, the political limitation remains the result of a conceptual limitation. The question is: *is this a limitation of Adorno's thought*, or *an inherent limitation on the critical functioning of autonomous art in capitalist societies*? On the Schillerian argument that both Adorno and Rancière appear to accept, autonomy appears most adequately, albeit only analogically, in the artwork, because it *cannot appear in the world*, directly, in practice itself – since freedom in the form of *pure* practical reason is *alienated from life*. Those who believe the contrary, however – that freedom does appear directly politically in a movement (autonomia and post-autonomia political movements, for example) – believe that it can do so only through *withdrawal* ('exodus') from the existing capitalistic form of the social. And they conceive of this relationship, politically, primarily negatively (although they rarely acknowledge this fact): freedom as negative freedom – *autonomy from* . . . economic determinations, capital, the state, the party, etc. – as the social condition of positive freedom, despite the latter's usually *ontological* construal. Yet, in an ironic mimesis of the autonomous work of art, such *autonomy from* – or separation from – prevailing forms of social practice makes the exercise of any such positive freedom *impotent*; impotence famously being the price of autonomous art's criticality. Political autonomy, in the autonomia tradition, is thus not so much the negation of the autonomy of the artwork as its ironic political mimesis. It is thus *critically* redeemable primarily only as art – an art more strictly *autonomous* than *political* art, the *heteronomy* of which it aims to radicalize. Such is the dialectics of activism and art in the politics of autonomia.

To put it more formally: Theorem 4 – Kant's concept of autonomy – cannot be true of art (analogically) and politics (directly) at the same time. It is in this historical contradiction between art and politics that the truth of autonomy lies.

5

Disguised as a Dog: Cynical Occupy?

What might it mean to 'go beyond' cynicism today?[1] To think about this, we need first to go back *behind* cynicism today and to think a little about what cynicism was and what it has become, historically and philosophically. In particular, we need to think about what it might mean to perform this 'going beyond' cynicism through 'political forms of opposition, protest and provocation in art'; we need to think about the intrinsically performative nature of cynicism itself. When we do this, we discover that things are not quite as simple as the affirmative character of this proclaimed 'going beyond' might lead us to believe. For viewed historically, it very much appears that this 'going beyond' may be nothing other than a form of cynicism itself.

I shall adopt a dual philosophical and artistic standpoint. I take my philosophical cue from a passage in Marx's 1839 'Notebooks on Epicurean Philosophy'. I take my artistic cue from the early work of Valie Export. The passage from Marx reads as follows:

As in the history of philosophy there are nodal points which raise philosophy in itself to concretion, apprehend abstract principle in a totality, and thus break off the rectilinear process, so also there are moments when philosophy turns its eyes to the external world, and no longer apprehends it, but, as a practical person, weaves, as it were,

1 This chapter derives from a talk to the symposium Beyond Cynicism: Political Forms of Opposition, Protest and Provocation in Art, held at the Moderna Museet, Stockholm, 18 March 2012, in collaboration with the Royal Institute of Art, Stockholm.

intrigues with the world ... and throws itself on the breast of the worldly Siren. That is the carnival of philosophy, whether it disguises itself as a dog like the Cynic, in priestly vestments like the Alexandrian, or in fragrant spring array like the Epicurean. It is essential that philosophy should then wear character masks ... philosophy casts its regard behind it ... when its heart is set on creating a world. But as Prometheus, having stolen fire from heaven, begins to build houses and to settle upon the earth, so philosophy, expanded to be the whole world, turns *against the world of appearance*. The same now with the philosophy of Hegel.[2]

And today, we might add, in the wake of the collapse of historical communism ('1989'): 'The same now with the philosophy of Marx.'

What, you may ask, is all that about? And what does it have to do with going 'beyond cynicism' through political forms of opposition, protest and provocation in art today?

It is about the historico-philosophical *necessity* of cynicism (in its ancient sense) – and other politically defined philosophical particularisms – at certain historical junctures, as the necessarily one-sided practical expression of the alienated universality of philosophy. Marx's doctoral research, culminating in his 1841 dissertation, *The Difference between the Democritean and Epicurean Philosophy of Nature*, was only superficially, or academically, concerned with a comparative analysis of two ancient Greek philosophies of nature. As the notebooks reveal, it was primarily, polemically, concerned with an allegorical reading of the condition of philosophy after Aristotle, as a model for understanding the situation of philosophy in Germany in the aftermath of the death of Hegel – and the political splits in the Hegelian school, in particular. Hence its renewed significance today.

Aristotle's and Hegel's philosophies are each presented by the young Marx as 'total' philosophies, in the wake of which the world appears 'torn apart'. As the passage quoted above continues:

2 Karl Marx, 'Notebooks on Epicurean Philosophy', in Karl Marx and Frederick Engels, *Collected Works, Volume 1: Marx: 1835–1843*, Lawrence & Wishart, London, 1975, pp. 403–514, p. 491, emphasis added.

While philosophy has sealed itself off to form a consummate total world, the determination of this totality is conditioned by the general development of philosophy, just as that development is the condition of the form in which philosophy turns into a practical relationship towards reality; thus the totality of the world in general is divided within itself, and this division is carried to the extreme, for spiritual existence has been freed, has been enriched to universality, the heartbeat has become in itself the differentiation in the concrete form which is the whole . . . The division of the world is total only when its aspects are totalities. The world confronting a philosophy total in itself is therefore a world torn apart and contradictory; its objective universality is turned back into the subjective forms of individual consciousness in which it has life.[3]

These one-sided but nonetheless universal attempts to close the gap between subjective forms of philosophical consciousness and the world by the becoming practical of philosophy (Marx will later call this its 'realization') embody Marx's initial, neo-Hegelian conception of the practice of critique. At such moments, as 'total' philosophies disintegrate into one-sided fragments through their opposition to the world of appearance, the young Marx argued, subjective necessities of practice become more important than the criterion of comprehensiveness that governs the idea of theory from which they derive and in whose name they act. Yet the necessary one-sidedness of the practices frustrates the universality they aim to realize. This analysis of the necessity of the split in the Hegelian school into a 'Right' and a 'Left' Hegelianism could be applied today to the opposition between what we might call 'political-economic' and 'subjective-political' Marxisms.

This questions current affirmative political discourses about 'going beyond' cynicism, because it questions the understanding of cynicism that they involve. Philosophically speaking, there are grounds for cynicism about this alleged 'going beyond' cynicism. However, to be cynical about the presentation of current forms of opposition, protest and provocation as going beyond cynicism is not necessarily to fail to support them politically. Rather, it may be that such forms are best understood – and practised – cynically, as contemporary political manifestations in

3 Ibid.

a long line of cynical practices of opposition, protest and provocation. The early work of Valie Export (to which Marx's doctoral notebooks may then be taken to offer a philosophical clue) provides an initial indication of the connection.

Valie Export and Peter Weibel's 1968 performance piece *From the Portfolio of Doggedness* – in which Export walks Weibel around Vienna on all fours on a lead – is a literal acting out of the 'mask' of the Cynic as a dog. The ancient Greek *kuōn*, meaning dog, is believed to be the source of the term 'cynic', *kŭnĭkós*; hence Marx's reference to the Cynic's disguise. This attribution of dogginess was famously based on the Cynics' polemical lack of sexual shame: masturbating in public and copulating in the marketplace, for example, as philosophical acts refusing the Sophists' distinction between nature and convention (*physis* and *nomos*), upon which ethics was founded. Export's 1969 performance *Action Pants: Genital Panic* comes to mind. In fact, ancient cynicism is an obvious philosophical key to the interpretation of Viennese actionism as a whole (pissing and shitting, see Figs 5.1 and 5.2, cutting, etc.),[4] in relation to which Export's early work is both a feminist appropriation and immanent gender critique. Actionism (Viennese and otherwise; subsequently, often feminist) followed in the steps of the Marquis de Sade. As such, it is the contemporary artistic version of the modern revival of the spirit of ancient Cynicism par excellence. The 'Occupy' movement, I shall suggest, is an exemplary political manifestation of the same spirit.

The question of cynicism in contemporary politics – and the desire to go beyond it, at least in its everyday modern sense – is, in large part, a question of the legacy of 1968 and of a radicalism which, 'turned against the world of appearance', *changed* the world of appearance in certain important respects, but not necessarily in the ways it intended or as a result of any deeper changes in *that which appears*: the fundamental form of the social relations of capitalist societies and the dynamics of accumulation it sustains. In this regard, it is interesting to see the way in which Export's early performances were repeated, in a collective mode, by the Valie Export Society in Estonia in 2000, in the context of the 'capitalist liberation' of the ex-Soviet Baltic states (figs 5.3 and 5.4). This

4 See Peter Weibel, 'Re-Presentation of the Repressed: The Political Revolution of the Neo-Avant-Garde', *Radical Philosophy* 137, May/June 2006, pp. 20–28.

Günther Brus, *Clear Madness – Urination*, 1970

is one of a number of reenactments, among which Marina Abramović's 2005 performance of *Action Pants* should also be mentioned.

More narrowly art-institutional cynicisms, on the other hand – such as the self-cannibalistic institutional critique of the Institute for Human Activities' 'Gentrification Project' in the Democratic Republic of the Congo and the associated seminar set up as part of the Seventh Berlin Biennale[5] – are of a different order. In historical perspective, they represent an unconscious revival of the weakened, 'polite', Enlightenment cynicism of the eighteenth-century French salon, against which first Rousseau (briefly) and then de Sade reacted.[6] This

5 See humanactivities.org, accessed 16 June 2012.
6 See Louisa Shea, *The Cynic Enlightenment: Diogenes in the Salon*, Johns Hopkins University Press, Baltimore MD, 2010, Part I. I rely on the framework of this excellent account below.

kind of art-institutional cynicism is a 'mere' cynicism, in its modern, everyday sense of 'enlightened false consciousness', historico-philosophically diagnosed by Peter Sloterdijk in his monumental *Critique of Cynical Reason*.[7] Georg Simmel characterized the connection of this modern cynicism to its predecessor, in *The Philosophy of Money* (1900), as follows:

Günther Brus, *Clear Madness – Excretion*, 1970

7 Peter Sloterdijk, *Critique of Cynical Reason* (1983), trans. Michael Eldred, Verso, London and New York, 1987. See my review in *Radical Philosophy* 55, Summer 1990, pp. 58–60.

Valie Export Society, *From the Portfolio
of Doggedness, Remake*, 2000, video still

Valie Export Society, *From the Portfolio
of Doggedness, Remake*, 2000, video still

Although the attitude that we today term cynicism has nothing to do
with the Greek philosophy from which the term originates, there
exists nonetheless, one might say, a perverse relationship between the
two. The cynicism of antiquity had a very definite ideal in life, namely
positive strength of mind and moral freedom of the individual. This

was such an absolute value for cynicism that all the differences between otherwise accepted values paled into insignificance ... all this is completely irrelevant for the wise person, not only in comparison with any absolute value, but also in that this indifference is revealed in their existence. In the attitude which we nowadays characterize as cynical, it seems to me decisive that here too no higher differences in values exist and that, in general, the only significance of what is highly valued consists in its being degraded to the lowest level, but that the positive and ideal moral purpose of this levelling has disappeared. What was a means, or a secondary result, for those paradoxical adherents to Socratic wisdom is now central and in the process has completely altered its meaning.[8]

This is a disillusioned 'knowing better' but living no differently, which, under the conditions of intensifying art-institutional complicities, tends towards a form of barely concealed self-hatred and despair. (Its unconscious element derives from its disavowal of its own self-interest.) It is the kind of cynicism that many see both oppositional politics and its artworld mimesis as currently 'going beyond'. However, it is intricately tied up with historical conditions that make the wishfulness of this 'going beyond' a clear target for the cynical impulse itself.

In short, in historical perspective, the question is not *whether* to be cynical, or *how to avoid* cynicism, but *how best* to be cynical: *in what mode* and *in what relation* to politics?

Cynicism In and Against the History of Philosophy, or, the Three Cynicisms

It is conventional to distinguish between two cynicisms: ancient Cynicism (spelt with a 'K' in German, *Kynismus*, and an upper-case 'C' in English), on the one hand, and modern cynicism, or cynicism in its everyday derogatory usage (spelt with a 'Z' in German, *Zynismus* and a

8 Georg Simmel, *The Philosophy of Money* (1900), trans. Tom Bottomore and David Frisby, Routledge, London and New York, 1990, p. 255 – correcting the typo of 'not' for 'now' in the published version.

lower-case 'c' in English), on the other. However, in the light of recent, post-Sloterdijkian debates – and the somewhat tendentious but none-theless widespread hopes for the political potential of Foucault's final lectures at the Collège de France[9] – it is useful to add a third: modern revivals of the spirit of ancient Cynicism, *against* its more widespread, debased modern sense. This is the most interesting, critical, dialectical and problematic sense of cynicism, which is at stake in the political interpretation of a movement like Occupy.

Ancient cynicism – archetypically associated with Diogenes of Sinope – was a critique of philosophy in its founding Platonic form which radicalized the Sophists' categorial separation of convention and nature (*nomos* and *physis*) into a paradoxical naturalistic critique of convention per se. This was a performative ethical and social critique, based on an alternative mode of life (the philosophical origins of 'counter-culture') dedicated to asceticism and the immediate fulfilment of natural need. Hence its association with marginality and shameless indecency: in dress and sexual practice, incest even, 'like a dog'. (The name 'cynic' is taken to have originated as a term of abuse, but has been taken over, affirmed and given the additional connotation of a 'watchdog', a *moral guardian* of nature within society, by Diogenes.) Such Cynicism was a pedagogy of life, philosophy's original vocation: to 'know thyself' in order to 'live better'. Antisthenes, the first Cynic, is said to have been a pupil of Socrates. Plato is said to have referred to Diogenes as 'Socrates gone mad'. Cynics were peripatetic philosophers, living on the margins of the Academy and the Lyceum, 'lone public haranguers' who taught primarily by provocation and lived example.[10]

Until Hegel, Cynicism was generally accepted as part of the history of philosophy, even though it was handed down only second-hand and predominantly via anecdotes (no original fourth-century BCE texts survive). The main source, Diogenes Laertius' *Lives of Eminent Philosophers*, dates from six centuries after Diogenes of Sinope. In the

9 Michel Foucault, *The Government of Self and Others: Lectures at the Collège de France, 1982–1983*, trans. Graham Burchell, Palgrave Macmillan, Basingstoke, 2011; *The Courage of Truth: Lectures at the Collège de France, 1983–1984*, trans. Graham Burchell, Palgrave Macmillan, Basingstoke, 2012.

10 Shea, *The Cynic Enlightenment*, pp. 1–20.

three things acknowledged to have dominated its transmission,[11] the shape of Occupy and related movements is clearly visible: (i) asceticism, living as simply as possible, being poor (Diogenes is said to have lived in a barrel); (ii) a naturalistic shamelessness and promotion of free or plain speech, delivered with provocative humour and wit; and (iii) contempt for power. (Laertius' archetypal anecdote has Diogenes responding to Alexander the Great's question about what the great ruler can do for him with the request that Alexander 'get out of his sun'.) During the Roman Empire, Cynicism was often associated with Stoicism and was even adopted by Emperor Julian (332–362 CE) as a universal philosophy, the high point of its influence. Later, it was identified with Epicureanism, on account of its hedonistic aspect. It is said to have contributed to aspects of the asceticism of early Christianity, which the Christian supporters of Occupy have themselves revived. As a movement, it disappeared in the fifth century, living on only in theoretical and literary guises. However, after Hegel's philosophical dismissal of Cynicism on the grounds that it lacked clearly stated 'principles' or systematic presentation, it fell out of academic histories of ancient philosophy, relegated to literary, dramatic and cultural histories, where it largely remains – Sloterdijk's heroic attempt at its philosophico-political rehabilitation notwithstanding.

Modern cynicism is usually dated from its 'polite' revival in the mid-eighteenth-century French Enlightenment by D'Alembert and Diderot. Hence the subtitle of Louisa Shea's recent book on the 'cynic enlightenment': *Diogenes in the Salon*. This 'cleaned up' cynical ethic was at once a part of Enlightenment naturalism, an alternative rhetorical style, and a source for a more radical auto-critique of Enlightenment, most notably, dialectically and transitionally, in the figure of Rameau's nephew in Diderot's posthumously published novel of the same name. In Shea's account, it is the character of Lui, the nephew, in dialogue with the philosopher Moi, who simultaneously transformed cynicism from an exceptional into a general regulative social principle and 'perverted' its ethical character into a self-interested and self-serving practice; thereby inaugurating its derogatory modern sense of disillusioned self-interest, which remains its usual connotation.[12] Henceforth

11 Ibid.
12 Ibid., p. 58.

cynicism would always exist in a relation of some sort to this eighteenth-century, political-economic conception of self-interest, familiar today in the ideological rhetoric of neoliberalism (albeit of little actual relevance to that ideology's corporate-transnational economic rationale: the legal persons freed by its deregulation of markets being, primarily, large businesses). Attempts to revive the spirit and practice of ancient Cynicism, and to radicalize it further, can never wholly escape this historically imposed context; not least, as we shall see, insofar as it is a result of the reduction of social relations to the mediations of the money form.

Modern revivals of the spirit of ancient cynicism include, most notably, de Sade's radical sexual cynicism, Nietzsche's metaphysical project to 'transvalue all values' (a debasement of all currencies), and Sloterdijk's reading of modern cynicism as the product of the *defeat* of Enlightenment and his call to revive, once again, the performative radicalism of the ancient model. Sloterdijk's book is especially insightful at the level of cultural history and the comprehension of the rhythm of defeats motivating successive cynical revivals: defeat/dialectic of Enlightenment – Sade and Nietzsche; aftermath of the First World War in Germany – Weimar cynicism; trauma of the Second World War – Viennese Actionism. And we might add: the consolidation of the defeat of the hopes of 1968 by the crisis of the international Left, after 1989 – current cynicisms, all of which can be read as *withdrawals from political space*, as previously conceived, into cynical social criticism. However, there is perhaps a deeper and more important dynamic at issue in the relationship between cynicism and politics as such, which is connected to current forms of political protest and provocation – and especially the problematic claim that these protests are in some sense 'beyond cynicism'. It derives from the intimate historical relationship between cynicism and money.

Cynicism, Power and Money

The idea of money as a metonym for the social is to be found at the source of Cynicism as a philosophical position. It explains the Cynical rejection of politics as a means for the pursuit of its radically naturalistic ethical goals. It derives from the famous injunction to the young

Diogenes offered by the Delphic Oracle: *parakharattein to nomisma*, usually translated as 'adulterate the coinage' or 'deface the currency'. Different versions of the story all tell of Diogenes (sometimes helping his father) counterfeiting money, and so being expelled from his native city of Sinope, before finding his way to Athens. His philosophical career is then taken to have begun when he realizes that he has misunderstood the oracle, in a literal manner. He finally solves its riddle by reading *nomisma* (currency) as a metaphor for *nomos* (convention). He thereby interprets the injunction henceforth to allow no authority to convention, but only to nature. This radical opposition of nature to any

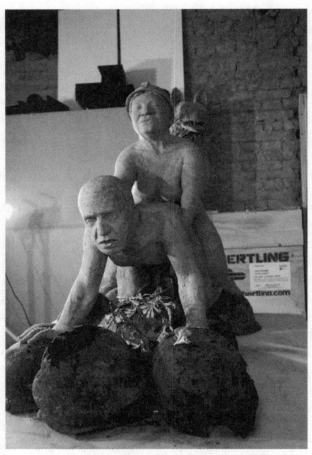

Ines Doujak, *Untitled*, work-in-progress, studio photo, 2010;
subsequently titled, 'Not Dressed for Conquering'

Ines Doujak, *Untitled*, work-in-progress, studio photo, 2010;
subsequently titled, 'Not Dressed for Conquering'

conception of convention involves the rejection of the definition of the
human as a social or political animal. As a life practice, ancient Cynicism
is thus opposed to the *polis*, and hence to politics as such, in the classical
sense. However, in its social critique and ascetic search for human
perfection (another well-known anecdote has Diogenes roaming Athens
with a lamp, in broad daylight, searching for a human) Cynicism cannot
help but enter into a critical relationship with politics, which is itself,
thus, 'political' in a paradoxical sense. This is the theatrical–political
aspect of protest and provocation.

We can see this in a recent artwork that is classically Cynical in the
form of its contempt for power: a sculpture by Ines Doujak, in which
King Juan Carlos of Spain, vomiting cornflowers (symbol of Nazism), is
being buggered by Domitila Chungara, a Bolivian activist from the
mining town of Potosí, who is herself being fucked by a wolf (figs 5.5
and 5.6). Werewolves were said to have been in the service of the
Wehrmacht. This is clearly a directly political work. It was never exhib-
ited in the show for which it was commissioned at Reina Sophia in
Madrid; it was withdrawn by the museum on account of a law deeming
it treasonous to insult the King of Spain. Having been shown at the São
Paulo Biennial in 2014, it was subsequently briefly censored once again
in Spain, at the Museum of Contemporary Art Barcelona (MACBA),

when the exhibition in which it was to appear ('The Beast and the Sovereign') was suddenly cancelled on the day of its scheduled opening, 18 March 2015 (the wolf is smiling triumphantly); only to be unexpectedly opened four days later.

Both the mode and the limits of cynicism in relation to politics are closely related to the mode of practice and the limits of what nowadays we call 'art'. In fact, one might push the analogy a little further and propose that just as (for a hundred years) art has constituted its autonomy by its incorporation of anti-art elements (of which 'politics' is one), and (for 165 years now) philosophy has remained a critical discursive mode only by its incorporation of anti-philosophical elements, so (since the 1960s, at least) the Left has depended for the effectivity of its politics on the *incorporation of anti-political aspects into political practice* – anti-political, that is, in the conventional or classical sense of a practice that is directed towards a decisive transformation of social relations via the medium of the state. Cynics do not 'believe' in 'politics'; but those who *do* believe in politics nonetheless need a cynical element to their politics if they are to register, within them, the currently problematic status of 'politics' relative to both social interests and the world-historical processes of capitalist accumulation.

It is the *powerlessness* and refusal of a political programme characteristic of the Occupy movement that places it in a social space related to, yet institutionally distinct from, art. For it is an ironic condition of the mass, long-term occupations of public space with tents, which the *indignados* started in Spain in spring 2011, that those public spaces are no longer sites for the articulation of power. Their occupation is thus necessarily symbolic. (The situation in North Africa and the Middle East is completely different from this and has wholly other political dynamics and meaning.) Indeed, Occupy Wall Street, in Zuccotti Park, was an explicit acknowledgement of that fact, insofar as 'Wall Street' is not a formally public space (hence eviction could take place on the basis of private ownership), and, on the other hand, as a metonym of finance capital, it is effectively everywhere. Hence, the slogans: 'Net, Square, Everywhere' and 'Occupy Everywhere!'[13] But this formal logic of universalization carries the danger of rapid auto-destruction, or at least

13 See Nick Dyer-Witherford, 'Net, Square, Everywhere', *Radical Philosophy* 171, January/February 2012, pp. 2–7.

extreme dilution, and mediatic culturalization. These issues are symptomatic of the currently problematic status of 'politics' as such relative to the world-historical development of capitalism. This problematic status is the result of three growing historical disjunctions: first, between individuals and effective collectives; second, between collectivities and social form; and third, between social collectivities and the historical process – we might call this the shedding of the illusion of 'world-historical' action, upon which the Enlightenment concept of politics depends, since its national–historical mediations are being destroyed by changes in the relationships of states to transnational forms of capital.

With respect to the cultural dimension of this situation, in European societies, it is the culture of punk – rather than the politicized social movements of the 1960s and early 1970s – that forms the background to Occupy and related movements (especially in the UK). Punk was the counter-cultural expression of the fiscal crisis of the capitalist state of the 1970s and early 1980s. Not for nothing did punks wear dog collars. This staged animalistic reduction is classically Cynical. In their rhetorical naturalistic levelling – think also of the role of the homeless and the debates that their presence occasioned within the Occupy camp at St Paul's, for example – such performances of life reappropriate the indifference to all 'higher' values that is inherent in the commodity structure of the money form.

Money is both the social source of the nihilistic modern form of cynicism and the reason for its inescapability. It carries with it the constant danger of the recoding of cynical critique of the social back into the nihilistic cynicism of self-interest – staged in the inevitable commodification of the cultural aspects of protest and provocation, familiar since the 1960s. Once again, the Seventh Berlin Biennale marks a low point here, with its institutional incorporation of a so-called 'autonomous section' including Occupy Museums within its programme. This effectively projects the international Occupy movement as an offshoot of the Berlin Biennale. Visitors, encouraged to start their visit to the Biennale in the Global Square in order 'to turn spectatorship into citizenship', could experience for themselves the formal subsumption of politics to the art institution. The Gentrification Project represents a transition to its real subsumption.

Simmel saw modern cynicism as

most effectively supported by money's capacity to reduce the highest as well as the lowest values equally to one value form and thereby to place them on the same level, regardless of their diverse kinds and amounts. Nowhere else does the cynic find so triumphant a justification as here . . . where the movements of money bring about the most absurd combinations of personal and objective values. The nurseries of cynicism are therefore those places with huge turnovers, exemplified in stock exchange dealings, where money is available in huge quantities and changes owners easily . . . The concept of a market price for values which, according to their nature, reject any evaluation except in terms of their own categories and ideals is the perfect objectification of what cynicism presents in the form of a subjective reflex.[14]

We do not need to accept Simmel's own neo-Nietzschean 'philosophy of values' to recognize our situation here, in this description of 112 years ago. His account of the corresponding 'blasé attitude', for which the indifference of things 'destroys all possibilities of being attractive', leading to a 'search for mere stimuli in themselves', is equally recognizable.

We have here one of those interesting cases in which the disease determines its own form of the cure. A money culture signifies such an enslavement of life in its means, that release from its weariness is also evidently sought in a mere means which conceals its final significance – in the fact of 'stimulation' as such.[15]

It is the social occupation of the place of the universal by money that makes the abolition of money central to the concept of communism, but that also, today, relegates communism to the status of an idea, thereby putting into place an inevitable cynical supplement to Left politics.[16] It is thus, as Marx argued in 1839, in the idealist terminology of the self-criticism of Hegelianism, that 'when philosophy . . . as a practical

14 Simmel, *The Philosophy of Money*, trans. Tom Buttomore and David Frisby, Routledge, New York, 2011, pp. 255–6.
15 Ibid., p. 257.
16 It also gives rise to the money-work as a staple genre of conceptual art: in relation both to forgery (Genpei Akasegawa's *Model 1000 Yen Note Incident*, 1963–73, for example) and to its destruction as an artistic act, from the KLF's burning of £1 million to Karmelo Bermejo's 2012 'Solid banknote or –*x* (minus *x*)'.

person, weaves intrigues with the world ... [i]t is essential that [it] should ... wear character masks': be it the mask of the dog or of Guy Fawkes – the *V for Vendetta* that is the V for Vengeance, the new mask of anonymity that oppositionally mimics the indifference of exchange-value to the use-values that support it. Under the conditions of a necessarily speculative collectivity, anti-capitalist politics is necessarily a politics of the mask.

All of which should give us pause for thought about precisely what 'cynicism' is, and the different ways in which it manifests itself in the current conjuncture, before we rush to try going beyond it.

PART III
Institutions

6

October and the Problem of Formalism

A little formalism turns one away from History, but . . . a lot brings one back to it.

Roland Barthes, 'Myth Today', 1957

This is a chapter about formalism – 'formalism' as a technical term and 'formalism' as a derogatory term, a term of abuse. It is about the power and the pitfalls of formal analysis. Above all, it is about formalism as an enduring *problem*. Formalism is not just *a* problem raised by 'theory' in the visual arts (and by the invocation of 'French Theory' in the visual arts in the USA since the 1960s, in particular); it is *the* problem raised by the reception of French Theory in Anglophone art criticism since the 1980s. Indeed, it is a problem that is raised not only by this reception, but by the very notion of 'art theory' as such, for which this reception was formative. Formalism is a problem for art theory, in general – and hence a problem for us – because *formalism is a problem for theory*, per se. When we speak of 'French theory', we are largely speaking of structuralism – 'the golden age of formal thinking'[1] – and the reactions to and against it. Formalism is a particular problem for *art* theory insofar as the concept of art retains a necessary reference to both (i) some critically significant, *irreducibly 'aesthetic'* aspect of the artwork – that is, a kind of sensuous individuality that cannot, in principle, be grasped by conceptual forms, and (ii) some critically significant, *irreducibly historical*

1 François Dosse, *History of Structuralism, Volume 1: The Rising Sign, 1945–1966*, trans. Deborah Glassman, Minnesota University Press, Minneapolis, 1997, pp. 210–22.

aspect, whereby the work is subject to processes of historical temporalization which destabilize and transform what might otherwise appear as purely structural relations, conceptual or aesthetic.

There would thus seem to be, at the outset, in principle, limits on the epistemological capacity of art theory to grasp its apparent privileged object, the work of art – assuming, for the moment, that is what it aspires to do. Or to put it another way: art theory must critically legitimate its *constructively reductive* transformation of the artwork into a structural object if it is to avoid the charge of formalism, as a kind of self-sufficient conceptual game ('game formalism' being the name of the predominant formalist interpretation of mathematics, of course). For, in the main critical sense in which I shall use it here, 'formal*ism*' designates the failure to respect the limits suggested above: an extension of formal analyses (of whatever kind) beyond the bounds of their legitimacy: the positing of an equivalence between the constructed objects of theory and works of art themselves. At its extreme, such a formalism implies that the real itself is produced by a structural combination of elements, reversing the original meaning of formalism in mathematics into a covertly ontological model.

But where, precisely, do these limits lie? How are we to understand them? (This need not be an *empiricist* objection, for example.) And what light does the seemingly unstoppable production of theoretical formalisms (or 'theoreticism' as it was once known) – their multiplication in art discourse through the appropriation of philosophies as found objects – throw on our understanding of current art-critical culture?

One of the main things at issue here is the relationship between art history (and other forms of knowledge about art's conditions) and art criticism; in particular, specifically 'artistic' judgements about art, or art judgements – by which I do not mean 'aesthetic' judgements in Kant's sense, since these are *not* specifically artistic, but pertain to the aesthetic attributes of all that is sensibly given. (In this respect, it was not Kant who inaugurated the modern philosophical discourse on art, but the early Romantics, since the latter were the first to think the ontology of the artwork, as the condition of its experience, rather than merely to subsume art to an independently formulated philosophical problematic: namely, 'aesthetic', or prior to that 'poetic'.) This is a crucial point. *Are historico-ontological art-critical judgements still possible?* It is important to distinguish this question of art judgement from that of aesthetic

judgement, since it was the twofold identification (i) of art-critical judgement with aesthetic judgement, and (ii) of aesthetic judgement with Greenberg's subjective, and essentially Humean version of Kantian aesthetic judgement – what he called judgements of 'quality' – that led the editorial group of the US art journal *October* to reject the problematic of judgement per se. We might call this 'the Greenbergian trauma'. This is a position they still maintained towards the end of their twenty-five-year journey (the theoretical journey of their first generation, at least), in 2002 in the notorious roundtable on 'The Present Conditions of Art Criticism' in *October* no. 100, tucked away at the end of a special issue on obsolescence. Unconsciously, perhaps: obsolescence of judgement? (We may take their journey to have ended definitively, symbolically, with the publication of *Art Since 1900*, in 2004.)[2] This enduring rejection of the problematic of judgement, in favour of a 'knowledge' subtracted from any sense of experience, was the condition for the development of 'French theory' within art discourse in the USA.

Formalisms, Theoretical and Aesthetic

It is important, in this respect, to distinguish the general *theoretical formalism* I am concerned with here from two other types of formalism encountered in US art criticism in the period under discussion: the *aesthetic formalism* that was the outcome of Greenberg's so-called formalist-modernism (better described as a 'modernist-formalism', since, by then, from the mid-1960s onwards, his modernism had been reduced to the establishment of the historical conditions for a generalized aesthetic formalism and had no further developmental dynamic); and *Russian formalism*, that school of linguistics concerned above all with the semiological specificity of the poetic or aesthetic literary work, which preceded and fed into French structuralism, in its Barthesean generalization, but retained an independent appeal, especially via Jakobson's later work with the Prague circle.[3] Both of these types of

2 Roundtable, 'The Present Conditions of Art Criticism', *October* 100, Spring 2002, pp. 200–28; Hal Foster, Rosalind Krauss, Yve-Alain Bois, Benjamin H.D. Buchloh, *Art Since 1900: Modernism, Antimodernism, Postmodernism*, Thames and Hudson, London 2004.

3 See Fredric Jameson, *The Prison-House of Language: A Critical Account of Structuralism and Russian Formalism*, Princeton University Press, Princeton NJ, 1972.

formalism are ultimately concerned, albeit in very different ways, with the individualizing function of the aesthetic, at the levels of feeling and signification, respectively. The more general *semiological formalism* of the 'theory' of French structuralism, on the other hand (and its immanent successors), is a self-contained epistemological discourse *qua* theory of signification; hence, its diametrical opposition to late Greenbergian formalism and, thereby, also its secret dialectical affinity with it.

'Theory', we may say, is the name given to those general-theoretical discourses that held themselves apart from the disciplinary constraints and history of 'philosophy' by achieving *immanently generalized, transdisciplinary forms of universality* – 'semiology', for example, or 'Lacanian psychoanalytical theory', or most generally, 'structuralism' as a new kind of transcendental philosophy; but also, let us not forget, 'historical materialism' as a wholly new kind of general-theoretical formation.[4] As such, it is in this conjoint 'holding itself apart' from both philosophy and its own privileged originating domains (linguistics, psychology, ethnology) that theory posits 'form' – intellectual form; at its purest, a purely differential system of relations – as being in some sense epistemologically self-sufficient. It is through this *self-sufficiency of pure intellectual form* that formal analysis becomes open to the project of formalization, in the logico-mathematical sense (as in the hyper-formalism of the French journal of the 1960s, *Cahiers pour l'analyse*, for example,[5] or the mathematizations of the later Lacan and middle period Badiou), and thereby becomes philosophically 'formal*istic*'. Insofar as it has a 'morphological' aspect (the *October* term for the later Greenberg's aesthetic formalism),[6] such formalism is *diagrammatic*: subject to representation by 'icons of relations' (Peirce's semiotic definition of the diagram). As we shall see, in its fondness for Greimas's structural semantics – his use of Klein group diagrams, in particular – Rosalind Krauss's work marks the displacement

4 Peter Osborne, 'Philosophy After Theory: Transdisciplinarity and the New', in Jane Elliott and Derek Attridge, eds, *Theory After 'Theory'*, Routledge, London and New York, pp. 19–33, 21. The idea of structuralism as a new transcendental philosophy derives from Deleuze. Gilles Deleuze, 'How Do We Recognize Structuralism?' (1967/72), in *Desert Islands and Other Texts, 1953–1974*, trans. Michael Taomina, Semiotext(e), Los Angeles and New York, 2004, pp. 170–92.

5 See Peter Hallward and Knox Peden, eds, *Concept and Form, Volume 1*.

6 'Introduction 3. Formalism and Structuralism', in *Art Since 1900*, p. 33.

of formalism from the aesthetic to the theoretical field, within her own development, with a trace of morphological continuity.

Structuralism is a formalism, for sure, indeed, ironically more of a formalism than Russian Formalism, since it pertains to 'the organiza-tion of the total sign-system'.[7] In Althusser's phrase from his 1974 'Elements of Self-Criticism', structuralism is a 'crazy formalist idealism' because it projects the production of the real out of a combinatory of elements. (Althusser himself confesses in this text to the 'deviation' of formalism in his work of the early 1960s, but *not* to being a structuralist. '[W]e were never structuralists', he insisted in 1974, on behalf of his group: 'we were never structuralists . . . *we were Spinozists*' – which is a whole different kettle of fish.)[8] In the language of the time, one might say that it was part of the aspiration of the *October* journal that the move from Greenberg to Krauss (*Artforum* to *October*) represent an 'episte-mological break' in the early Althusserian sense. Much ink has been spilt over the Althusserian concept of the 'break' or rupture. But as Althusser himself came quite quickly to see, the real problem was less the concept of the break itself than 'the idealist connotations of *all epis-temology*'[9] – a position he shared with Adorno. This remains the case today. Form is opposed here, in his self-criticism, by Althusser neither to 'content', nor to 'matter' (nor to the 'referent'), but to *practice*. This should be borne in mind constantly. It is not that there cannot be struc-turalist practice, a transition from the structuralist concept of the subject to practice (the final section of Deleuze's 1967/72 essay, 'How Do We Recognize Structuralism?' gestures explicitly towards it), but rather that this practice is restricted to working on the formal variations set down by the logic of the structure itself – which is not what Althusser had in mind when he used the term 'practice'. I will come back to this question of practice at the end.

First, though, let us briefly recall two paradigmatic formal analyses by Rosalind Krauss, from the standpoint of the problem of formalism, in order to get a more concrete sense of the issues it carries that remain alive in different forms today: 'Sculpture in the Expanded Field', first

7 Jameson, *The Prison-House of Language*, p. 101.
8 Louis Althusser, 'Elements of Self-Criticism' in *Essays in Self-Criticism*, trans. Grahame Locke, New Left Books, London, 1976, pp. 128–9, 131–2.
9 Ibid., p.124, note 19.

published in *October* in 1979, and the semantic analysis of 'the logic of modernism' as it appears at the outset of *The Optical Unconscious* (1993).[10] I treat Krauss here as the symbolic representative of the French-theoretical trajectory of *October*, and I take *October* to function as a metonym for the reception of 'French Theory' in the Visual Arts in the Anglophone artworld from the mid-1970s to the mid-1990s. These are classic analyses of the application of structural semantics and Lacanian theory, respectively, to contemporary art. As such, they illustrate both the extraordinary power and the theoretically problematic status of the formalism of structural analysis.

Example 1. Krauss on sculpture:
the semiotic redemption of a decomposing medium

'Sculpture in the Expanded Field' represents the second stage in the five-stage odyssey of Krauss's reflections on medium. Krauss travels from the internal transformation of sculpture as a conventional medium charted in *Passages in Modern Sculpture* (1977) – 'the transformation of sculpture, from a static, idealized medium to a temporal and material one, that had begun with Rodin'[11] – (stage 1); to 'Sculpture *in* the Expanded Field' (stage 2); to the recovery of a more differentiated history of modernisms – a more general project of the *October* journal, holding its various theoretical trajectories together – (stage 3); to an acknowledgement of the 'post-media condition' (stage 4); to the subsequent project to 'reinvent' medium (1999) (stage 5).[12] In this developmental context, the essay appears less as the affirmation of an expansion of the field that it seemed to be, and something more like a case study in the theoretical *management* of historical change. Its historical meaning is to be found less in what the analysis itself proposes than in its inadvertent effects in

10 Rosalind Krauss, 'Sculpture in the Expanded Field', *October* 8, 1979, reprinted in *The Originality of the Avant-Garde and Other Modernist Myths*, MIT Press, Cambridge MA and London, 1985, p. 276–90.
11 Rosalind Krauss, *Passages in Modern Sculpture*, MIT Press, Cambridge MA and London, 1977, pp. 282–3.
12 Rosalind Krauss, *The Optical Unconscious*, MIT Press, Cambridge MA and London, 1993; 'A Voyage on the North Sea': Art in the Age of the Post-Medium Condition, Thames and Hudson, London, 1999; 'Reinventing the Medium', *Critical Inquiry* 25(2), Winter 1999, pp. 289–305.

supporting the expansion not of the field in which 'sculpture' is located – its topic – but the institutional definition of sculpture itself; and thereby, the ideological reappropriation of all those practices of object-making that were *against* 'sculpture' by the idea a *renewal* of sculpture. This was the great reactive victory of artistic tradition in the 1980s (rather than the short-lived revival of expressionist painting, which gained attention at the time). This is perhaps most explicit in the case of Robert Smithson,[13] but the point is a general one. Let us see how it worked.

The starting point is the Klein group. This a simple structure originally employed in mathematics (also known as the Piaget group, in its social psychological application) and sometimes known as the Greimas square, for the latter's application of it to semantics – Krauss's source. Krauss herself calls it 'structuralism graph' (Fig. 6.1).

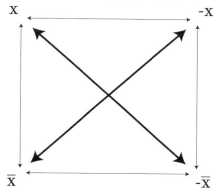

Fig. 6.1 Klein Group – 'Structuralism's Graph'

Krauss was influenced here, I think, by Jameson's 1972 *Prison House of Language*, in which Greimas appears as playing an important role in re-diagrammatizing Lévi-Strauss's structures from triangular to rectangular forms. (Jameson's influence also appears in the title of *The Optical Unconscious*, which is not an allusion to Walter Benjamin's remark about photography, as one might think, but to Jameson's 1981 *The Political Unconscious*.) The Klein group consists of relations between four terms

13 See Peter Osborne, 'An Interminable Avalanche of Categories: Medium, Concept and Abstraction in the Work of Robert Smithson, 1966–1972', in *Cornerstones*, Witte de Witt/Sternberg Press, Rotterdam/Berlin, 2011, pp. 132–51, and in a revised version as ch. 4 of Osborne, *Anywhere or Not At All*.

generated by contrariness (opposition) and formal contradiction – two different types of negation – expanding outwards from a founding term (X). In the case of the structural analysis of the field generating the category of sculpture, sculpture is located by Krauss within a structure defined by the opposition between landscape and architecture as the point of indifference between 'not-landscape and not-architecture' (Fig. 6.2). This is both a novel analysis of the categorical status of sculpture as monument (the whole analysis depends on that definition), and an analytical reduction of the remaining possibilities within its field to three basic types, or what might retrospectively be called new mediums: labelled 'site construction', 'axiomatic structures' and 'marked sites'.

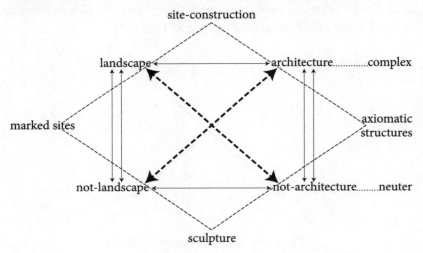

Fig. 6.2 Krauss's 'Sculpture in the Expanded Field'
(from *The Originality of the Avant-Garde*)

The combination of logical simplicity and taxonomic productiveness of the structure of this diagram is extraordinary, especially in the context of the categorical chaos of critical discourse at the time in response to the multiplicity of new practices of the previous decade (1967–77) – a situation Smithson had described as an 'interminable avalanche' of categories.[14] The structure appears as a 'generative' mechanism: it generates

14 'What Is a Museum: A Conversation Between Allan Kaprow and Robert Smithson', in *Robert Smithson: The Collected Writings*, edited by Jack Flam, University of California Press, Berkeley and Los Angeles, 1996, p. 48.

formal possibilities. However, the structure of interpretation is clearly grounded retroactively in the *prior* identification of 'site constructions', 'axiomatic structures' and 'marked sites' as new types of work, which are then 'produced' and so given new formal meanings, in a purely logical categorical form, as an effect of the founding opposition between landscape and architecture, which sustains the definition of sculpture as 'monument'. This is a powerful interpretative tool, but the outcome of the game is fixed in advance, determined, on the one hand, by the *decision* upon a founding element (X/landscape) and its particular opposite (-X/architecture); and on the other, by transcoding (or in this case, simply selecting) the derivative taxonomical terms from an existing critical vocabulary, which is thereby theoretically redefined. (One could imagine a quite different structural definition of sculpture in relation to the scale of the human body, for example.) Is this not precisely the kind of thing that Althusser was complaining about in his 'Elements of Self-Criticism', when he wrote of the 'idealism' of the effect of 'producing the real by a combinatory of elements'?[15] That depends upon how these categories are treated. It is the way in which they are taken up into critical and institutional practices which is what ultimately determines their status.

What is interesting in this case is the way in which the cultural authority of the traditional term ('sculpture') gradually came to override the new, 'expanded' categorical system, such that by the end of the 1980s, the institutionally legitimated situation was that of a sculptural appropriation of the expanded field itself, in which the previous 'sculptural' position was reduced to the 'monumental' definition from which it derived (Fig. 6.3). This is largely how it remains today. The term 'sculpture' is wholly restored, in an expanded sense far, far wider than the initial expansion of the early 1970s, recuperated by Krauss in *Passages in Modern Sculpture*. The appropriative logic of the institution semantically overdetermined the rigid structure of formal possibilities, turning 'sculpture' into a metacritical term and exploding the quantitative restrictions of the model to embrace a more radical multiplicity of practices – just as, theoretically, critics of structuralism had proposed replacing its structural logic with a logic of multiplicity. The Deleuze–Guattari critique of structuralism, for example, broadly corresponds to what Adorno diagnosed as the *increasing nominalism* of artistic

15 Althusser, 'Elements of Self-Criticism', p. 127.

production, but in the form of an *embrace* of the entropic crisis of art-critical categorization. Philosophically, however, this apparently 'superior' empiricism (transcendental empiricism) just throws criticism back on to a new version of more traditional categories: ontology of sensation. It is interesting that while a shallow version of Deleuze-Guattarian aesthetics has become hegemonic in some British art schools, it does not appear to have made that much headway in a US art-critical context.

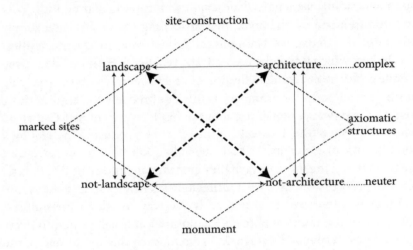

Fig. 6.3 The expanded field of 'sculpture'

Krauss's subsequent analysis of the optical logic of modernism follows the same model, although 'modernism' here means, restrictedly, *modernist painting, in a strictly Greenbergian sense* – at which point all fundamental critical issues about modernism have already been begged. This is thus not actually about 'modernism' but rather about our understanding of those works that fall within Greenberg's conception of modernist painting. The difference here is that a psychoanalytical dimension is overlaid on the basis of a homology between the Klein group and Lacan's schematization of the structure of the subject. Psychoanalytical theory is thereby used to deconstruct the self-understanding of Greenbergianism. In this instance, Krauss is not concerned with the generation of new categories (post-sculptural objects) through reflection on the points of indifference in the semantic relation between two basic categories (previously, landscape and

architecture), but rather with the way in which a practice transcodes particular categories and thereby transforms the meaning of the structure.

Example 2. Krauss on modernism as a structural logic of vision

The analysis sets out from the relation of opposition between ground and figure that constitutes an illusionistic pictorial space (Fig. 6.4). It proceeds via the interpretative transcoding of their negations (not-ground and not-figure) by some early paintings by Mondrian from 1914 to 1916 – *Pier and Ocean*, 1915; *Composition in Lines* (Black and White), 1916–17; and *Composition 1916* – to give us a new optical logic, here called 'modernism' (Fig. 6.5).

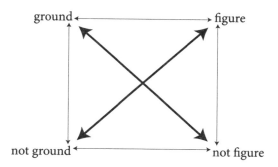

Fig. 6.4 Pictorial space (*The Optical Unconscious*, p. 14)

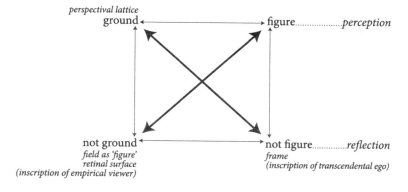

Fig. 6.5 Logic of modernism (*The Optical Unconscious*, p. 20)

This optical structure is then itself transcoded with some of the basic categories of Lacanian psychoanalysis (Fig. 6.6), including Lacan's schema of the structure of the subject itself (Fig. 6.7), giving us the following concluding, palimpsestic analysis of an 'automatist' modernism (Fig. 6.8).

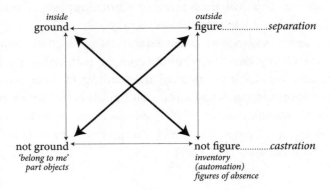

Fig. 6.6 Psyche-logic of modernism (*The Optical Unconscious*, p. 74)

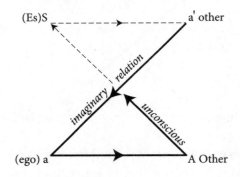

Fig. 6.7 Lacan's L schema (*The Optical Unconscious*, p. 23)

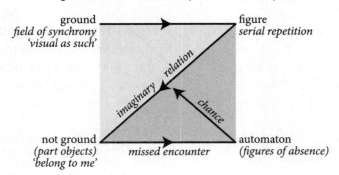

Fig. 6.8 Automatist logic of modernism (*The Optical Unconscious*, p. 75)

The problem, of course, once again, is not the logic of possibility here – which is indeed exhilarating – but the logic of *exclusion*, the exclusion of more radically experimental multiplicities. As her own formal model of unconscious structural inversion indicates, *Krauss's theoretical formalism mirrors, precisely, the a priori limits of Greenberg's aesthetic formalism.* As the family romance of the literary form of the text of *The Optical Unconscious* betrays, in a truly extraordinary symptom, Krauss appears as 'uncle Clem's' *theoretical unconscious.* 'French theory' is here well and truly *domesticated.* This suggests that the story of 'French theory' in the USA is perhaps best imaged not economically, as a tale of imports and exports, but as a narrative of domestication.

Reduction, Multiplication, Pragmatism

Theoretically, the problem of the exclusion of more radically experimental multiplicities is, of course, a new version of structuralism's old problem of the exclusion of history. This takes us back to my epigram, Roland Barthes' famous motto – 'a little formalism turns one away from History, but . . . a lot brings one back to it' – to which it is necessary to give a new meaning. What Barthes meant by this (I have always presumed) was that the more formalistic the analysis, the more purified of historical contingencies, the more structural the analysis, then the more *fundamental* the categories detected will be, operating submerged beneath the realm of appearances, determining its ideological and unconscious meanings; and the most fundamental of categories would be those of history itself (historical materialism). It is 1957. The context was Barthes' collection of his 'mythologies', and he capitalizes the word 'History'. This Marxist version of early structuralist theoretical optimism (Barthes was basically still a Brechtian at this time) was, of course, not sustainable. Both meaning and historical actuality turned out to be a lot less stable than the semiotic model of ideology-analysis allowed – brilliant though it remains, not just in its simplicity, but in its insight. So where does this leave Barthes' motto? (And how can the *October* quartet continue to cite it affirmatively, as they do, in their third 'Introduction' to *Art Since 1900*, entitled 'Formalism and Structuralism'?) One is tempted to say that 'history' has falsified it: that 'a little formalism turns one away from History, and . . . a lot takes you even further away'. But

this would be wrong, I think. For the problem here has as much to do with the simplicity of the concept of history to which Barthes appeals as it has with formal analysis as such. The problem of the relationship of formal analysis to history needs to be reposed, from both sides. On the one hand, there is the under-determination (and hence proliferating multiplicity) of the basic categorical oppositions out of which structures like Klein groups are constructed; on the other, there has been a multiplication of theoretical paradigms through which these structures of practice are transcoded. A lot of formalism does thus indeed 'turn one away' from a lot of history (those aspects of historical actuality not grasped by a concentration on particular basic structure). However, if we reflect on this distance from the standpoint of the multiplication of structures of practice and theoretical paradigms that produces it, we see that this theoretical multiplicity models something of the multiplicity of the historical actuality that produces the problem for any particular formal analysis. We could call this reflection 'philosophical' (philosophy is 'second reflection' in Adorno's phrase) in order to draw attention to the way in which it is occluded from 'theory' by theory's founding exclusion of philosophy and its history from its formal constitution – an act of insulation that its Anglophone reception has by and large preserved. There will be no 'Elements of Self-Criticism' by Rosalind Krauss.

The character of the problem thus shifts. It becomes that of how we are to conceive and deal with theoretical multiplicity (which, qua 'theory', will always remain formalistic, at some level – if not necessarily in a structuralist manner). This is where the question of practice returns as the question of what kinds of *social* practice theoretical practices are part of. In the founding, 'heroic' period of French theory in France, from the 1950s to the end of the 1970s, the answer was always ultimately *politics* of one sort or another, which gave practical meanings to theoretical universalities. In the founding period of 'French theory' *qua* 'French theory' in the USA, from the mid-1970s to the mid-1980s, it was a mixture of academic and art-institutional practice with politics. In the subsequent period, from the mid-1980s to the end of the century and beyond, it has been by and large exclusively academic and art-institutional practices. This has changed theory's relations to practice and marks another, broader domestication: the appropriation of French theory by the dominant US intellectual tradition of *pragmatism*: here, in its degenerative, non-metaphysical (non-Peircean) form – pragmatism

as an interest-based management of theoretical multiplicity, with eclecticism as a kind of market-based democracy of theoretical forms.[16] At its most extreme, the principle of critical distribution becomes: 'to each artist their own French theorist' – something of this can be detected in Hal Foster's critical practice, I think. This is the consequence of formalism under particular social and political circumstances. The questions that we face are: Just how universal have these circumstances become? And what can be done about them?

16 Cf. Peter Osborne, '"Whoever Speaks of Culture Speaks of Administration as Well"': Disputing Pragmatism in Cultural Studies', *Cultural Studies* 60(1), 2006, pp. 33–47.

7

Existential Urgency: Contemporaneity, Biennials and Social Form

Art today lives – can there still be any doubt? – in 'the age of the biennial': large-scale international exhibitions of contemporary art, which impose upon the artworlds of the world, the professionals who inhabit those worlds, and significant numbers of inhabitants of the cities that host them, a certain, very particular rhythm: the time of the every-other-year. As we know, such events have proliferated exponentially since the late 1980s. The Havana Biennial, founded in 1984, was at that point only the fourth generally internationally recognized biennial in the world – following Venice (1895), São Paolo (1951) and Sydney (1975) – although there were several other, less well-known ones between São Paolo and Havana. By the time of Second World Biennial Forum, in November 2014, thirty years after the First Havana Biennial, there were over forty times that number: 175. Today (June 2017), the Biennial Foundation website lists 213, a further increase of over 20 per cent in a mere 31 months. (Fig. 7.1). They extend across a proto-global space and the scope of their ambition is no longer primarily national, or even regional, but that of a geopolitical totalization of the globe, homologous with the ongoing, post-1989 expansion of the social relations of capitalism itself.

Since the end of the 1980s – symbolically, at a world-historical level, since '1989' – we have seen the emergence of biennials characterized by two main features: artistic 'contemporaneity' and geopolitical 'globality'. These two features are inextricably linked, since it is the tendential

BIENNIAL
FOUNDATION

MAGAZINE ⌄ KNOWLEDGE ⌄ ART ⌄ NETWORK ⌄ ABOUT ⌄ SUPPORT Q

Directory of Biennials

A

Adelaide Biennial of Australian Art (Australia)
AFiRIperFOMA Biennial (Nigeria)
Aichi Triennale (Japan)
Americas Biennial (United States)
Andorra Land Art (Andorra)
Antarctic Biennale (Antarctica)
Anyang Public Art Project (Korea)
ARoS Triennial (Denmark)
ARS (Finland)
Art Wuzhen (China)
Arts: Le Havre (France)
Asia Pacific Triennial of Contemporary Art (Australia)
Asia Triennial Manchester (United Kingdom)
Asian Art Biennale (Bangladesh)
Asian Art Biennial (Taiwan)
Ateliers de Rennes (France)
Athens Biennial (Greece)
Atlanta Biennial (USA)
Auckland Triennial (New Zealand)

B

Bahia Biennale (Brazil)
Baltic Triennial of International Art (Lithuania)
Bamako Enounters, Biennale of African Photography
(Mali)
Bangkok Art Biennale

Biennial Foundation website map (July 2017)

globalization of relations of social dependence, through the operations of transnational capital, that has produced the new and distinctive temporality of contemporaneity – a disjunctive unification or coming together of different social times – as a *historically actual* temporality for the first time.

If we understand the modern – the temporal logic of the new – to be a cultural expression of the temporality of capital accumulation ('the aesthetic seal of expanded reproduction', in Adorno's phrase),[1] its tendential global extension brings with it not just a global modernity, but through the latter, a new temporal structure articulating the fractured temporal unity of this global extent. 'Contemporaneity' is the temporality of global modernity, the temporal product of globalization.[2] The temporalities of the modern and the contemporary are not successive historical stages (modernity has not been surpassed) but rather coexist in complex and contradictory ways, transforming the conceptual shapes of the modern and the contemporary themselves.

1 Theodor W. Adorno, *Aesthetic Theory*, p. 21.
2 See Chapter 2.

As an art-historical periodization, then, 'the age of the biennial' may be taken to be, for the first time, a genuinely, properly or fully 'historical' periodization – in the modern philosophical sense of 'history' in the collective singular (*Geschichte* in the German) that emerged in Europe over the course of the eighteenth century. 'Biennial' thus presents itself as the first category of an incipient global art history. Or at least, this is the theoretical ambition implicit in its current understanding: its *constitutive fiction*. And it corresponds to a certain practical, intellectual and cultural ambition associated with the recent practices of biennials themselves. In this respect, it is their *collective fantasy*, we might say: the fantasy of providing comprehensive artistic coverage of the globe, through something like a world system of art. It is a powerful, self-actualizing institutional fantasy. Within this system, the biennial would appear as the dominant form, articulating the relations between itself and other elements – museums, art centres, galleries of multiple kinds, festivals, fairs, markets, sponsorships and other forms of institutional funding; overdetermining these other elements and the relations between them, while being determined in its own development by them in turn.[3] The 'exhibitionary complex' will no longer be museological, it will be 'biennial' – a strangely simple temporal designation for what has become a highly complicated and contradictory institutional reality.[4]

What are the characteristic features, contradictions and prospects of this new biennial form? What are the deeper and wider histories of which it is the product?

To begin with, to stick with its literal temporal designation, one might note that the mechanistic chronologism dictating the periodic occurrence of biennials, every-other-year (or once-every-three for a triennial; every-five for a quintennial . . .), projects an open-ended, serial, mathematical continuity, which installs a certain ideality and, with it, a comforting imaginary permanence. In combination with the recent exponential proliferation of instances, this envisages a kind of utopian/dystopian, progressive filling-up of the world – and by extension of the lives of the occupants of the world art system and of cities more generally – with biennials, until there is one in each major city of the world.

3 For the notion of overdetermination, see Louis Althusser, 'Contradiction and Overdetermination: Notes for an Investigation', in *For Marx* (1965), trans. Ben Brewster, New Left Books, 1977, pp. 87–128.

4 See Tony Bennett, 'The Exhibitionary Complex' (1988), in *The Birth of the Museum: History, Theory, Politics*, Routledge, London and New York, 1995, ch. 2.

Indeed, having a biennial is increasingly one criterion of the status of a city being a major city, one way of 'putting it on the map'. There are currently enough biennials to attend at a rate of one every three-to-four days, prospectively, for a lifetime. Every-other-year is now (for the global artworld) twice-a-week. As such – that is, as a whole – '*the* biennial' is no longer a feasible object of experience for even the most energetic of artworld professionals.

The longevity of the founding instances – Venice and São Paulo – helps sustain a sense of the continuity of biennials as a quasi-natural process. (Venice was 120 in 2015, its 56th edition; São Paulo is already sixty-five years old.) Indeed, thus far, terminations of a sequence once initiated are extraordinarily rare; the loss of face is too great, perhaps. Johannesburg lasted only two editions (1995 and 1997), but it was the uniqueness of its failure that was exemplary. In fact, biennials are also reborn. In Brazil this year, for example, the Bahia Biennale, forcibly closed by the military dictatorship in 1968, was brought back to life for its third edition after a forty-six-year hiatus. This raises the Christological spectre that every terminated biennial is only a biennial waiting to be reborn; just as every city without a biennial is the site of a virtual biennial-to-come. It is the *religious naturalism* of this spectre of an endlessly repeated structure – rapidly 'routinized' and hence culturally entropic, yet not just recurring but spreading: a religious temporality of expanded reproduction, one might say, a new form of 'capitalism as religion' – that has provoked declarations of a 'crisis of the biennial', although these declarations have mainly emanated from ex-biennial curators moving on to other parts of the art system and so should perhaps be taken with a pinch of salt. And, in any case, to every crisis comes its overcoming. 'To biennale or not to biennale?' was the clever question framing the 2008 international conference on biennials in Bergen, Norway – which gave birth to the 2010 *Biennial Reader*, an early staging post in the increasingly self-reflexive character of biennial discourse. But that conference was organized as part of the preparations for what was to become the Bergen Triennial (first edition, 2013). Whatever views would come to be expressed there, the answer was never in doubt: to biennale![5]

5 See Elena Filipovic, Marieke van Hal and Solveig Ovstebo, eds, *The Biennial Reader: An Anthology of Large-Scale Perennial Exhibitions of Contemporary Art*, Bergen Kunsthall/Hatje Cantz, Berlin, 2010, pp. 292–375.

One of the interesting things about the proposal behind the 2014 Bahia Biennale is the way in which it mediated a return to its original regional project with its new global context; or better perhaps, the way in which its original regional project, retrospectively recoded, now appears as anticipatory of the newly global biennial form. Its title, 'Is Everything Northeast?', was a classical biennial title of rhetorical speculative totalization. The biennale, its 'Curatorial Proposal' reads, 'aligns itself with the main aim behind the two other editions of the Biennale of Bahia: instead of being historically and artistically read by the "Other", it is the local experience, thought universally, that reads this "Other" '.[6] 'Local experience thought universally', posited against the background of its inverse – international experience thought locally – has become a kind of chiasmic motto, or mantra even, of the self-consciousness of the form. It is the main, albeit the most abstract – because purely geographically formulated – mechanism for producing those 'general socio-political questions' that Charles Esche, in his Introduction to the Afterall book on the Third Havana Biennale, has argued is an important characteristic of the biennial in its post-1989 form.[7] Yet it is also problematic, precisely because of its abstraction: an abstraction from the political-economic processes through which, in the current historical conjuncture, locality is *produced by* a globalization that is not opposed to it, but which rather *circulates* the 'localities' that it produces as localities, as its own constituent internal elements. As Arjun Appadurai has put it: 'histories produce geographies and not [any longer] vice versa'.[8]

I would like to dwell for a moment here on Esche's extraction of a series of distinctive features of the post-1989 biennial form, from his interpretation of the Third Havana Biennial (1989), which, as he points out, 'opened eight days before the Berlin Wall fell' – an event that has recently marked its twenty-fifth anniversary. From the standpoint of this anniversary, the Third Havana Biennial represents a kind of historical hinge or vanishing mediator: it introduced a series of innovations

6 Third Bahia Biennale, 'Curatorial Proposal', bienaldabahia2014.comf, accessed 1 November 2014.

7 Charles Esche, 'Introduction: Making Art Global', in Rachel Weiss et al., *Making Global Art (Part 1): The Third Havana Biennial 1989*, Afterall Books, London, 2011, p. 9.

8 Arjun Appadurai, 'How Histories Make Geographies: Circulation and Context in a Global Perspective', in *The Future as Cultural Fact*, p. 66.

that would subsequently be taken up in a new and very different geopolitical context, to be given new meanings that would become constituent features of a new form.

The first five distinctive features of post-1989 biennials that Esche retrospectively finds in the Third Havana Biennial are:

(i) a symbolic recognition of the art of the geopolitical periphery,
(ii) a shift towards thematic curatorial authorship, generally taking the form of . . .
(iii) a posing of socio-political questions, which leads to . . .
(iv) an emphasis on debate and a strong discursive or pedagogical dimension, along with . . .
(v) a demographically based cultural self-definition in terms of 'the political and social mix of the cities that host them'.[9]

As Esche indicates, the Third Havana Biennial was an exception to the model it inaugurated in two respects: first in being an international *socialist* mobilization of those regional art communities 'marginalized' from the main international networks in 1989; and second in being a self-consciously 'Third World' event. And, I would like to add, there is an internal relationship between these two aspects. The largest exhibition within the Biennial (at the National Museum of Fine Arts/Museo Nacional de Bellas Artes) was called 'Three Worlds' ('Tre Mundos'). Yet, in the wake of the end of state communism in Eastern Europe (and with it, the 'Second World' of so-called 'historical communism'), 1989 was the very last moment that the concept of the 'Third World' could be mobilized. Subsequent, definitively post-communist biennials may have been increasingly self-consciously postcolonial, but this postcoloniality could no longer be thought as a 'third' world: the object of an ideological struggle between two world systems, struggling for its own, 'third' way (Bandung). This was not because the referent of 'Third World' disappeared, but because the Second World did, overnight, creating, on the one hand, a newly bipolar geopolitical system, symbolically named as 'North' and 'South', and on the other, more complicated economic and ideological divisions within capitalism: between China and the USA, and between increasingly religiously

9 Esche, 'Introduction', pp. 8–11.

coded combatants, respectively. The purely 'economic' category of the BRIC countries to which Brazil 'belongs' – Brazil, Russia, India and China – is in this respect a somewhat spurious unity. China is a new global power in the way in which the others are not yet, while Russia is neither a country of the 'South' nor a prospective engine of the world economy. The recent addition to the group of South Africa, pluralizing the acronym, as BRICS, only draws attention to the incoherence and ideological overdetermination of the idea by financial markets in search of tidy packets of imaginarily mitigated risk. Geopolitics – and the geopolitical imaginary through which politics itself is so often conducted – continues to resist reduction to financial markets, however much these markets may come to dominate the relations between states.

Ironically, at an ideological level, socialism has remained more recalcitrant to global capitalism than Third Worldism. The general 'sociopolitical questioning' that came to characterize post-1989 biennials as a result of the recognition of the art of the geopolitical periphery is grounded on a combination of postcolonial nationality and transnational capitalism. As such, it offers less of an alternative perspective to the latter than a new mode of its articulation. This resonates with the new political-economic function of the post-1989 biennials, to which we must add a final, sixth feature: namely (vi) that they are declarations that particular cities are (in Esche's phrase) 'open for business'. The post-1989 biennial form is ineluctably tied up with corporate, municipal, national and regional development projects, and property markets in particular. The important role of biennials within the art market is, in this respect, by no means the main capital function at stake in biennials themselves.

The combination of the third of these features (the posing of social and political questions) with the first (the recognition of the geopolitical periphery by cultural institutions of the 'centre') is clearly in tension and potentially direct contradiction with the sixth: the capitalistic political-economic function of corporate, municipal, national and regional development. It is this contradiction, I think – rather than the 'routinization' attendant upon repetition generally cited – which is the more critical rationale behind the currently perceived crisis in the development of the biennial form. It has led to a displacement of the previously generally critical, socio-political questioning

of the 1990s and early twenty-first century into increasingly intense self-historicizations of the biennial form – of which the founding of the World Biennial Forum, by the World Biennial Foundation, is an important institutional manifestation. Not only do we now have the verb, 'to biennial' and the concept of 'biennialization' – often a perceived threat to the so-called 'ecology' of local artworlds – but we also have a new proto-sub-discipline of art history: 'bienniology'. These self-historicizations have increasingly been accompanied by often quite vaguely defined curatorial poetics, which distance curatorial thematics from social and political themes while also re-presenting such themes through various quasi-literary recodings. It is the academicization of the discourse of self-reflexivity, perhaps, that has provoked the poetic character of its supplement/compensation/consolation, as part of what appears to be a withdrawal, not from politics as such, but from a historically imagined critical-political curatorial thematics. This is the real, critical crisis in biennial curation, derived from the increasingly inassimilable legacy of the previous primacy of social and political questions in what we might call the early post-1989 biennial problematic. That problematic expressed itself artistically in the art-critical primacy of postconceptual work. This legacy continues, not at the level of curatorial thematics, but at that of the need to mine the archive of 'as-yet-unrecognized' formally and conceptually serious work from the 1950s to the 1970s, upon which biennials increasingly depend for their art-critical as well as their art-historical legitimacy. 'To each biennial its own art-historical discovery' is the new moral law of biennial curation here.

Such art – like much of the postconceptual work into whose canon it now enters, as 'contemporary' art in a critical serious sense – has an *immanently artistic* 'critical acceptance of art's relation to politics and social context'.[10] In this respect, one might say, at their best, biennials are places where the contemporaneity of art can engage its geopolitical conditions in the newly global, historical contemporaneity itself. (And it need not be especially chronologically recent to be activated as 'contemporary' in this respect.) When this happens, such works perform individual condensations of the cultural forms of historical (that is,

10 Esche, 'Introduction', p. 12.

political-economic, technological and socio-political) contemporaneity into artistic events.[11]

With regard to the historical structure of this new contemporaneity as it manifests itself within the biennial form, it is useful to contrast it with two other historical-temporal problematics with which it is bound up, but which it definitively transcends: (i) the temporal dimension of the *critique of anthropology*, or *the coeval*, and (ii) the avant-garde temporality of *socialist postcoloniality*, represented by the Third Havana Biennial. Schematically, as critical-theoretical formations, one might associate the former with the 1960s and 1970s and the latter with the 1970s and 1980s. While today's formation as the temporality of a global capitalist modernity, emerges from the 1990s onwards – with the postmodern problematic consigned to the past, not as a vanishing mediator so much as a now-redundant historical place-holder for the new categorial form. (We should note here the fundamental critical irrelevance to historical contemporaneity of the whole 'postmodern' problematic.)

These are three successive historical problematics of 'the contemporary' that incorporate the previous ones within themselves, not through a Hegelian sublation (negated and preserved, transformed), but in a much more contradictorily 'living' manner, as registers of subordinate but still (at certain times, in certain places) decisive contradictions. Each problematic has its own concept of 'the contemporary', but it is only in the third problematic that contemporaneity comes into its own as a historico-temporal structure, acquiring a distinctive and decisive temporal form. I shall briefly review these forms before ending with some concluding remarks about the temporality of the biennial form.

Critique of Anthropology, or, the Coeval

Classically, anthropology played a founding role in the establishment of a historical differential between cultures (the basis of all developmentalist and modernization theories) by virtue of positing the existence of

11 For an emphasis on the 'evental' character of the biennial, in distinction from the museum, see Terry Smith, 'The Doubled Dynamic of Biennials', www.globalartmuseum.de, accessed 2 November 2014.

non-European cultures in *another time*. The concept of the coeval takes centre stage in the critique of the time-consciousness of the discipline of anthropology via its identification as that which anthropology denies. In the words of Johannes Fabian, whose 1983 book *Time and the Other: How Anthropology Makes Its Object* is the basic text here (summing up two decades of critique): denial of coevalness – characteristic of anthropology – is 'a persistent and systematic tendency to place the referent(s) of anthropology in a Time other than the present of the producer of anthropological discourse'. Coevalness, then, would be a recognition that 'the referent(s) of anthropology' inhabits 'the same Time as the present of the producer of anthropological discourse'.[12]

There are three things to note here. First, it is more than a simultaneous occurrence in *physical* time that is at stake (which Fabian refers to instead as synchronicity, or *Gleichzeitigkeit*, in German). Rather, coevalness is 'a common, active "occupation", or sharing, of time'. It is a social, intersubjective concept. Second, this social time of communication is not an intersubjective given or a transcendental form given as a condition of communication. It 'has to be created' through a communicational relationship, and, in the case of anthropology, this is a relationship between different or 'other' social times. However, third, for Fabian himself, this shared time is *not* to be associated with contemporaneity. For Fabian, 'contemporary asserts co-occurrence in ... typological time', i.e. it is a sociologically periodizing category. For Fabian, coevalness marks the fact that contemporaneity itself is 'embedded in culturally organized praxis'. Or, to put it another way, 'intersocietal contemporaneity' must be actualized as coeval praxis.[13] In other words, for Fabian, contemporaneity is not a theoretical category as such. Nonetheless, coevalness lays the groundwork for the subsequent construction of contemporaneity as a theoretical category once it comes to critical self-consciousness over the course of the 1990s in the context of globalization. As a category of the philosophy of historical time, contemporaneity projects coevalness at the level of the global social whole. In the process, its conceptual shape (and the shape of the coeval itself) changes. For, the open-ended global totalization of the multiplicity of relations of

12 Johannes Fabian, *Time and the Other: How Anthropology Makes Its Object*, Columbia University Press, New York, 1983, p. 31.
13 Ibid., pp. 31–4 and 148.

coevalness (sharings of time) can only be a fractured whole of relations that are as disjunctive (in their multiplicity) as they are conjunctive (in their intersubjectivity). Theoretically, its unity can only be speculatively projected, since it cannot be unified, in principle, within the purview of an actual subject. 'The coeval' thus anticipates, but is structurally transformed by the global 'contemporary'.

The second problematic, the avant-garde of a socialist postcoloniality, recognizes coevalness as the temporal ground for its construction of traditions but maintains a much stronger sense of futurity.

Socialist Postcoloniality, or, the Avant-Garde Construction of Traditions

Here, I shall take Geeta Kapur's presentation to the conference of the Third Havana Biennale, 'Contemporary Cultural Practice: Some Polemical Categories', as my exemplar. It was written on the cusp of the transition from the dominance of the second to the third of these problematics, and, although primarily concerned with contemporary art in India, it has a general theoretical significance marked by the context of its presentation in Havana. The two main polemical categories at issue are 'Tradition' and 'Contemporaneity' – the subtitle of the 'Three Worlds/Tres Mundos' exhibition within the Biennial – with the category of modernity as a background, mediating third term. All three categories are treated as 'notations within the cultural polemic of decolonisation', which function 'largely as pragmatic features of nation-building'. Kapur writes,

> the term 'tradition' as we use it in the present equation is not what is given or received as a disinterested civilizational legacy, if ever there should be such a thing. This tradition is what is invented by a society's cultural vanguard in the course of a struggle.

Indeed, since

> tradition even in its conservative allegiances emerged in the decolonising process as an oppositional category, it has the power of resistance . . . the power to transform routinely transmitted materials from

the past into discursive forms that merit in consequence to be called contemporary, even radical.[14]

In the case of the Third Havana Biennale, it was the use of 'pre-Columbian traditions in contemporary Latin American art' that was at stake – especially its relations to Latin American constructivism in the Argentinean context, as discussed by Luis Camnitzer in his review of the Biennale.[15]

What is of particular retrospective interest about Kapur's 1989 text is the way in which the term 'contemporary' is introduced, yet 'assumes a kind of neutrality'. It does not yet have a polemical force of its own. Rather, she argues:

> We can, if we want, 'correct' the situation by giving contemporaneity the ideological mantle of the term 'modernity'. [But i]mmediately, of course, complications arise, but that is perhaps the point: to induce the turmoil and give a definitional ambiguity to the present so that the future is predicated at a higher level of consciousness.[16]

The modern functions here as 'a signalling device for the future', while the contemporary primarily marks off the historical presentness of the present from the past, whose elements it recombines and refunctions. Kapur continues,

> We have to bring to the term tradition . . . the concreteness of extant practice, and to make the genuine extension of small particularities into new and contemporary configurations. Also, at the same time, we have to bring to the term modern a less monolithic, a less formalistic, indeed a less institutional, status, so at least to make it what it once was, a vanguard notion leading to a variety of experimental moves. Only with such initiatives can Third World cultures begin to justify their worth as alternative cultures.[17]

14 Geeta Kapur, 'Contemporary Cultural Practice: Some Polemical Categories', in Weiss et al., *Making Global Art (Part 1)*, p. 194.
15 Louis Camnitzer, 'The Third Biennial of Havana', in Weiss et al., *Making Global Art (Part 1)*, p. 211.
16 Kapur, 'Contemporary Cultural Practice: Some Polemical Categories', p. 198.
17 Ibid., p. 201.

'Alternative' here has the political sense of offering a political alternative to the current historical state of things (beyond a merely cultural meaning): 'Thus, positing a tradition-in-use in Third World societies encourages an effective method of politicising culture.' In the context of the post-1989 biennials, however, there has been an intensification of what was already an inherent danger: namely (and I quote), 'the commodification of traditions as such, and of traditional forms and artefacts, to serve both the state and the market'.[18] The *trans*nationalization of postcolonial economies, associated with the post-1989 globalization of capital, refunctions national identities forged in the struggle for decolonization into cultural commodities for international consumption. In the process, an established 'postcolonialism' (as opposed to an ongoing *process* of postcolonial decolonization) takes the invented traditions *out* of one contemporary use (the building of alternative cultures) into another, using them instead as icons of an imaginary cultural continuity, the imaginary status of which is covered over and repressed. It is for this reason, Kapur concluded, that the task of what she was still calling the Third World intelligentsia, including artists, should be 'to bring existential urgency to questions of contemporaneity'.[19] Her essay thus takes us, with an acute theoretical and political self-consciousness, to the threshold of the current period, in which the historical role of a globalizing transnational capital has given both new meanings to the terms 'contemporary' and 'contemporaneity' and a newly generalized existential urgency to the experience of the temporal forms that they have come to denote.

In the internally fractured and multiple modernity of a globally transnational capitalism, the perspective of the agents of decolonization (of the 1970s) is folded back into the cultural-political dynamics of global capitalism as a residual, but still problematic and contradictory, one. It is this set of contradictory relations that many of the biennials of the 1990s and early twenty-first century attempted to present through a new kind of curation of art, but which is rapidly being overridden by dynamics more wholly immanent to the logic of capital accumulation itself.

18 Ibid.
19 Ibid., p. 203.

Global Capitalist Modernity: The Contradictory Contemporaneity of the Biennial Form

The problem that biennials currently face, at the level of pure temporal form, is that the periodic rhythm of artistic-cultural definitions of the historical present, in each place, every-other-year (or every-three-years, or even every-five) has become overcoded, at the level of the whole, by the intensive serial sequence of biennials, the temporality of two-every-three-weeks, all of which are competing for the *same* contemporaneity – seemingly without end. Not only is every-other-year always this-year, but every-other-place is always next-week. This is the famous bad or 'spurious' infinite of the temporality of capital accumulation – expanded reproduction – subsuming the biennial to capital at the level of its temporal form. Terry Smith, among others, has referred to this as a problem of 'overproduction'[20] – the overproduction of biennials and hence of artworks for them to show. In a sense, this is true, at the level of the whole (and its intelligibility as a whole) at least, although not necessarily at the level of more local participants and audiences. However, we should remember that 'overproduction' is a necessary systemic effect of capitalist production as the production and accumulation of value, a driver of crisis as the mode of transformation of one regime of accumulation into another. Overproduction is not something that can be dispensed with while still producing and accumulating value, and biennials are now, even if only indirectly, very much an integral part of such production. The logic of contemporaneity as a historical-temporal form and the temporal logic of the biennial as a systemic form are varying *articulations* of the temporal logic of capital accumulation – although not reducible to it: they articulate its temporality with other temporal forms.

Perhaps it is time to stop thinking about the contemporary within the terms of historicism, to stop asking ourselves, 'When *did* the present begin?' – the question of the durational extension of the present backwards.[21] Rather, perhaps we should begin again to ask, in the present tense, 'When *does* the present begin?', the present as the time of

20 Smith, 'The Doubled Dynamic of Biennials'.
21 Cf. Peter Osborne, 'To Each Present, Its Own Prehistory', in Noack, ed., *Agency, Ambivalence, Analysis*.

utterance, of enunciation and of action (see Fig. 7.2).[22] Or better still, perhaps, to ask in the future tense, 'When *will* the present begin?': the present as the time of the production of a qualitatively different future.

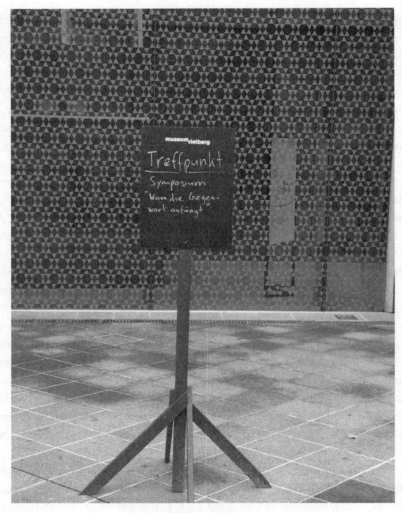

Museum Rietberg Symposium sign

When will the present begin again?

22 'When the Present Begins' was the title of a conference held in Zurich, 10–11 October 2014, at the Museum Rietborg and Johann Jacobs Museum, organized by Roger Buergel, Director of the Johann Jacobs Museum.

Archive as Afterlife and Life of Art

Only in isolated instances has it been possible to grasp the historical content of a work of art in such a way that it becomes more transparent to us *as a work of art*.

Walter Benjamin, 'Eduard Fuchs, Collector and Historian', 1937

It is hardly news that in recent decades the institution of the museum has undergone a period of sustained transformation. As part of this process, each of its constitutive categories – collection, preservation, documentation, archiving, classification, curation, display and exhibition – has been called into question, along with the relations between them. New practices have blurred or eroded the boundaries between certain categories and led to the apparent antiquation of others. The causes of this process have been multiple and intertwined – political, economic and technological, in particular – but their combined effects have been structural in character. In the case of the art museum – and the museum of *contemporary art* in particular – the process has been further complicated by fundamental changes in the character of art itself, dating back to the 1960s, which have been increasingly reflectively incorporated into institutional practices. The postconceptual ontology of contemporary art has thus developed not only through the critical weight and dissemination of new artistic practices but also through changes in art space, the social space of their presentation or 'exhibition'.[1]

1 See Osborne, *Anywhere or Not at All*, ch. 6. Kant's used *Darstellung* (most frequently translated as 'presentation', in contrast to *Vorstellung*, standardly rendered into English as 'representation') as the German equivalent for the Latin *exhibitio*.

Much of the literature that has discussed these changes has been museological in character and, with respect to the art museum, has tended to focus on the changing role of the curator and the growing importance of the temporary exhibition relative to the display of collections. Museum Studies, Curatorial Studies and Exhibition Studies have developed in rapid succession. For political and economic reasons, within institutions themselves emphasis has shifted from objects and works to 'visitors' and the qualities of their experiences.[2] Less attention has been paid to the way in which the conventional distinction between the collection, on the one hand, and the document and archive, on the other, has been progressively broken down; to the relationship of this process to the ontology of the postconceptual work; and to its implications for art practices and their public presentation alike.

An 'archival impulse' has been detected within contemporary art practice,[3] but this has been more about an artistic preoccupation with the fragilities of memory under the conditions of a waning historicality than with the more fundamental issue of the archival status of the artwork itself and its growing indifference from documentation. In contrast, more boldly, Boris Groys has proposed that we are witnessing an epochal shift 'from artwork to art documentation' in the 'age of biopolitics', in which the installation of the documentation of art events produces a new kind of 'bio-art' which makes such documentation literally 'live'. Under that scenario, the artwork disappears: the 'work' of the installation of documentation is no longer to make 'art', but the reverse: 'the art of making living things out of artificial ones'.[4] Art drops out: we just have documentation and its 'enlivening' in and by art spaces.

Let us not rush to this conclusion just yet though: not least because so much contemporary art fails, precisely, to 'live' (it fails to quicken

2 Peter Vergo, ed., *The New Museology* (1989), Reaktion Books, London, 2011, chs 4–8.

3 See Hal Foster, 'The Archival Impulse', *October* 110, Fall 2004, pp. 3–22 – a generalization of the argument developed in Benjamin Buchloh, 'Gerhard Richter's *Atlas*: The Anomic Archive', *October* 88, 1999, pp. 116–45. See also Charles Merewether, ed., *The Archive*, Documents of Contemporary Art, Whitechapel/MIT Press, London/Cambridge MA, 2006.

4 Boris Groys, 'Art in the Age of Biopolitics: From Artwork to Art Documentation' (2002), in *Art Power*, MIT Press, Cambridge MA and London, 2008, pp. 53–65, p. 57.

and transform experience); and it fails to live precisely because it wants to live in *just the same way* as other forms of life. It fails to live at all because it fails to live as art. It wants the historical avant-garde's putative end-state of tomorrow, immediately, today, *without having to transform the rest of society*. As if the magical power of art space alone was enough. Insofar as art institutions continue to exist, in their specific difference from other kinds of cultural spaces, what is presented within them will 'live' there (rather than being interned) only through their ongoing production and critical instantiation of that specific difference – however ironic, dialectical or purely differential the difference may be.[5] The question is thus not 'How does documentation come "alive" in the museum?' but rather, 'What does the *becoming art* of documentation have to tell us about the historical ontology of the artwork – and hence about the critical possibilities of the experience of contemporary art?'

In addressing this question, it is helpful to recall two very different, but related, texts about collecting by Walter Benjamin: 'Unpacking My Library: A Talk about Collecting', published in the Berlin literary weekly *Die literarische Welt*, in July 1931, and 'Eduard Fuchs, Collector and Historian', published in the Frankfurt School journal, *Zeitschrift für Sozialforschung*, in the autumn of 1937. The difference is one of both standpoint and genre: from the radical individualism of the bourgeois conception of the collector (mirrored in the essay form) to collection from the point of view of the 'historical situation', as perceived by 'the pioneer of a materialist consideration of art'.[6]

5 Groys effectively recognizes this, having formally denied it, in his belated restoration of the concept of the aura as the criterion of the life of *installed* documentation. 'Art in the Age of Biopolitics', pp. 60–5. In this respect, his 'bio-art' is ontologically quite conventional, while 'installation' remains Groys' basic art category. Installation into art space is deemed sufficient to produce aura.

6 Walter Benjamin, 'Ich Packe meine Bibliothek Aus: Eine Rede über das Sammeln' (1921), *Gesammelte Schriften Band IV. 1*, Suhrkamp, Frankfurt am Main, 1991, pp. 388–96, translated as 'Unpacking My Library: A Talk about Collecting', in *Selected Writings, Volume 2: 1927–1934*, pp. 486–93. Walter Benjamin, 'Eduard Fuchs, der Sammler und der Historiker' (1937), *Gesammelte Schriften Band II. 2*, Suhrkamp, Frankfurt am Main, 1991, pp. 465–505, translated as 'Eduard Fuchs, Collector and Historian', in *Selected Writings, Volume 3: 1935–1938*, pp. 260–302.

History

Nestling within the autobiographical narrative of 'Unpacking my Library' is an almost personalist theory of collecting as the privileged medium of the historical existence of objects. It hinges on the private collector's 'passion' for possession and the fact that 'for a collector . . . ownership is the most intimate relationship that one can have to things'. This is described as a relationship to objects 'which does not emphasise their functional, utilitarian value – that is, their usefulness – but studies and loves them as the scene, the stage, of their fate'. It involves placing them within a collection (for books, a library) – subjecting them to the 'order' and 'mild boredom' of the catalogue in the construction of an archive. But it is only in the 'chaos' and 'confusion' of the private collection (its relative 'disorder') associated with the collector's passion that objects are said to 'get their due' [*kommen . . . zu ihrem Recht*]. Such loving study produces a 'rebirth' of the 'old world' of the object: 'the renewal of existence' [*die Erneuerung des Daseins*]. Acquisition, curation in its original sense (care of the object) and archiving are thus existentially united in the private collector, in a manner that public collections cannot match, even though they 'may be less objectionable socially and more useful academically'. And interpretation – effect of the documentary location of the object in the 'magical encyclopedia' of its background – appears implicit in the physiognomic act of acquisition itself: 'collectors are the physiognomists of the world of things'.[7]

Benjamin knows that this model is historically redundant. 'Only in extinction is the collector comprehended', he writes, in a passage including a rare reference to Hegel.[8] But it nonetheless sets the philosophical terms that any subsequent, more socialized, historical-materialist model of collection must meet: to give an account of its role in the *historical existence of objects*. 'Eduard Fuchs, Collector and Historian' offers just such an account, in which collecting appears (in the spirit of Marx's eighth fragment of 'On Feuerbach') as 'the practical man's answer to the

7 Benjamin, 'Unpacking My Library', pp. 492, 487, 491, 487; 'Ich Packe meine Bibliothek Aus', pp. 395, 389–90.
8 Benjamin, 'Unpacking My Library', p. 492.

aporias of theory'.[9] The theory here being 'the recent past of Marxist theory of art' ('one moment swaggering, and the next scholastic', as he puts it in *The Arcades Project*), which, divorced from 'human practice and the comprehension of this practice' (as Marx put it), will, like all such theories, lead only to 'mysticism'.[10]

Benjamin locates Fuchs's contribution as a collector in his being 'the first to expound the specific character of mass art' and thereby to have 'cleared the way for art history to be freed from the fetish of the master's signature' – a path that was subsequently to be rather less travelled than Benjamin might have hoped. Fuchs founded what was then 'the only existing archive for the history of caricature, of erotic art, and genre painting'.[11] Reconstructing the theoretical meaning of his practice, Benjamin expounds a general theory of the historical ontology of art in which critical and institutional reception act retroactively upon the very being of the artwork:

> For the dialectical historian concerned with works of art, these works integrate their fore-history [*Vorgeschichte*] as well as their after-history [*Nachgeschichte*]; and it is by virtue of their after-history that their fore-history is recognizable as involved in a continuous process of change.[12]

Artworks are subject to constant transformation by the system of relations into which they enter as part of their reception, which retroactively changes our understanding of what they are. As a part of this, 'historical understanding [*Verstehen*]' is itself 'an afterlife of that which has been understood [*des Verstandenen*] and whose pulse can be felt in the present'. It is the critical task of the collection '[t]o *put to work* an experience with history', so understood, 'a history that is orginary for every present'. Such a putting-to-work is said to 'blast the epoch out of its reified "historical continuity", and thereby the life out of the epoch, and the work out of the lifework', in such a way as to result,

9 Benjamin, 'Eduard Fuchs, Collector and Historian', p. 263.

10 Ibid., p. 260; Walter Benjamin, *The Arcades Project*, [N4a, 2], p. 465; Karl Marx, 'Concerning Feuerbach', in *Early Writings*, Penguin Books/New Left Review, Harmondsworth/London, 1975, p. 423.

11 Benjamin, 'Eduard Fuchs, Collector and Historian', p. 283.

12 Ibid., pp. 283, 261.

paradoxically, in 'the lifework *in* the work, the epoch *in* the lifework, and the course of history *in* the epoch being preserved and superseded [*aufbewahrt und aufgehoben*]'.[13]

What light does this constructivist historical ontology throw upon the structure of the postconceptual work and the new institutional practices with which it is bound up?

Art

The first thing to note here is that insofar as the identity of a postconceptual work is not tied to any particular materialization, but rather to the temporally open totality of its materializations, in reflective relation to its idea, it has an immanently constructive and processual character. Each materialization – and the boundaries of what is included in the work are porous – becomes at once a documentation of the work and a set of materials for a subsequent presentation of the work. In this respect, the work includes its own documentation and, to the extent that it proliferates and its materializations are collected, its own archive as well.[14]

Groys argues, oddly, that artworks 'cannot refer to art, because they *are* art'. Consequently, he thinks that 'art documentation' – which refers to art – cannot be art.[15] But this is a sophistical argument, since modern

13 Ibid., p. 262, trans. amended and emphasis added; 'Eduard Fuchs, der Sammler und der Historiker', p. 468. It is important to note that his simultaneous preservation and supersession is *not* that of the comprehensive intelligibility produced by the integral movement of the Hegelian dialectic – with which it might easily be confused, especially given Benjamin's earlier reference to Hegel. Rather, it is the product of a punctual act of construction, located in the relation of a specific 'now' to a specific 'then', and its existence is conditional upon the renewal of such acts. *Between the object and the event lies the act.* In this respect, Benjamin's concept of afterlife (*Nachleben*) is close to Warburg's. (Aby Warburg, *The Renewal of Pagan Antiquity: Contributions to the Cultural History of the European Renaissance* (1932), Getty, Los Angeles, 1999.) However, it remains distinct from Georges Didi-Huberman's recent appropriation of their notions, in combination, as 'survival' (*survivance*), which suppresses the constructivism of Benjamin's conception. Georges Didi-Huberman, *L'image survivante*, Minuit, Paris, 2002.

14 See Osborne, *Anywhere or Not At All*, pp. 99–116, 141–51, where this is demonstrated, with reference to works from the 1960s by Robert Smithson, Dan Graham and Gordon Matta-Clark.

15 Groys, 'Art in the Age of Biopolitics', p. 55.

art has been bound up with a certain *self*-referentiality since its beginnings. (Indeed, for Greenberg, with modernist painting, that became its exclusive signifying function.) Rather, we might say, contemporary art as a postconceptual art is an art in which the artistic materiality of the work and its documentary function are combined. This is clearest in the temporal logic of performance or the art event (and by extension, the performative or evental aspect of any work), but it is equally the case in the disjunction between the material and the ideational or conceptual aspects of other kinds of work – be it 'conceptual' in inspiration or a result of the extended relational structure of postminimalist spatially orientated works or installations. This is part of the postconceptual logic of all critically contemporary art. It finds its institutional correlate in the gradual recognition of a growing indifference between the artwork and its documentation at the level of the collection. This is marked by, for example, on the one hand, the opportunistic reclassification of 'documents' related to the history of conceptual art as 'works', and on the other, the emergent integration of photography into the exhibition of historical collections of painting. These processes are gradually effecting an ontological change in the status of the museum archive, in which works and documentation are increasingly treated on the same 'level': first, as cultural artefacts, but then, by virtue of the art institutions' inherent character and socially coded modes of attention, as art.

The process has been reinforced by the change in the character of the curator from custodian of a collection to exhibition impresario, which has aesthetically orphaned the collection, placing it back in the domain of the historical remnant, on the same ontological plane as its documentation, patiently awaiting a recall to life by being plucked from the stores and inserted into some new, thematically defined set of relations, proposed by an independent curator from afar. The artistic archive is thus no longer a documentary archive that surrounds the works of the collection with interpretative materials but a combined archive of works and documents in which 'the scene, the stage' of the 'fate' of works are laid out, in a functional equivalent to the transformative space produced by the passion and love of the ideal private collector.

This archive preserves and conserves work, in a newly extended sense of the artwork including documents (texts, images, objects) constituting their afterlife. Here, the conservation of the elements of an exhibition is not merely 'documentary', but itself constitutes – and is constituted as

– artistic materials for possible subsequent exhibition. This process of ontological homogenization, associated with the spatial, temporal, conceptual and institutional extension of the concept of the artwork within the generic conception of art, is reinforced by the ubiquity of the reproductive technology of the digitally produced image, which threatens an effective reduction of archives to digital archives.

Image

Under the conditions of digital technologies, there is a tendential – but *necessarily incomplete* – reduction of the social objectivity of works and documents to that of their distributed images.[16] And within this ontologically reduced form of the image, there is a dialectic between a multiplicity of visualizations and a technologically based virtuality that parallels that between both the aesthetic and the conceptual (taste and non-taste) within the postconceptual work, and site and non-site within the social space of its institutions of display (Fig. 8.1).

actual	virtual
aesthetic	conceptual
multiplicity of visualizations	image
site	non-site

Fig. 8.1 Dialectics of the artwork

Historically, the mistake has been to associate the artwork with one or other side of these conceptual pairs. However, ontologically, it is spread *across* these dynamic dialectical pairs; as indeed it is across the more conventionally 'material' forms making up the objects of images, residing in the literal physical spaces of the archive in its 'old' sense. The archive, we should remind ourselves, was to begin with a place of power, the magisterial residence, *archia*, in which public records were kept. But power itself has become socially diffused. Reduction of the social objectivity of works and documents to the image will remain incomplete so

16 See Chapter 9.

long as such places continue to exist as sources for historical experiences that are 'originary for every present'. The process of ontological homogenization associated with the spatial, temporal, conceptual and institutional extension of the artwork is *reinforced* by the logic of the digitally produced image, but it remains discrete from it, insofar as the former is ultimately an ontological space of history itself, to which the latter is subjugated via the logic of the artwork. As Benjamin put it, earlier, in his *Origin of German Tragic Drama*: 'The function of artistic form is . . . to make historical content . . . into a philosophical truth.'[17] The tactile materiality of the 'old' archival forms is the emblem of this difference, which is now distributed across that expanded conception of the archive that includes the collection within itself.

We can see this dialectic at play – the dialectic of the old and the new archival materials within the new archive – in the development of the Arab Image Foundation, for example, as both a photographic archive and a set of artistic materials for new image-based art practices, by Walid Raad, Akram Zaatari, Ania Dabrowska and others.[18] Within those digital art practices, it is nonetheless still the individual photographic print that carries the symbolic burden of historical experience, even though such prints are disseminated only through digital reproductions. Yet it is not the 'uniqueness' of each individual originating print that grounds its truth-content (however much it may superficially appear to be so), but the specific present, Lebanon today, *for which* it is 'originary' [*ursprüngliche*].[19] Such archives thereby acquire an afterlife. Their pulse can be felt in the present. Their afterlife *is* their life.

17 Benjamin, *The Origin of German Tragic Drama*, p. 182.

18 See, for example, Ania Dabrowska, *A Lebanese Archive: From the Collection of Diab Alkarssifi*, Bookworks and Arab Image Foundation, London/Beirut, 2015.

19 Cf. Benjamin, 'Eduard Fuchs, Collector and Historian', p. 262; 'Eduard Fuchs, der Sammler und der Historiker', p. 468. In Benjamin's sense of the term 'origin', there is no origin other than *for* a specific present.

PART IV
Art and Image

Art and image

9

The Distributed Image

'Art' versus 'Image'?

Art versus image. Art *versus* image?[1] The opposition appears at once instantly recognizable, almost commonsensical, yet also deeply puzzling – more deeply puzzling, in fact, the more one dwells on it. It would certainly seem puzzling to an art historian[2] – which does not necessarily mean that it is misplaced, of course. What might lead one to oppose these two terms in so stark a manner? Two familiar, mutually reinforcing genealogies spring to mind.

First, there is that famous critical history of late nineteenth and twentieth-century Western art that centres upon the 'purification' of discrete, historically received artistic media, in which the aesthetic dimensions of the 'literal physical properties' of works, appropriate to their mediums, are exclusively valorized – thereby excluding 'image' as a category of artistic analysis, indeed, as a constituent of the experience of modern art itself. Call it formalist-modernism; call it Greenbergianism; call it what you will. Second, there is the related association of images with media (and image theory with media theory), in the sense of the mass media of newspapers (with their photographic reproductions), film and television, and the 'new media' of digital image production, storage,

1 The first part of this chapter was commissioned for a special issue of the journal *Texte zur Kunst* entitled *ART vs. IMAGE/BILD vs. KUNST*.

2 Georges Didi-Huberman, for example. See Georges Didi-Huberman, *Confronting Images: Questioning the Ends of a Certain Art History* (1990), translated by John Goodman, Pennsylvania State University Press, University Park PA, 2005.

distribution and recovery or reactualization. An opposition between art and image thus presents itself in this dual context as both one of cultural space (art institutions versus popular culture) and cultural value (insofar as modernist criticism claimed a type of universal human significance for modernist-formalist art that it denied to other cultural artefacts).

This 'great divide' is the well-established cultural stereotype of capitalist societies after the Second World War, frequently but erroneously associated with the Frankfurt School, and Adorno in particular, especially in the USA. It gained renewed impetus in the late 1960s, from two different directions. On the one hand, Debord's 1967 *Society of the Spectacle* reinforced the association of the image with the commodity, to the point of identification, effectively reducing it to a function of capitalist reproduction. On the other hand, the dialectical inversion of modernist criticism into the project of Conceptual art (through the recognition of the constitutive role of discourse in the art-character of the artwork) further distanced the concept of art from that of image through the attempted elimination of the material 'carrier' of images, the aesthetically significant dimension of the artwork. Thus, while aesthetic formalism had excluded the image on the grounds of its essentially representational character (be it naturalistic, metaphysical or theological), canonical Conceptual art's anti-aesthetic aspired to remove its material support.

The trajectory running from modernist-formalist aestheticism into its opposite, Conceptual art, thus appeared to have imposed a quasi-'Judaic' ban on images, in contrast to the iconophilia of the main, Christian tradition of post-Renaissance art, continued in the twentieth century largely through the 'mass' media of photography and film. Yet this was only an appearance, of course. In the first place, works in the modernist-formalist canon have always been prone to alternative metaphysical or theological – and thereby imagistic – interpretation (Rothko, Newman, Reinhardt, in the tradition of spiritual abstraction, for example), despite the tendential elimination of internal relations within the works. Adorno belongs in such a broad interpretative tradition. More fundamentally, the move from opticality to textuality (from painting to proposition) simply shifts the means of production of the image from picture to text. After all, in its modern, Romantic critical sense, in which it is tied up with the modern concept of art itself, 'image' was

primarily a *literary* concept. By the late nineteenth century, 'painting' may have become the metonym for 'art' (at least in France) – and it would remain so, for some, for more than a hundred years, despite its destruction by Duchamp – but 'poetry', or what became 'literature', was the founding metonym, through which the modern concept of art achieved philosophical definition, in Jena Romanticism. Conceptual art returned us, philosophically, to that moment. (And what is the ban on images itself, in any case, if not the quintessential *image* of Germanic-Judaism.) The regime of the image has a persistence far more fundamental than any alleged 'aesthetic regime'.

If the critical opposition between 'art' and 'image' appeared to be reinforced from both sides in the late 1960s, by Conceptual art and Debord's theory of the spectacle alike, it was not long (the early 1980s) before it came under explicit attack, in the attempt to introduce the concept of postmodernism into the visual arts, through the idea of a newly homogenized cultural space.[3] It is at this point that things become more complicated. Not because art suddenly entered the space of the image – art always produced images, and all autonomous art can be said to function 'like an image', on Adorno's persuasive account at least. Rather, things become more complicated because it was at precisely this point that Anglophone cultural theory gave up on the *concept* of the image and started to subject all representations to semiotic interpretation: the regime of the sign. From the standpoint of semiotics, as W.J.T. Mitchell put it at the time: 'an image is the sign that pretends not to be a sign, masquerading as (or, for the believer, actually achieving) natural immediacy and presence'.[4] From a semiotic point of view, *there are no such things as images as such*; image is an ideological concept. This is where the problem lies. This is why, in the words of the editorial framing of the issue of *Texte zur Kunst* in which this chapter first appeared: 'whereas a critical analysis of art is well put in place . . . there seems to be a lack, or at least dearth, of comparable attempts when it comes to analyzing images'[5] – with respect to contemporary art, at least.

3 Hal Foster, *Recodings: Art, Spectacle, Cultural Politics*, Bay Press, Port Townsend WA, 1985; and more generally, Andreas Huyssen, *After the Great Divide: Modernism, Mass Culture and Postmodernism*, Indiana University Press, Indianapolis, 1986.

4 W.J.T. Mitchell, *Iconology: Image, Text, Ideology*, University of Chicago Press, Chicago, 1986, p. 43.

5 Preface, *Texte zur Kunst* 95, September 2014, p. 6.

The irony, and the source of some confusion here, is that it was precisely this (anti-imagistic) semiotic paradigm that became, in the 1990s, the intellectual basis for the new proto-disciplinary field of Visual Culture or Visual Studies.[6] The new field primarily involves the application of the methods of Cultural Studies to specifically visual cultural forms. It deals with images, but it lacks a convincing theorization of the image in its distinction from the Saussurean sign. One response to this situation was to undertake a quixotic quest for a theorization of 'the visual' in order to establish a discrete object-domain, often via the psychoanalytical theory of the gaze. This 'visual turn' appeared as an extension of the much-heralded 'spatial turn' in cultural theory more generally. Yet, in a further, inverse irony, such 'visual essentialism' simply reproduces the presuppositions of precisely that formalist-modernism the abandonment of which was the historical condition for the development of the field of visual culture in the first place. Studies in Visual Culture thus came to be constituted with a double disability in relation to the critical interpretation of contemporary art: it is polemically indifferent to the art/non-art distinction; and, insofar as it has attempted to constitute a discrete object-domain, it has done so in a manner that is disjunctive with the structure of current art practices and restorative of an old ideology of 'the visual' on new theoretical grounds. Its productivity derives largely from its more para-disciplinary aspects as a result of its fundamental theoretical eclecticism.

This is not the place to set out a philosophical defence of the image against the sign.[7] Suffice to say, contra Mitchell, the specificity of the image cannot be reduced to the masquerade of 'presence' or 'immediacy'. Indeed, in the context of the Kantian opposition of intuition to concept – aesthetic to logic – that structured the philosophical self-consciousnesses of aesthetic art and canonical Conceptual art alike, it is precisely the *mediating* quality of the image – *neither* aesthetic *nor* logic – that is significant for art. In the first edition of

6 The *Journal of Visual Culture* began publication in spring 2002. In a number of institutions in the UK, Art History was dissolved into Visual Culture, often along with Film Studies, although some literature departments have been tenacious in hanging on to film as an object of narratology and psychoanalytical theory.

7 See my 'Sign and Image', in Peter Osborne, *Philosophy in Cultural Theory*, Routledge, London and New York, 2000, ch. 2.

the *Critique of Pure Reason*, 'image' is the mediating term between aesthetic and logic, in which intuitions achieve a *non-conceptual synthesis* and (in both editions) in which *concepts are rendered sensible* through the action of a transcendental schematism and hence become capable of organizing sensible intuitions into cognitive experience. Or again, in the *Critique of the Power of Judgment*, image is that *non-conceptual but more-than-sensible* form in which aesthetic ideas become actual. Aesthetic ideas are those that can be actualized in images, but the image itself, qua image, is *de*-realized, insofar as it is a replicable (hence ideal) structure actualized, in each instance, in a specific material 'bearer'. It is in this respect that digital technologies of image production render explicit the ontological structure of the image as the *distributive* unity of the relations between a materially embedded virtuality and an infinite multiplicity of possible visualizations.[8]

The Distributed Image

Digital technologies of image production render explicit the ontological structure of the image, and in so doing, it would seem, take over from 'photography' as the historically dominant artistic form. However, for all the growth and significance of the computer-generated imagery this involves, it is nonetheless *photographically originated* digital images (digital photography) that dominate the image-spaces of mass media and art institutions alike.[9] The place of the photographic (in its extended sense, including film and digital video) within the image-sphere has thus become doubled. It is at once the signifier of a past technological form of image production, in which iconicity is tied to indexicality and thereby a specific kind of truth (however constructive the photographic practice may be), and an equal participant in the infinitely multiplying visualizations of data that fill the screens of the digital meta-medium. Within this latter space, visual 'information' may be

8 See 'Photographic Ontology, Infinite Exchange', in Osborne, *Anywhere or Not At All*, ch. 5.

9 This second part of this chapter derives from a commissioned contribution to the special issue of the journal *Texte zur Kunst: Photography*, no. 99, September 2015.

quantitatively reducible to data, but both knowledge and truth continue to elude such reduction. In fact, quantitative and visual degradation of the image as an effect of copying, reformatting and passing through digital networks of distribution may *increase* its truth-content in a variety of ways.[10]

This convergence of information and image production within the digital problematizes – indeed, reverses – two influential historical narratives about cultural form. One is the self-understanding of canonical Conceptual art: a construction in which information and image ('morphology') were opposed and Conceptual art was taken to represent a transition from image-based forms of artistic production to an informational one. The other is the deeper technologically based historical narrative about the changing communicational forms of modernity – associated with Walter Benjamin, but subsequently widely developed in various forms – that holds modernity's 'destruction of tradition' to involve the replacement of the essentially oral narrative form of the story by what Benjamin himself called the 'new form of communication' of 'information'.[11]

In the first instance, information, presented as the meta-linguistic medium of Conceptual art, was used to oppose – if not negate or at least to neutralize or render indifferent – the aesthetic aspect of the artwork, even when images were themselves the means of such negation. Indeed, this was the main role of photography within those practices. '[P]hotography is dead as a fine art', Ed Ruscha declared to *Artforum* in February 1965, 'its only place is in the commercial world, for technical or information purposes'.[12] Yet the polemical project for the de-aestheticization of art quickly ran up against its limit in the necessarily aesthetic aspect of all forms of presentation (however minimal) and the refusal of aesthetic to remain indifferent within art spaces. In turn, the formal qualities of the photographic image became increasingly central to the self-consciously strategic character of the critical

10 See Hito Steyerl, 'In Defense of the Poor Image', in *The Wretched of the Screen*, Sternberg, Berlin and New York, 2012, pp. 31–45.

11 Walter Benjamin, 'The Storyteller: Observations on the Works of Nikolai Leskov', in *Selected Writings, Volume 3, 1935–1938*, p. 147.

12 Extracted in Lucy R. Lippard, *Six Years: The Dematerialization of the Art Object from 1966 to 1972* (1973), University of California Press, Berkeley/Los Angeles/London, 1997, p. 12.

refunctioning of aesthetics within the postconceptual structure of a generic contemporary art.[13]

Within such an art, information and image no longer appear incompatible. Rather, they are mediated as the dual aspects or dimensions of a single practice. This is a structural matter, at the level of the ontology of the postconceptual work, but it is also a historical one, insofar as this ontology develops in relation to new technologies of image production. What digitally produced images and postconceptual art have in common is a certain structure of distribution. Both the digitally produced image and the postconceptual artwork are *distributed forms*, but they are distributed across different fields, in related but ontologically distinct ways.

To take the digitally produced image first: it is a distributed image in several senses. First, the digital composition of its informational structure distributes imagistically heterogeneous elements, homogeneously, across any particular site of visualization or screen. Structurally, each pixel is of equal value in the *production* of the image, and in the pixel the informational structure of the image is rendered literally visible. This is a new spatial ontology in which the photographic no longer appears opposed to the space of the graphic, but is rather one of its modes.[14] This changes the historically received meaning of 'the photographic' in a fundamental way.

Second, in digital video this new spatial ontology combines with the temporality of cinematic montage to produce a new technological means for the realization of what, in the mid-1960s, Alexander Kluge and others anticipated as that 'greater degree of complexity' in the 'combination of verbal, auditory and visual forms and their integration' that would concentrate its subject matter 'in the spaces between the forms of expression'. In this classically constructivist account of the structural possibilities of film, the accumulation of elements 'preserve[s] a certain tension in relation to each', which makes itself felt 'in the gaps which montage create[s] between the disparate elements of filmic expression'.[15] With and within digitally produced images, these

13 See Osborne, *Anywhere or Not At All*, ch. 2.

14 Cf. Lev Manovich, *The Language of New Media*, MIT Press, Cambridge MA, 2001, p. 311: 'The photographic and the graphic, divorced when cinema and animation went their separate ways, met again on the computer screen.'

15 Edgar Reitz, Alexander Kluge and Wilfried Reinke, 'Word and Film' (1965), trans. Miriam Hansen, *October* 46, Fall 1988, p. 87.

'disparate elements of expression' are radically expanded, incorporating both photographic and non-photographic elements, and the possibilities of relations (and hence 'gaps') between them are multiplied. In particular, in digital video we see the return of the oral narrative of the story (often in the form of testimony) as one of these elements of expression among others, used as a means to establish living relations to various historical actualities. Here digitally produced moving images distribute experience across a new temporal, as well as a new spatial field.

Just as information is no longer opposed to image, but is the very matter of its construction, so too information no longer appears incompatible with the story (as it was for Benjamin), but incorporates it as an element – indeed, often as an articulated combination of elements: auditory and visual – into its constructive logic. The translation of 'the archive back into individual life stories' (to evoke the analogy with Kluge again),[16] which this makes possible, has become the means for certain artists to use memory against the grain of its dominant sentimental use as a repression of the history it claims to represent, as an element in the construction of historical experience.[17] For the temporality involved here is not that of the simple addition, or layering, of cinematic montage onto the new spatial ontology. Rather, it is a more complex temporality constructed out of the relations between the narrativity of the story and the interruptive, spatially distributed character of the still or unmoving image, the stasis of which registers the common now of the time of viewing. This is central to the establishment of the historical *contemporaneity* of such works: their bringing together of different times (different social times and different historical times) within the disjunctive 'living' unity of the present. Within the relational whole of the articulated ensemble of elements, each component functions as a separate subject of speech, creating a pluri-vocal ensemble in which it is the exchange between the *thing-like* and *subject-like* aspects of the image that establishes its specific temporality.

16 Andreas Huyssen, 'An Analytic Storyteller in the Course of Time', *October* 46, Fall 1988, p. 121.

17 I am thinking in particular here of works produced by artists working out of the archive of the Arab Image Foundation in Beirut, especially Walid Raad and Akram Zaatari. See Chapter 10.

Third, the image itself (as a de-realized entity) is distributed across the open and indefinitely proliferating field of its multiple instances of production/visualization, within a wide variety of different formats and material instantiations, and through a variety of processes of transformation (degradation/augmentation) to which it is subjected in the course of its distribution. This contrasts with the emblematically singular actuality of the chemically based photographic image, which lies metonymically in the individual photographic print, however frequently replicated. There, the theological structure of the photograph derives from its famous indexical 'immobilization of time'.[18] And yet, the theological structure of the digital image resides primarily in the *infinite productivity of the variety* of its forms of visualization.[19] Formally, digital photography, at the outset of producing an image, holds the potential of both these characteristics. Once digitalized, however, the photographic image enters the economy of the digitally produced image per se, and its specifically 'photographic' characteristics (which were always ultimately *imaginary*, in their dependence upon an extra-temporal, God-like view of its temporal relations) are eroded. Herein lies the fundamental ontological ambiguity of the expression 'digital photograph'.

Finally, the digitally produced image is a distributed image in the sense that it is open to a tendentially global *social distribution* via the internet. The dense and extended yet contingent social actualization of the quantitative potential of the indefinite proliferation of visualizations produces a qualitative transformation in the social space, the functions and hence the meanings of the images produced. It is not just images of migrancy that exhibit the politics of a crisis-ridden globalization (the restricted meaning given to the phrase 'migrant image' in T.J. Demos's recent book),[20] but equally the migrancy of the image itself. There is an inherent tendency in the distributive networks of the digital image to move the image on. This affects not only the ontology of the image (the de-realization of which is intensified by the multiplication of its instances), but also the ontology of the social field across which it is

18 Roland Barthes, *Camera Lucida: Reflections on Photography* (1980), trans. Richard Howard, Fontana, London, 1984, p. 91.

19 Cf. Osborne, *Anywhere or Not At All*, pp. 129–31.

20 T.J. Demos, *The Migrant Image: The Art and Politics of Documentary during Global Crisis*, Duke University Press, Durham NC and London, 2013.

distributed, since that field is now partly constituted by this distribution.[21]

The digitally produced and distributed image 'lives' (has social actuality) increasingly, through its relations to and *transformation into* other images, within a tendentially globalized image-space – rather than through a direct relationship with 'the real' (the indexical model), even if the content of the individual image is photographically indexically derived. And insofar as the distributive networks of digital imagery are an increasingly constitutive part of the social reality that they image, they carry with them a multiplicity of relations to other social practices. In this respect, digital imagery is an element of immanent reflexivity within global social practices and processes. Furthermore, the exchange of images – and links to images – itself produces new social networks that, in turn, become the conditions of production for new images. This is one of the historical conditions for the return of the story. For it was not just the temporal difference between information and storytelling that led Benjamin to see the latter as a waning cultural form in modernity, but more fundamentally what he took to be the loss of 'the ability to share experience'.[22]

If the digital is the primary means of image production in contemporary art today (with digital photography as its main form), it nonetheless remains the case that the ontology of art cannot be reduced to the ontology of the image – digital or otherwise. Its social and institutional constitution and functions are too specific. At the level of its basic structure, though, postconceptual art is also a distributed form, albeit in rather different ways.

First, the postconceptual work is also distributed across the open and, in principle, indefinitely proliferating totality of instances of its production and exhibition. However, rather than these instances being, exclusively, instances or events of 'visualization' (in the sense in which an image is always a perceptual abstraction of a visual structure from its material instantiation), in the postconceptual artwork they are also

21 This migration of images is very different from the migration of forms that Ruth Novak and Roger Buergel used as the organizing curatorial principle of *documenta 12* (2007), which remained morphologically conceived. See Ruth Noack and Roger M. Buergel, 'Some Afterthoughts on the Migration of Form', *Afterall* 18, Summer 2008, pp. 5–15.

22 Benjamin, 'The Storyteller', p. 143.

instances of *materialization*. The aesthetic fullness of the material means is as significant to the work as the structure of their image – along with the wider relational and conceptual aspects of the work, through which it derives its social and historical meanings. The artwork cannot be reduced to its character as an image. The work is thus best identified with the *distributive unity* of the totality of its materializations at any one time, rather than with the *element of identity* that links the distributed series of visualizations of digitally produced images at the level of their visual form. In terms of its logical form, the postconceptual artwork is thus more radically distributive than the digitally distributed image.

Second and conversely, however, with regard to the social distribution of the elements of the work, the artwork is far more restrictedly distributed and its distribution is far more rigorously policed by the laws of ownership and control (by art institutions and artists' estates) than the digital image, which proliferates exponentially on the internet. The legal ground underlying the cultural authority of institutional display makes all art – without exception – subject to far more conservative regimes of circulation than images as such. The digital artwork straddles these two contradictory regimes of social distribution. It is, no doubt, the anxiety surrounding its potentially uncontrolled proliferation that leads the exhibitionary complex to insist upon specific modes of installation of digital video, for example, frequently supplemented by sculptural elements which 'protect' the work from unrestricted distribution by expanding its material constituents.

Photography straddles the overlapping categorical divides of the digital/non-digital and art/non-art. It links them and is divided by them alike.

10

Information, Story, Image: Akram Zaatari's Historical Constructivism

Authentic montage is based on the document.
Walter Benjamin, 'The Crisis of the Novel', 1930

Under digital conditions of image production, it was argued in Chapter 9, image and information no longer appear as cultural forms that are separate, historically sequential in their dominance, and conceptually incompatible (as they did in the 1960s, to the founding practitioners of Conceptual art), but rather as discrete but dialectically interpenetrating elements or dimensions of postconceptual art practices. Furthermore, and equally fundamentally, information no longer appears incompatible with the narrativity of the story, but an integral part of new sorts of storytelling through which a certain kind of contemporary art – what I shall call a historical constructivism of the image – inscribes itself into the historical present. Such art thereby comes to practice a certain politics of historical experience.

This is precisely the opposite, of course, to what 'contemporary art' is thought to do, on its received, commercially encoded conception as a 'presentist', post-historical art, preoccupied with market-orientated aesthetic immediacies and a shallowly imagistic sense of up-to-dateness. And it is different too from the cultural politics of *memory* familiar from a certain, biographically based and geopolitically regionalist, biennial art of the last two decades, which has been the main supplementary – politically compensatory – form of art in relation to the more image-

based immediacies of the market.[1] For the method of construction places multiple temporalities into dynamically *disjunctive* relations with one another – rather than using the subjectivity of memory to project temporal unities and continuities through identification – within the image-like stasis of the work.

Associated by Benjamin in the 1930s with the newspaper, information had for him two main features: prompt verifiability and 'understandability in itself', or semantic self-sufficiency. As he put it: 'The value of information does not survive the moment in which it was new. It lives only at that moment; it has to surrender to it completely and explain itself to it without losing any time.'[2] This has achieved its full actualization today in the online streaming of news in so-called 'real time' and 'live' photographic news feeds. Benjamin took the need to 'sound plausible', according to the criterion of prompt verifiability, to be incompatible with the 'spirit' of storytelling, which 'preserves and concentrates its energy and is capable of releasing it even after a long time'. Indeed, the storyteller, who 'borrow[s] his authority from death', is understood to refer his stories all the way 'back to natural history', through a structure of transgenerational repetition.[3] Information thus appeared to Benjamin to mark the decline of narrative itself – which he associated with the epic, of which storytelling represented the 'purest' form in the prose tradition.[4] However, this should not be understood (as it often is) as itself a narrative *of* decline but, he argued, rather 'only a concomitant symptom of the secular productive forces of history'. Furthermore, it is not just a technological phenomenon, but primarily the effect of the historical dissolution of the social body carrying the transcendental function of narrativity: the 'community of listeners'.[5] The dissolution of that communitarian communicational social body created a new communicational body, of course, which was to become not only sublimely larger (globally transnational in its, first, photographic, then

1 For the dialectical opposition of memory to history, see Osborne, *Anywhere or Not At All*, pp. 190–201.
2 Walter Benjamin, 'The Storyteller: Observations on the Works of Nikolai Leskov' (1936), in *Selected Writings, Volume 3*, pp. 143–66; p. 147.
3 Ibid., pp. 147, 151.
4 Walter Benjamin, 'The Crisis of the Novel' (1930), in *Selected Writings, Volume 2*, pp. 299–304; here, pp. 300 and 299.
5 Benjamin, 'The Storyteller', pp. 146, 149.

digitally based forms), but also largely disjunctive from the dynamics of other aspects of social reproduction: no longer a community, nor even a 'society', as understood in the late nineteenth and early twentieth centuries.

The historical terminus of Benjamin's sequence, epic–novel–information (which, in the self-sufficiency of the elements of information, grounds the historical primacy of *montage* and *construction* in twentieth-century literary, plastic and film forms alike) was replayed at high speed, in condensed form, at the high point of the curatorial history of Conceptual art as a movement between spring 1969 and autumn 1970: in the series of exhibitions running from 'When Attitudes Become Form' (Bern, spring 1969), subtitled, 'Works-Concepts-Processes-Situation-Information' (information is fifth in an informational series), via 'Information' (MOMA, New York, July 1970) – in which information became synonymous with the work of art – to 'Software: Information Technology – Its New Meaning as Art' (Jewish Museum, New York, autumn 1970), in which information was itself reduced to its latest technological medium. However, such techno-utopian informational progressivism has subsequently been confounded by the obvious narrative content and structure of most contemporary art video, in which 'living' relations to various historical actualities are increasingly established by placing the *narrativity* of the story (often in the form of testimony) at the heart of the *constructed* filmwork.

Information and story appear here, at once, as relatively self-sufficient, mediated via the image, and in the process of turning into each other. Furthermore, a certain *use* of the story has become the means, for certain artists, to deploy memory (against the grain of its dominant use as a repression of the history it claims to represent) as an element in the construction of historical experience. As a cultural form, the story thereby appears no longer historically discarded, but incorporated, via digital video (including, crucially, sound) into the non-organic or constructive work, as an aspect central to the establishment of its contemporaneity – its bringing together of different social times within the disjunctive 'living' unity of different geopolitically distributed lives. This act of 'putting into relation' is at the same time an act of translation, whether it involves linguistic translation – which it generally does, hence the imagistic import of subtitles – or not.

Zaatari

Here, I take two digital film installations by Akram Zaatari as paradigmatic instances of such work, or models: *In this House* (2005) and *Letter to a Refusing Pilot* (2013). *In this House* centres upon an orally narrated story, a testimony, in the form of a thirty-minute documentary video in which a split-screen presentation (with English-language subtitles translating the Levantine Arabic) is supplemented with textual and photographic, biographical and other documentary materials, along with information about characters who were present during the main narrative action playing in the right-hand window, whose voices can be heard, but who 'refused to be videotaped' (generally, police, military and other 'agents'). The story is about the retrieval of a letter buried in a mortar canister in the garden of the Dagher family house, which was occupied by a militia during the war in Lebanon. When the war ended in 1991, the military commander who occupied the house (who is interviewed in footage shown in the left-hand window, in the first part of the film) wrote a letter to the family justifying the occupation of the house and welcoming them back home. The footage in the right-hand window documents the digging in the garden, searching for, and ultimately finding, the canister, in November 2002. Graphic elements surrounding the two windows provide further documentary commentary (Figs 10.1–10.4).

Letter to a Refusing Pilot, 2013 – a thirty-four-minute digital film first shown in the Lebanese Pavilion within the Arsenale at the Venice Biennale, and then in a different installation at Weils, in Brussels, in spring 2014 – intermixes a story about an Israeli pilot who refused to bomb a school in the Lebanese town of Saida during his mission (when he recognized that it was a school from the aerial architecture) with autobiography, documentary and 'fictional/fictionalized' material about pupils in the school. The artist had known the school as a child. The film begins with a shot taken from a drone launched from the roof of a building in Beirut and juxtaposes footage of childhood documents (the book *Le Petit Prince* and family snapshots) with the act of drawing the school, the sculptures in its gardens, and the beginning of an ordinary school day. Cutting to the close of the school day, pupils climb to the roof of the school to launch paper aeroplanes; one, digitally transformed, becomes

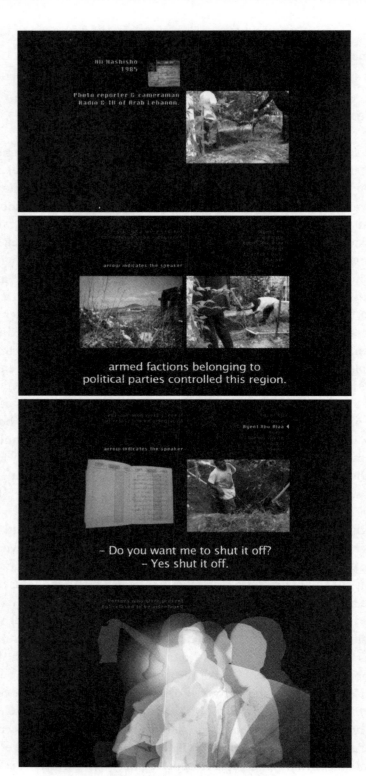

Figs 10.1–4 Akram Zaatari, *In this House*, 2005.
Digital video, 30 minutes, stills

Figs 10.5–8 Akram Zaatari, *Letter to a Refusing Pilot*, 2013.
Digital film, 34 minutes, stills

the jet that dropped its munitions into the sea rather than bomb the school. To conclude, the pilot's story is told in simple typed sentences. 'The school was bombed a few hours later by another pilot.' And a diary, photographs and news footage of the event and its aftermath are displayed (Figs 10.5–10.8).

In these two works, Zaatari's art appears as the inverted, dialectical complement to the fictional use of documentary by his colleague Walid Raad's The Atlas Group. For, while The Atlas Group used fiction (posing as documentary) to produce history Zataari uses documentary history to produce stories. As individual parts of the collaborative project of the Arab Image Foundation in Beirut, one might even think of the two bodies of work as aspects or elements of a single broader practice. Another thing that they share is a constant re-presentation of elements of their works within other works, and a constant changing of the material forms of particular, individual works themselves as they are shown in different locations over time, in a process of *self-cannibalization and mutation* that is emblematic of a postconceptual ontology in which there is an acknowledgement of a potential infinite multiplicity of materializations of any particular work.

The first and most obvious thing to note about these two works is that the artistic materials here include Benjamin's cultural forms of information ('The value of [which] does not survive the moment in which it was new') – newspapers, TV news – in combination with more traditional bourgeois genres of self-formation – personal photographs, diaries, letters, identity cards – which themselves now borrow from those forms (the diary entries borrow the forms of TV news), each of which appears as a separate element within the graphic space of the digital screen.[6] In *In This House*, especially, the screen is used as a space of writing in which the visual image appears as a graphic element – punctuated by the other graphic elements – and vice versa, insofar as the literally graphic elements appear imagistically. This is what Zaatari has called his 'Godard lesson'.[7] Late Godard – and his *History of Cinema*, in particular – is basic to

6 Other of Zaatari's works do this in a technologically more emphatically contemporary manner. See, for example, *Dance to the End of Love* (2011), a twenty-two-minute, four-channel video installation compiled out of YouTube material of young men from various middle Eastern countries filming themselves. Available at Vimeo.com, accessed 3 February 2017.

7 *Film as a Form of Writing: Quentin Latimer talks to Akram Zaatari*, Weils, Brussels, 2014, p. 19.

questions of form here. We could also call it a 'Kluge lesson' (after Alexander Kluge), insofar as Kluge provides another model of 'An Analytic Storyteller in the Course of Time' – to use the title phrase of Andreas Huyssen's essay on Kluge. Zaatari, like Godard and Kluge, is – to quote from Huyssen on Kluge – 'a storyteller in a structuralist age [who] translates the archive back into individual life stories or, rather, shows how the archive permeates individual modes of speech, behaviour and action.'[8]

One may also position these works within a longer history of technological form, as narrated by Lev Manovich in *The Language of New Media*, whereby 'computer media return us to the repressed of the cinema'. 'The photographic and the graphic', Manovich writes, which 'divorced when cinema and animation went their separate ways, me(e)t again on the computer screen' to create the new hybrid language of what he calls 'cine-grat-ography', which combines temporal montage with a new spatial ontology.[9] Parallels appear between three historical stages: the early cinema of the 1890s; the structuralist film-making of the 1960s; and so-called 'new media' from the 1990s onwards. This is a historical line to which Renaissance painting may be retrospectively appended as a similar kind of densely narrated 'information space'. All are examples of explorations in spatial narrativity.

All past literary, visual and sound forms reappear as possible elements of works within the digital meta-medium. Each is staged, often quite theatrically (the white gloves of archival preservation, in *Letter to a Refusing Pilot*, for example, Fig. 10.8),[10] as a separate, independent element, as well as a component of the ensemble; indeed, in Adorno's terms, as a separate *subject of speech*. In Kluge's own classically constructivist account of the structural possibilities of film, the accumulation of elements 'preserve[s] a certain tension in relation to each', which makes itself felt 'in the gaps which montage create[s] between the disparate elements of filmic expression'. 'In layering expressive forms in such a manner', the group continues, 'film would succeed in concentrating its subject matter in the spaces between the forms of expression.'[11] This is the logic of construction

8 Huyssen, 'An Analytic Storyteller in the Course of Time', p. 121.
9 Lev Manovich, *The Language of New Media*, pp. 308, 311–2, 322.
10 Cf. the white gloves of the archival assistants in *On Photography, People and Modern Times* (2010), Zaatari's two-channel, video installation 'subjective story' of the Arab Image Foundation, Available at vimeo.com, last accessed 3 February 2017.
11 Reitz, Kluge and Reinke, 'Word and Film', p. 81.

of a pluri-vocal ensemble, in which it is the exchange between the *thing-like* aspect and the *subject-like* aspect of the work *within* the image-space that both secures the status of the work as art (in its self-consciously illusory, autonomous sense) and establishes its specific temporality. The formal aspect here depends upon a *technical* appropriation of technology that is not itself technologically, but is rather artistically, determined, while its temporality is constructed out of the *relations* between the interruptive character of the image and the narrativity of the story.

This is a temporality that is grounded on the structural affinity between the twofold characters of memory and the image, which mediate them with history and narrative, respectively.

Memory, Image, Narrative

Memory is twofold as (i) simple presence of the past (*mneme*) – in the Augustinean sense of being one aspect of the threefold present: memory, in the singular as a distinctive phenomenological quality of intentionality ('having' a memory); and (ii) as recollection (*anamnesis*), or memories in the plural. This maps on to the twofold structure of the image as at once (i) the *presence* of an absent thing and (ii) the designation of the present thing *as unreal or absent*. In other words, temporally, the image points in two directions at once. It is constitutively ambiguous. It points to the *presence of the unreal* and the *absence of the real* – it is this absence that becomes real in it, as a mode of reality of the unreal (Fig. 10.9).[12]

Memory

('having a memory') ('memories')

simple presence recollection

Image

presence of an designation of a
absent thing presence as unreal

Fig. 10.9

12 I draw here on Paul Ricœur, *Memory, History, Forgetting*, pp. 44–55.

Memory is connected to history via the narrativity of the relation between its two elements. Narrative thus connects and mediates memory and history, as a collective aspect of the transcendental structure of narrativity (Fig. 10.10).

Memory **History**

('having a memory') ('memories')

simple presence recollection

 – narrative – – narrative –

Fig. 10.10

The image, on the other hand, separates itself out from history by the *non*-narrative structure of the relation between its elements. It thus appears from a historical standpoint as stasis, or, more negatively and powerfully, as interruption or externality (Fig. 10.11).

Image **History**

presence of an designation of
absent thing presence as *unreal*

 [*non*-narrative onto- stasis / interruption of
 theological structure] narrative / externality /
 wholeness

Fig. 10.11

This is famously its role in Benjamin's work, of course. As such, it becomes a standpoint from which to figure history 'as a whole', or in its unity: a unity that can only appear from the standpoint of exteriority, because history itself is ongoing and incomplete. Hence, to return now to the twofold homology of memory and image, in their mutual relations to history, the homology becomes the shape of a contradictory relation which dialectically restructures the concept of history itself – on the right-hand side of Fig. 10.12.

Within the structure of the *memory image* (Fig. 10.13), the designation of the presence in the image as unreal (on the right-hand side of the diagram), registers the fundamental *otherness* of the past, while the

	Memory	**History**
simple presence	recollection	
	– narrative –	– narrative –

Image

presence of an	designation of	
absent thing	presence as *unreal*	+
	[non-narrative onto-	= stasis / interruption of
	theological structure]	narrative / externality /
		wholeness

Fig. 10.12

immediate presence of the absence thing is what Ricœur calls 'a model of mineness' – appropriating Heidegger's concept of 'mineness' from his discussion of death and displacing it, via Locke, on to memory. One is linguistically constituted as a subject by being the possessor of one's own memories: that is John Locke's concept of the self.[13]

Memory Image

simple presence		unreality of
of an absent thing		recalled presence
Mineness	+	Otherness
		– of past &
		– of others

Fig. 10.13

This not only projects the externality of the image (via memory) back into histor, as the externality of the past to the present (which is the specific and paradoxical modality of its presentness); it also opens up the *social* dimension of the relationship between memory and history, as different but intimately related modes of representation of the past, via the analogy between the 'otherness of the past' and the 'otherness of others'. 'The past is a foreign country', as the opening line of L.P. Hartley's 1953 novel, *The Go-Between*, goes: 'The past is a foreign country, they do things differently there.'

This is the sense in which Ricœur writes that: 'The discovery of

13 Ricœur, *Memory, History, Forgetting*, pp. 96–120.

what is called historical memory consists in a genuine *acculturation to externality*. This acculturation is that of a gradual familiarization with the unfamiliar, with the uncanniness of the historical past.'[14] This is the sense in which historical knowledge performs an ethico-political function analogous to the *goals* of multiculturalism, but in a different way. Historical knowledge *models a relationship to the otherness of others*; an otherness that is, of course, always very precisely socially and historically, culturally and geopolitically, coded as the otherness of *particular* others (it never appears as otherness in general). In the history of Western capitalism, these particular others are mainly indigenous peoples: from 'the orient', native Americans, Africans and Aborigines, along with the Jews and, more recently, the Palestinians and exiled and migrant communities of all sorts. At least, these are those who are currently remembered as having-been-forgotten. There is a dialectic of memory and forgetting within this historical experience, offering up the 'unsettling spectacle' of 'an *excess of memory* here [in one place], and an *excess of forgetting* elsewhere.'[15] This is the problem with the politics of memory: collective subjectivism, or the absolutization of the standpoint of particular groups.

The relationship that is modelled here – the acculturation to externality – is driven by mechanisms of identification that are internal to the structure of memory itself. These concern not only the function of memory in forming the subject-self as an 'I' (memory as a model of mineness), with the temporal continuity of a history (a biography), but also, crucially, the function of memory in forming the subject-self as a social being. As Halbwachs put it in his book *Collective Memory*: 'a person remembers only by situating him [or her]self within the viewpoint of one or several groups and one or several currents of collective thought'. Or in Ricœur's more pithy version: 'One does not remember alone.'[16]

This social function of mediating the individual ego and collectives via memory and historical knowledge and, in particular, via the memories shared with 'close relations' (familial or otherwise) is famously

14 Ibid., p. 394.
15 Ibid., p. xv.
16 Maurice Halbwachs, *The Collective Memory*, trans. Francis J. Ditter and Vida Yazdi Ditter, Harper, New York, 1950, p. 30; Ricœur, *Memory, History, Forgetting*, p. 121.

closely tied to place, and to some places in particular: the *house/home* and *the school*. Not accidentally, I would suggest, are these the locations for Zaatari's two films, which use these archetypical locations to mediate memory and history via the relations between individual biographies and the history of nations and states. Yet it is from their formal *fictional* qualities – the emblematic power of their integration of information and image – that these stories derive their political power and importance.

11

Dialectical Ontology of Art: Xavier Le Roy's *Retrospective* in/as Contemporary Art

Much has already been written about Xavier Le Roy's *Retrospective*, first performed/exhibited at the Fundació Antoni Tàpies in Barcelona, 24 February to 22 April 2012, and much of it has focused, unsurprisingly, on the artistic and critical uncertainties generated by such an extended and sustained occupation of gallery space by dance. Yet, for all the emphasis that has been placed on the self-reflexivity and deconstructive intent of the piece (expanding the reach of the analytical aspect of Le Roy's work from dance to the conventions of a broader artistic space), along with the subtle and nuanced phenomenology of its perception, there has been surprisingly little interrogation of its significance for the concept of contemporary art, or, conversely, of the relevance of the idea of contemporary art, in its most general critical sense, to the comprehension and criticism of *Retrospective*. Yet much of the critical interest of *Retrospective* lies precisely in its claim (explicit in a practical state) to be a work of contemporary art as such.

Entranced to the point of beguilement by the combination of its strategies for engaging its audience, on the one hand, and the affective power of the dance fragments on display, on the other, critics have tended either to rest with the idea of a sceptical destabilization of the boundaries between categories (dance–performance–exhibition and viewer–audience–participant) or to seek meaning in an expanded aesthetic response, incorporating the mild bewilderment occasioned by the

suspension of 'rules of the game' of exhibition space into the force of the work.[1]

This is in part a consequence of following a certain trail of artistic intentionality, highlighted by the place of interviews with the artist in the literature on the work. In part, it is a result of presuming a substantial or 'ontological' category of dance (at the core of a wider concept of performance) as the medium of the enactment of its own questioning, deconstruction, unravelling, expansion and transformation. If the former is a symptom of the critical renewal of Romantic individualism under the conditions of neoliberalism, the latter is a sign of the still-enduring power of the discourse and practices of medium-specific modernism. Here, however, such practices coexist alongside and in relation to what otherwise appears as the beating heart of the counter-tradition of categorial mixing and principled indeterminacy: the legacy of Duchamp–Cage–Cunningham–Fluxus, reactivated under new institutional conditions.[2]

Clearly, there is a lot going on here – in the work, the writing on the work, and the institutional space it inhabits – that belies the powerful, honed-down simplicity and the directness of address so important to the immediate experience of the work itself. Three separate sources of complexity converge: the history of the individual pieces from which the fragments that make up *Retrospective* are extracted and reworked, the state of critical discourse on contemporary art, and the highly fluid current situation of the institutional space of the gallery within the broader set of relations that constitute the social and artistic actuality of 'contemporary art'. I shall concentrate my remarks here on the relations between the latter two. For it is the way in which *Retrospective* is

1 See, for example, Marcella Lista, 'Xavier Le Roy: A Discipline of the Unknown' and Chris Sharp, 'Xavier Le Roy: *La Règle du jeu*', *Afterall* 33, Summer 2013, pp. 27–37 and 19–25, respectively. Generically 'sceptical' interpretations of art that has a strong conceptual dimension are increasingly commonplace. Two artists whose work has provided a model for such criticism are Gerhard Richter and The Atlas Group.

2 For a recent recovery of this legacy, see Carlos Basualdo and Erica F. Battle, eds, *Dancing Around the Bride: Cage, Cunningham, Johns, Rauschenberg, and Duchamp*, Philadelphia Museum of Art, Philadelphia, 2012 – the catalogue of the exhibition of the same name – 30 October 2012–21 January 2013, Philadelphia Museum of Art and Barbican Art Gallery, London, 14 February–9 June 2013. The Centre Pompidou exhibition, *Dancer sa vie*, November 2011–April 2012, was in many respects the converse of this show, subjecting the 'expanded field' to an expanded concept of dance.

constructed with regard to – and intervenes into – these relations that constitutes it as a work of contemporary art as such rather than, more simply, a contemporary dance event in a gallery space.[3]

Much rests on *Retrospective*'s particular mediation of the critically opposed traditions of medium-specific and inter/transmedia modernisms and the way in which the categorial dissolutions of 'dance' into 'performance', and 'performance' into the performativity of 'art' in general – which act as historical and conceptual relays between these traditions – are suspended here by a particular way of inhabiting the exhibition space of the gallery: its *complete durational occupation* by performance while the space is open to the public. What this means is that the temporality of the dance/performance events themselves (even in their empirical totality as the event of the work, *Retrospective*) does not exhaust the temporality of the work, but rather occurs internally to a broader, overarching, de-temporalizing temporality of art in general, which renders the work ideational, thereby substantializing it, but only within the domain of the imaginary or that of a constitutive illusion. This is derived, on the one hand, from the art-constituting institutional space of the gallery (indeed, in the case of the Tàpies Foundation, an explicitly art-history-constituting space), and on the other, from the unifying function of the title, *Retrospective*, which posits the work as a metonymic selection or sample of a preconstituted whole (the artist's oeuvre up to that point). The fragmentary status of the dance components making up the work renders explicit this ontological inadequacy of the dance elements (in their empirical totality) to the work of which they are a part – the ontological insufficiency of 'dance' to 'art' within the work.

Overarching art-historical and art-critical narratives gain their meanings from their heuristic function in the interpretation of particular works. These in turn appear most interestingly when they problematize certain of the assumptions underlying such narratives. The revisionist historiography of Western art from the late 1950s through to the end of the 1970s – the period of the formation of what we now call

3 For a dance-orientated critique of the work based on the principled insufficiency of exhibition space to dance (and of *Retrospective*'s fragments to the works from which they are extracted), see Nikki Columbus, 'Changing Partners: "Retrospective" by Xavier Le Roy', *Parkett* 91, 2012, pp. 196–200.

'contemporary art' – has come, increasingly, to privilege various performative, aleatory and intermedia lineages. And it has tended to stress their independence from the subsequent histories of the mediums out of which these lineages developed (music and dance, in particular) and with which they interacted (painting and sculpture, especially), a still prevailing tendency to trace back the source of all art 'action' to Jackson Pollock, via Allan Kaprow, notwithstanding. One of the things that is most interesting about *Retrospective* is the way that it stages (and thereby condenses) relations between medium-specific categories ('dance') and generically artistic categories ('art', 'exhibition') at the point of their transformation into one another – dance becoming performance becoming art; generic art 'made of dance' – in such a way as to dissolve the ontological significance of medium-specificity without dissolving the critical significance of medium as a historically received element or sedimentation within the work. At the level of its ontology, *Retrospective* seems to work in both directions at once: from the (medium-)specific to the generic, and as a nominalistic particularization of the generic. This is a sign of the rigorously dialectical character of the internal structure of the work.

By virtue of its sustained occupation of the ('art'-defining) exhibition space at the Tàpies Foundation, *Retrospective* occupies the conceptual space of performance in its opposition to dance. Yet it does so, explicitly, via its function as a type of retrospective, as a kind of *sampling* of dance. The pieces have a history, and are staged, as elements of dances, even if these dances have previously been performed in art-institutional spaces. (A generically artistic institutional space is not enough to convert dance into performance if its occupation is merely evental. Nor is it enough to convert performance, ontologically, into art in its fully generic sense, even if its occupation is permanent. As is shown by the Tate Modern 'tanks', for example, which reinforce performance as a *distinct* genre of contemporary art, taking place in a performance – rather than an exhibition – space within an art institution. This is very different from the institutional status of the exhibition space at the Tàpies.) The work thereby sets up a dialectic between dance and performance, internal to its own practices, in which the difference between them appears in its negativity (as a kind of mutual negation), yet without thereby subjecting this difference to the *positivity* of some more all-encompassing term, since 'art' functions here generically, in a

manner that can be rendered positive only at the level of the determinacies of the individual work.

Rather, this dialectic of dance and performance is sustained, negatively, by the negativity of the generality of 'contemporary art' as the space mediating the disintegration of mediating critical categories and the individuality of particular works. The title, *Retrospective*, thus functions here allegorically, making explicit the claim on the genus made by the individual work, under the conditions famously described by Adorno as the tendentially increasing 'nominalism' of modern art. And it does so not only via its allusion to the expansive universality of the oeuvre, to which it inevitably refers, but, crucially, with the reference to the temporality of the unity of art itself. As Adorno put it,

> The universal determinations of art are what art developed into. The historical situation of art, which has lost any sense of art's very raison d'être, turns to the past in the hope of finding the concept of art, which retrospectively acquires a sort of unity. This unity is not abstract but is, rather, the unfolding of art according to its own concept. At every point, therefore, the theory of art presupposes concrete analyses, not as proofs and examples but as its own condition.[4]

At the same time, this retrospective construction of unity gains its artistic meaning from the ongoing *negations* to which it is subjected by current practices. Historically, it exists as a unity only as the unity of what is being negated:

> The definition of art is at every point indicated by what art once was, but it is legitimated only by what art became with regard to what it wants to be, and perhaps can, become . . . Because art is what it has become, its concept refers to what it does not contain . . . Art can be understood only by its laws of movement, not according to any set of invariants. It is defined by its relation to what it is not . . . Art acquires its specificity by separating itself from what it developed out of; its law of movement is its law of form.[5]

4 Theodor W. Adorno, *Aesthetic Theory*, p. 263 / *Ästhetische Theorie*, p. 392.
5 Ibid., 2–3 / 11–12. Cf. Chapter 1, note 38.

The law of movement of *Retrospective* is that of a type of sampling, closer to the logic of compilation than to musical sampling. Musical sampling generally involves the sample as an element of construction within a work made of markedly different other compositional materials, subjecting the sample to a new and independent logic of production, in relation to which it functions, in part, interruptively. Here, however, the principle of sampling is generalized and subject to the logic of representativeness of the museum. And yet each sample is nonetheless immanently transformed by its mode of presentation as an extract from another, larger/longer work, by the dancer involved. (This is the 'autobiographical' element in the dancer's narration to visitors of the significance to them of the particular dance fragment they will perform.) The self-sufficiency of each sample relative to the construction of *Retrospective* as a whole – necessary to the inorganic structure of the work – which derives from its place within the work from which it has been extracted, is augmented by this appropriation, which reinforces its status as a self-contained miniature work. (Duchamp's 1935–41 miniaturized, 'portable museum', *Boîte-en-valise*, comes to mind.) The principle of construction is thus applied not only at the level of the whole, but internally to each component, separately, by each of the performers. It is this constructive, rather than ready-made, element of the self-sufficiency of the components of the exhibition that make it a 'work' in a strong, individual sense, well beyond the popular idea of the 'exhibition as work' associated with the increased institutional power of curators.

At another level, this independent constructive input from the performers appears as a collective, cooperative aspect of the work, associated by many with the 'participatory' interaction between dancers and visitors, and the repeated requests by the dancers to be invited to perform, especially. ('Would you like me to perform . . . for you?' recurs as the concluding motif of most of these interactions.) In the literature on *Retrospective* (as in that on related types of work, by Tino Sehgal, for example), the supposedly 'democratic' character of such interactions is generally associated with the epistemological scepticism of a broadly deconstructive approach to the social objectivity of aesthetic forms. Categorial indeterminacy – linked to 'aesthetic' in its Kantian formulation – appears as a theoretical form of 'democratic openness', marking a withdrawal from critical judgement on the political grounds of the multiplicity of views in a participatory democracy. However, there are

grounds for scepticism about this rather-too-comfortable democratic politicization of indeterminacy.

In the first place, in the aesthetic dimension, such indeterminacy offers no grounds for a withdrawal of critical judgement to a 'democratic' multiplicity of positions. Quite the reverse, in fact. Famously, in Kant, indeterminacy is the very ground of the reflecting power of judgement, of which aesthetic judgement is an instance; it is a ground of judgement itself. The universality of aesthetic judgements may be subjective, and empirical claims may be multiple, but each makes a claim on the same universality and a 'demand' on all others, which, in its difference from their judgements, conflicts with them. These are agonistics. There is no comfortable pluralism here in the retreat to aesthetic. Nor can a convincing political case be made for the practical, 'relational' aspects of this aesthetic.

In fact, one might question the description of the role of visitors in the interactions with performers in *Retrospective* as being 'participatory' in any meaningfully democratic sense. Indeed, one might suggest the reverse. Like many so-called 'participatory' works involving scripted interaction with visitors, the structure of authority is less democratic than formally authoritarian due to the institutional imposition upon visitors of particular scripted forms of social exchange. The sovereignty of the art institution over its visitor-subjects – who are taken to have consented to the interaction by entering the institutional space (just as one consents to the terms of exchange by entering the market) – is explicit. Often, in this kind of work, it is less 'bewilderment' that is produced and more a barely suppressed, doubled embarrassment, which is embarrassed in large part about this very embarrassment itself. There is, of course, a politics to the production of this kind of interaction that goes beyond the reproduction of the sovereign structure of subjection that it enacts as a condition of the reception of the work of art. But again, it would be wishful to associate it with anything democratic in the pluralistic liberal (market-based) sense that is normally, if vaguely, evoked. These works are, one might say, 'better' than that, however much they may trade upon the comforts of such misrepresentation.

Historically, conceptual, contextual, situational and relational works of art were among the conditions that established the possibility for performance and dance to become practices of contemporary art, in a strong and critical sense, by changing the character of art space and the

spatial ontology of the work of art alike. Xavier Le Roy's *Retrospective* inhabits – indeed fills – this new kind of art space (the space of contemporary art) in a manner that both reveals and gives determinacy to its generic structure through a mode of individuality that remains very much its own.

12

The Kabakov Effect: 'Moscow Conceptualism' in the History of Contemporary Art

Starting in the late 1960s . . . [the Moscow conceptual] circle of artists became an engine in the development of aesthetic and conceptual models that, while reflecting on local issues, also fit successfully into the discourses that were being developed by their contemporaries in the West. Indeed, it can be claimed that the 1970s and 1980s were the last era when a channelling of local contexts into an international language was effectively realised, just as in the period of the historical avant-garde.

> Margarita Tupitsyn, curatorial statement
> for the Russian pavilion of the 56th
> edition of the Venice Biennale (2015)

The term 'Moscow' is heavy enough to outweigh any Western term like 'futurism' or 'conceptualism'.

> Boris Groys, introduction to *History Becomes Form*

These two statements raise a series of interesting historical and methodological issues about the emergent discourses of a global art history and histories of contemporary art, in particular. Taken together, they highlight the tension internal to the phrase 'Moscow Conceptualism', in which a Western category ('conceptualism') is conjugated with a purportedly Eastern name ('Moscow') in order that the latter may be

raised to the power of an established 'international' art discourse, while at the same time expanding and re-inflecting that discourse towards a more geopolitically comprehensive set of artistic practices.[1] The history of conceptual art has been at the forefront of this kind of revisionist historiography, and 'conceptualism' has been the main category through which its unity has been sought.[2] Within this field, though, Margarita Tupitsyn and Boris Groys offer conflicting standpoints.

Tupitsyn takes the aesthetic and conceptual models developed by the Moscow conceptual circle to 'fit successfully' into the Western discourses of conceptual art by some kind of pre-established historical harmony, while Groys considers the designation 'Moscow' to be sufficiently singular to 'outweigh' *any* term of Western art history. It is thus by virtue of its differential singularity (rather than its discursive fit), for Groys, that twentieth-century Russian art is to become part of an international art history. This is the internationalism of an aggregative unity of self-contained art nations, rather than that of either an expansionary Western discourse or a received Soviet one (with Marxism–Leninism as the language of a Communist International, of communism as internationalism).

What neither Tupitsyn nor Groys considers is the possibility that 'Moscow Conceptualism' might re-inflect (or might already have re-inflected) the Western discourse of conceptual art to the point of its critical transformation. This is the interesting possibility: the critical transformation of the discourses of conceptual art by the term 'Moscow'; a critical transformation that is at the same time a key mediating moment in the constitution of the category of contemporary art as a postconceptual art.[3] It is here that the original terms of Groys's invention of 'Moscow Conceptualism' become germane. For the subsequently suppressed,

1 The idea that Moscow is an 'Eastern' name is, of course, a distinctively Western one. Within Russia itself it has for a long time stood for a certain 'Westernizing' imaginary.

2 See in particular Luis Camnitzer, Jane Farver and Rachel Weiss, eds, *Global Conceptualism: Points of Origin, 1950s–1980s* (exh. cat.), Queens Museum of Art, New York, 1999, and L. Camnitzer, *Conceptualism in Latin American Art: Didactics of Liberation*, University of Texas Press, Austin, 2007. For an alternative attempt at a historically based, *internal* expansion of the notion of 'conceptual art' itself, see Peter Osborne, 'Survey', in Peter Osborne, ed., *Conceptual Art*, Phaidon, London, 2002, pp. 14–51.

3 For the critical claim that 'contemporary art is post-conceptual art', see Osborne, *Anywhere or Not At All*, pp. 3 and 46–53 in particular.

conceptually differentiating, middle term in Groys's initial analysis was, of course, 'romantic' – 'Moscow Romantic Conceptualism' in the title of his now well-known essay of 1979, published simultaneously in Russian and English in France.[4] Retrospectively, with its dual columns and passport-type photograph of its author, this essay itself appears as something of a conceptual piece, effecting a certain auto-fictionalization of Groys as a character in his own story. Writing this story, Groys recounts, he 'used the word "Romantic" precisely to indicate the difference between Anglo-American conceptual art and Moscow art practices'.[5] At that time, Conceptual art was associated with a relatively narrow canon of mainly New York-based artists, and the critical literature was dominated by the 'analytical' self-understandings of those artists, rooted in mathematical and linguistic analysis: Sol LeWitt, Joseph Kosuth and the British group Art and Language in particular.[6] So the term 'Romantic' – used by Groys for 'a combination of dispassionate *cultural* analysis with a Romantic dream of the true culture' – had a radically differentiating effect.[7] During the 1980s, however, the qualifying term was soon discarded; 'Moscow Conceptualism' came to be adopted as a primarily geopolitical label encompassing a larger group of artists in Moscow than the more strictly 'Romantic' ones – while aspects of the stricter artistic characterization in fact apply equally to artists from Leningrad and Odessa, who may have passed through Moscow but whose practices derived from elsewhere.

The weight of the term 'Moscow' in Groys's analysis turned out to be heavy enough to outweigh – or at least, to incorporate – the term

4 Boris Groys, 'Moscow Romantic Conceptualism' (1979), reprinted in Groys, *History Becomes Form*, pp. 35–55.

5 Boris Groys, *History Becomes Form*, MIT Press, Cambridge, MA, 2010 p. 7.

6 Indeed, this remained true into the new century. The most comprehensive anthology, published at the turn of the century – *Conceptual Art: A Critical Anthology*, MIT Press, Cambridge MA, 1999, edited by Alexander Alberro and Blake Stimson – contains no reference to conceptual art practices in Moscow. Its only references beyond the Anglophone world and Europe are to Latin America. For the range of philosophical positions within even this narrow band of practices, see Peter Osborne, 'Conceptual Art and/as Philosophy', in Jon Bird and Michael Newman, eds, *Rewriting Conceptual Art: Critical and Historical Approaches*, Reaktion Books, London, 1999, pp. 47–65.

7 Groys, *History Becomes Form*, p. 7, emphasis added. Of the first generation of canonical US conceptual artists it was only Dan Graham who based his practice in a form of cultural analysis. See Dan Graham, *Rock My Religion: Writings and Art Projects, 1965–1990*, ed. Brian Wallis, MIT Press, Cambridge MA, 1993.

'Romantic' too. *Happy Moscow*.[8] This weight is not just the weight of the city as a metonym for the country of which it is the magnetic capital, itself metonymic for the empire; ultimately it is the weight of the term 'history' itself. 'Through the art of Moscow conceptualism', Groys writes, 'a certain period of modern history – namely, the history of realisation of the communist project – finally becomes form'.[9] Following Groys, 'Moscow Conceptualism' thus became a metonym for the artistic expression of everyday life in the Soviet Union. It thereby became a relay connecting the specific body of (Russian) work to which it originally referred to a far wider body of Eastern European art, the framework for the unity of which it thereby provided: everyday life under Soviet communism.[10]

At the same time, it was the 'conceptualist' component of the phrase that allowed for the integration of that broader body of work into what Tupitsyn calls the 'international language' of 'the discourses that were being developed in the West': that is, the emergent genre of what is now known as the 'history of contemporary art'. There are thus two distinct kinds of 'international language' at play here: the language of Marxism–Leninism, of communism as an internationalism – a central textual and imagistic component of the everyday life of Soviet communism – and the art-historical languages of 'conceptual art' and then 'contemporary art'.

Groys does not mention the difference between 'conceptual art' and 'conceptualism' as critical and historical terms – although it was the silent choice of the latter over the former that allowed him to dispense with a comparative analysis of the relations of the Russian art in question to the 'founding' conceptual practices in New York in the 1960s. The 'ism' term marks a looser affinity, to the point of a critical slackening, in those relations. In this regard, conceptual*ism* functions as a mediating term between 'conceptual art' and 'contemporary art', as critical categories – generalizing the former, while specifying the latter. And

8 Andrey Platonov, *Happy Moscow*, trans. Robert and Elizabeth Chandler, New York Review Books, New York, 2012.

9 Groys, *History Becomes Form*, p. 3.

10 In fact, the very concept of everyday life (*byt*, in Russian) has one of its main genealogical starting points in the Soviet debates of the 1920s. See John Roberts, *Philosophizing the Everyday: Revolutionary Praxis and the Fate of Cultural Theory*, Pluto, London, 2006, ch. 1, and Christina Kiaer, *Imagine No Possessions: The Socialist Objects of Russian Constructivism*, MIT Press, Cambridge MA, 2005, chs 1 and 2.

during the 1990s, it was 'Moscow Conceptualism' – alongside 'Latin American Conceptualism' – that came to play a central geopolitical role in that mediating movement of generalization. In fact, there is a serial development of critical art-historical terms and concepts at stake here, which runs: conceptual art; conceptual*ism*; conceptualism*s*; contemporary art; postconceptual art. This is a serial development with a narrative logic that retrospectively overdetermines the conceptual dynamics of the series.

Retrospection plays a constitutive role, to the point of retroactivity, in art-historical narrative here. (Retrospection is an epistemological category – call it hindsight. Retroactivity is a temporal-ontological process by which what Walter Benjamin called the 'afterlife' (*Nachleben*) of a work comes to determine what it *is*, and hence also what it *was*, although, paradoxically, it could not be that in its own time.) The retroactive constitution of critical categories dictates that the term 'Moscow Conceptualism' means something more now than it did when it was first coined in 1979. In particular, the meaning of 'Moscow Conceptualism' has become overdetermined by what we might call a Kabakov effect.[11] For it is Ilya Kabakov's role in the development of the installation form in the West, from the mid-1980s through to the end of the 1990s, that retrospectively overdetermines the meaning of 'Moscow Conceptualism' as a privileged moment in the transition from 'conceptual art' to 'contemporary art', and hence as a *signifier of the conceptual character of contemporary art itself* – a character that is actually best grasped, I have argued elsewhere, by the idea of postconceptual art, or the postconceptual character of contemporary art as such. First, however, before we look at the structure and mediating function of the field of conceptualisms, it is necessary to reconnect what is perhaps the most enduring of the 1960s interpretations of conceptual art to its suppressed Soviet lineage.

Dematerialization: A Soviet Genealogy

As is well known, the term and the concept of conceptual art in its founding and still hegemonic Anglo-American sense (representing,

11 See the *October* magazine special issue on Duchamp, *The Duchamp Effect*, *October* 70, Fall 1994.

like 'minimal art', a small *set* of competing practices) can be traced back to 1967–9, in its distinction from Henry Flynt's earlier 'concept art' (which was a medium-based category), in the famous essays by Sol LeWitt ('Paragraphs on Conceptual Art', 1967), Lucy Lippard and David Chandler ('The Dematerialization of Art', 1967/8), 'Art and Language' (introduction to *Art-Language: The Journal of Conceptual Art*, May 1969) and Joseph Kosuth ('Art After Philosophy', 1969).[12] (Of course, some of the practices to which the idea refers clearly predate its formulation, going back to at least 1961 in the immediately pre-Fluxus conjuncture in New York, as well as much further back to early Duchamp.)

There are two things of significance to note about the early critical discourse of conceptual art in relation to the category of Moscow Conceptualism. The first is the *singularity and universality* of the claim made by the idea of conceptual art in its strongest 'analytical' forms. The second concerns an intriguing historical contingency in the background to one of its main, and most enduring, interpretations: the idea of dematerialization, through which conceptual art appears as part of the afterlife not of Duchamp, but of 1920s Soviet Constructivism.

The 'universality' of the idea of conceptual art derives from its claims for a redefinition of art as such, most famously in Kosuth's statement: 'All art (after Duchamp) is conceptual (in nature) because art only exists conceptually'.[13] Art and Language had a similarly strong programme. Of the critical founders, LeWitt alone was more constrained: he thought of conceptual art only as a particular kind of art, among others. These are critical philosophical claims. The most widely disseminated – and also immediately contested, by Art and Language for example[14] – has been what is now thought of as Lucy Lippard's 'dematerialization' thesis, although it first appeared in Lippard and Chandler's previously mentioned short article, written in late 1967 and published in the February 1968 issue of *Art International*. This essay provided the basis for the first subtitle of Lippard's famous

12 See Alberro and Stimson, *Conceptual Art: A Critical Anthology*, pp. 12–16, 46–50, 98–104 and 158–77, respectively.

13 Joseph Kosuth, 'Art After Philosophy', ibid., p. 164.

14 As excerpted in Lucy R. Lippard, *Six Years: The Dematerialization of the Art Object, 1966–1972* (1973), University of California Press, Berkeley, 1997, pp. 43–4.

1973 anthology, *Six Years: The dematerialization of the art object from 1966 to 1972: a cross-reference book of information on some esthetic boundaries: consisting of a bibliography into which are inserted a fragmented text, art works, documents, interviews, and symposia, arranged chronologically and focused on so-called conceptual or information or idea art with mentions of such vaguely designated areas as minimal, anti-form, systems, earth, or process art, occurring now in the Americas, Europe, England, Australia, and Asia (with occasional political overtones) edited and annotated by Lucy R. Lippard.* Surely one of the greatest book titles of all time.

The source of this notion of dematerialization, I would like to suggest, lies not merely in an intuitive sense of the process-based immateriality of the results of the art practices of the mid-1960s, and their relations to language and performance in particular, but much further back, to the Soviet avant-garde; specifically, to El Lissitzky's 1926 essay 'The Future of the Book', the English translation of which appeared in *New Left Review* in 1967 – a few months before Lippard and Chandler wrote their essay.[15] In Lissitzky's essay, dematerialization is associated not with language, concept or mental representation, but with *energy*.

The idea moving the masses today is called materialism, but dematerialisation is the characteristic of the epoch. For example, correspondence grows, so the number of letters, the quantity of writing paper, the mass of material consumed expands, until relieved by the telephone. Again, the network and material of supply grow until they are relieved by the radio. Matter diminishes, we dematerialise, sluggish masses of matter are replaced by liberated energy. This is the mark of our epoch.[16]

15 El Lissitzky, 'The Future of the Book', *New Left Review* 1(41), January/February 1967, pp. 39–44 first published in the *Gutenberg-Jahrbuch*, Mainz, 1926–7. I am grateful to Juan Rinaldi for pointing out this translation to me, in the course of his research on media art in Argentina in the 1960s, where the influence is explicit. See Juan Rinaldi, 'Art and Geopolitics: Politics and Autonomy in Argentine Contemporary Art', PhD thesis, Centre for Research in Modern European Philosophy (CRMEP), Kingston University, London, 2013.

16 Lissitzky, 'The Future of the Book', p. 40.

There follows a tabulated comparison of forms of transport with those of 'verbal traffic':

Interventions in the field of verbal traffic	Interventions in the field of general traffic
Articulated language	Upright gait
Writing	The wheel
Guttenberg's printing-press	Carts drawn by animal power
?	The automobile
?	The aeroplane

Blank topological spaces appear, already reserved for the computer and the digital. In the meantime, before the generalized replacement of the book by 'auto-vocalising and kino-vocalising representations', a new international graphic language was taken to be required: the international 'hieroglyphic book', as opposed to the national 'alphabetic book'. This universalism was thus radically 'non-national', in contrast to the 'language' of Art and Language, which was, of course, English, albeit standing in for a mooted philosophically ideal language of propositions. In this respect, we can say that in its founding manifestation, 'conceptual art' was indeed *Anglo*-American, even though many of its main practitioners were Japanese (Yoko Ono, On Kawara), European (Hanne Darboven, Bas Jan Ader) and South American (Hélio Oiticica).

The prioritization of energy over language as the means of 'dematerialization' considerably broadens the scope of 'conceptual art' (acted out in its extensive definition in Lippard's anthology) and prefigures the critical expansion of the notion in the course of the subsequent decades. With regard to Seth Siegelaub's famous photograph of New York conceptual art's 'gang of four', for example, it suggests the priority of Robert Barry and Douglas Huebler (on the left) over Kosuth and Lawrence Weiner (on the right) – an inversion of the way that history has usually been written (Fig. 12.1). It is interesting to place this rock-band-style photograph besides the famous image of the Collective Actions group used by Tupitsyn in the vestibule to the Russian pavilion at the Venice Biennale in 2015 (Fig. 12.2) to produce a dialectical image of the identity in difference of conceptual art in Moscow for today.

Fig. 12.1 Robert Barry, Douglas Huebler, Joseph Kosuth
and Lawrence Weiner, 1969

Fig. 12.2 Collective Actions, *The Russian World 1985*, performance documentation.
Annotation by Margarita Tupitsyn from the Russian Pavilion, 56th Venice Bienniale,
2015, indicating the four participants to have had solo exhibitions in the Russian
Pavilion in the post-Soviet period

However, rather than an immanent expansion of conceptual art as a critical category, what happened in most of the curatorial and critical literature from the end of the 1970s onwards (emblematically in Groys' 1979 essay), leading up to the 'Global Conceptualism'[17] exhibition at the Queens Museum of Art in New York in 1998, and beyond, was an increasing deployment of the more generalized '-ism' term, conceptual-*ism*, in a historically generalized manner, to cover a geopolitically expanded range of artistic contexts. Meanwhile, a mimetic and often jokey neo-conceptual art developed in the practices of a new generation of artists in the 1990s in the UK and the USA, for which the portmanteau term 'conceptualism' was also frequently used, further loosening the remaining critical purchase of the latter.

Conceptualism: Two Critical Strategies

The category of conceptualism is a part of the afterlife of Conceptual art from which the concept of conceptual art itself must nevertheless be critically distinguished. For the extended pluralization of practices inherent in the structure of the 'ism' presupposes the necessary failure of the strong analytical version of the conceptual programme. In contrast to the claimed universality and singularity of 'conceptual art', this pluralization is necessarily a relativization. The main form taken by the pluralization of conceptualisms was a multiplication of relatively independent national contexts: Moscow Conceptualism (standing in for 'Russian Conceptualism'), Latin American Conceptualism (more specifically, Argentinean and Uruguayan Conceptualisms[18]), Polish Conceptualism, Czech Conceptualism, Chinese Conceptualism, etc.

This raised two issues: first, the legitimate range of applicability of the label in even its most extended sense ('Is there such a thing as African

17 'Global Conceptualism' was an extraordinarily important exhibition for its idea, even though curatorially it was a highly restricted one because of the state of the generalized knowledge and availability of works at the time. See Camnitzer et al., *Global Conceptualism: Points of Origin, 1950s–1980s*.

18 Although, interestingly, not Brazilian conceptualism – historically, as a national category, within this particular moment in the literature – because of the specificity of the post-neo-concretist lineage, perhaps.

Conceptualism?', Okwui Enwezor asks in a well-known piece);[19] and second, the theoretical mode of its global totalization and purely geospatial unification, as projected in the 'Global Conceptualism' show. Responses to each issue have tended to be polarized. With regard to the applicability of the label, on the one hand, there is an export/import model of influence; 'Who was reading *Artforum* and *Studio International,* where, in the mid-to-late 1960s?' being the leading question. (More artists than you might think, in fact.) On the other hand, there is a model of independent multiple paths to broadly similar destinations. The former leads to a totalizing method of the aggregation/accumulation of new national contexts for the artistic elaboration of a single idea, while the latter tends towards a perspectival pluralization of universals, requiring that we view the whole history, in each instance, from the standpoint of a distinct geopolitical context, as Luis Camnitzer does in his book *Conceptualism in Latin American Art: Didactics of Liberation,* for example.[20]

So how do 'Moscow Conceptualism', and 'Moscow Romantic Conceptualism' in particular, fit into this history?

As we have seen, Groys's essay is distinctive in attempting an art-critical specification of the geopolitical label, via the term 'Romantic'. Despite the 'weight' claimed for the term 'Moscow', it is the 'Romantic' that carries the methodological burden of discrimination, with the term 'conceptualism' acting as little more than a silent, abstract ground enabling the comparison. However, if one digs deeper into the philosophical history of early German Romanticism, one finds arguments for the philosophically 'Romantic' status of conceptual art *tout court,* as the philosophically orientated practice of a *generic* (non-medium-based) conception of art. Or, to put it another way, if one rereads philosophical Romanticism genealogically, from the standpoint of contemporary art, what one finds, retroactively, is the anticipation of conceptual art.[21]

19 Okwui Enwezor, 'Is There Such a Thing as African Conceptualism?', in Salah Hassan and Olu Oguibe, eds, *Authentic/Ex-Centric: Conceptualism in Contemporary African Art,* Forum for African Arts, Ithaca NY, 2002, pp. 72–82.
20 See Camnitzer, *Conceptualism in Latin American Art: Didactics of Liberation.*
21 See Osborne, *Anywhere or Not At All,* ch. 2. Furthermore, with regard to the missing theorization of conceptualism as an 'ism' (as opposed to conceptual art), there is in this particular instance a more submerged philosophical logic, with an independent genealogy. This is the logic of conceptualism not as an art historical or art critical category but as a purely philosophical position: broadly, the theory that universals can be said to exist, but only as concepts in the mind. It is a modern version of scholastic

What is at stake here is the continuing priority of poetics over aesthetics. This is why Rancière is so very, very wrong in his insistence on what he calls the 'aesthetic regime'. This Romanticism was expressed negatively in now classical Anglo-American conceptual art in its campaign against the aesthetic institution of the spectatorship of 'the beholder', as theorized in particular by Charles Harrison of Art and Language.[22] It was expressed positively by more explicitly Romantic US conceptual artists like Robert Smithson and explicitly in conceptual art practices in Moscow, as theorized by Groys. Groys, we might say, stands to Kabakov and Collective Actions as Harrison stood to Art and Language: playing the double game of being simultaneously a native informant and international mediator. As Groys puts it, in a passage about Lev Rubinstein, life becomes lived as something to be 'read': in 'life as existence in the impossible space of literary language . . . things become signs in a poetic sequence'. It is this poetic sequence that ties conceptual art (*all* conceptual art), and the conceptual aspects of *all art*, to narrative and, in particular, to storytelling as an oral tradition.[23]

The Corridor of Two Banalities

In the alternative institution of the apartment as exhibition space in Moscow, 1982–4, everyday life was retold through the accumulation and restaging of its objects, so that the apartment itself quickly became not just the scene of the exhibition but part of the *narrative structure of the*

nominalism. If you look up 'conceptualism', even on Wikipedia today, for example, you will not find an art movement or an art critical category – all you will find is a description of this philosophical position. Belief in the conceptual character of art does not commit you to any philosophical position on the status of concepts. But it is allied to, and has affinities with, the more psychologistic and 'spiritual' philosophical self-understanding of some, rather than other, conceptual art practices – LeWitt as opposed to Kosuth, for example – and also the more scientistic versions of the mystical strand of Moscow Conceptualism (cosmicism), within which science and mysticism are in no way simple opposites.

22 Charles Harrison, 'Conceptual Art and the Suppression of the Beholder', *Essays on Art and Language*, Blackwell, Oxford, 1991, pp. 29–62.

23 Groys, 'Moscow Romantic Conceptualism', p. 42. See also Chapter 11 in this volume; and in the Russian context, Maria Chehonadskih, 'The Form of Art as Mediation, Before and After Conceptualism', in Elena Zaytseva, ed., *Cosmic Shift: Russian Contemporary Art Writing*, Zed Books, London, 2017, Ch. 10, pp. 131–46.

exhibited object itself. Such 'apartment art', or APT ART as it became known, was both the stage for the creation of characters, in which visitors such as Kabakov invested their productive subjectivity, and the site of a constructed world inhabited conjointly by APT ART artists and their works.[24] In its role as an enclosed fictional environment in which artists acted out various personae, the Moscow apartment was the mediating form of the transition to installation art as a dominant genre of contemporary art immanent to 'Moscow Conceptualism'. Works by Kabakov emblematic of this transition include *The Man Who Flew Into Space from His Apartment* (1985, first shown in New York in 1988) and *The Man Who Never Threw Anything Away (The Garbage Man*, 1988, permanently installed in the old Norwegian national bank building in Oslo that forms part of the National Museum of Art, Architecture and Design).

Garbage was a central theme in Kabakov's *rota* paintings of the early 1980s, such as *Carrying Out the Slop Pail* (1980). *The Man Who Flew* and *The Man Who Never* are transitional works between Kabakov the Moscow Conceptualist and Kabakov the international installation artist of the 1990s, a trajectory that has led up to such vast works as the 2014 Monumenta installation in the Grand Palais in Paris, within which a series of separate rooms/buildings were constructed to produce a multiplicity of installation spaces.

Most critically interesting, perhaps, this transition also involved an explicit mediation of Kabakov's work with the canonical New York conceptual art of the late 1960s, in the form of *The Corridor of Two Banalities* (1994), a joint work/installation with Kosuth at the Centre for Contemporary Art at Ujazdowski Castle in Warsaw (figs 12.3 and 12.4).[25] This exhibition staged the dialectical identity and difference between 'New York' and 'Moscow' in the afterlife of a certain conceptual art as installation art. It is precisely here, after 1989, that those 'local issues' to which Tupitsyn refers are 'channelled into' in a new international (soon to become globally transnational) art language. The work is made up of texts (and in Kabakov's case, a few postcard images): fictional texts of the agendas and minutes of the meetings of residents of collective apartments, on

24 See Ilya Kabakov, 'Artist-Character' (1985) in Margarita Tupitsyn, Victor Tupitsyn and David Morris, eds, *Anti-Shows: APT ART 1982–84*, Afterall Books, London, 2017.

25 *The Corridor of Two Banalities* (25 April–3 September 1994) was curated by Milada Slizinska.

the Moscow side (Fig. 12.5), and of quotations from famous figures that approach the status of Jenny Holzer-type 'truisms', on the New York one – the vacuous rhetoric of a certain international politics: 'What people want in the world is not ideology; they want goods and services' (Andrew Young, US ambassador), for example, juxtaposed, in a manner whereby also rendered equivalent, with Leon Trotsky's 'The leaden rump of bureaucracy outweighed the head of the revolution.'[26]

Fig. 12.3 Ilya Kabakov, Concept drawing for
The Corridor of Two Banalities, not dated,
watercolor, colored pencil and lead pencil,
40.4 x 2.6 cm, signed on the back

26 The model within Kosuth's own work for this practice (taking up a well-known trope of Walter Benjamin's) is his 1968 'Editorial in 27 Parts', published in the first issue of the New York School of Visual Arts' journal *Straight*, which Kosuth himself edited. The most recent and largest enactment of the Benjaminian literary fantasy of a book composed wholly of quotations is Kenneth Goldsmith's enormous *Capital: New York, Capital of the 20th Century*, Verso, London and New York, 2015.

Fig. 12.4 Ilya Kabakov in the installation of *The Corridor of Two Banalities*, Centre for Contemporary Art, Ujazdowski Castle, Warsaw, 1994

These are two geopolitically very different kinds of banality, dialectically identified here in the mutuality of their banality as such. Kabakov uses the textual banalities of the Soviet everyday to assert his place in an international lineage of text-based works; Kosuth seeks for his proto-Pop conceptual typography the critical redemption provided by historical meaning.[27] Here, the specificity of 'Moscow Conceptualism' ('the artistic expression of everyday life under Soviet communism' – the Constructivists would have said: 'The material expression of communist structures!') is at once communicated and internally negated by a generic art format, of which it was partially constitutive, but which now wholly overdetermines its artistic effect – in the transition from Moscow conceptual art to a proto-global contemporary art. Under these conditions, rather than being a carrier of Soviet history, the fictionalization of the Soviet erases the hinge between history and fiction, leaving history engulfed by fiction; or, to put it another way, leaving Soviet history engulfed by Western art. 'Moscow', shed of its weight, is no match for the Western term 'contemporary art'. This is the Kabakov effect.

27 Kosuth was at this time reinventing himself as a Hungarian-American artist, the US-identity-politics route to historical meaning.

Complaint

I request that you investigate my complaint thoroughly. I reside
in the apartment along with cit. E. K. Selezneva who systemati-
cally terrorizes me and doesn't allow me to relax in peace. In
her presence I cannot enter the kitchen, while I am cooking din-
ner she shakes out her things and dust flies into my food, fur-
thermore, she systematically causes scandals, insulting me, call-
ing me whatever enters her head. . . even that I am a thief and
steal from everyone. She screamed at the top of her voice that I
had supposedly stolen from cit. K. A. Nesterova who comes to
visit me but who lives on Warsaw Highway, building 135, apt. 16.
I request that in investigating my complaint, you summon cit.
Nesterova.
Cit. Seleznova herself has repeatedly argued with the other res-
idents as well and she has been investigated by the House
Management in connection with a complaint filed by cit.
Makhtakova, who she even fought with......

<div align="right">Voevodina</div>

...... We have reached the conclusion that: from this day for-
ward we will live peacefully, and will be mutually polite to one
another

<div align="right">Dudina
Nazarova</div>

Complaint

I request that you investigate my complaint of the following. I
Peter Alekseevich Kozhanov have not lived with my wife Zinaida
Matveevna Kozhanova since 1960 she has a child for whom I pay
alimony, at the present time she is registered in the same room
with me but she doesn't reside here but her things are in the
room and she takes up the floor with her things she doesn't pay
for the apartment she doesn't clean the room which is in anti-
sanitary conditions and demands immediate repairs in response to
my repeated demand that we do the repairs jointly and after that
we can exhange apartments she refuses categorically and this is
why I request the House Committee to render its decision in the
above complaint on the transferring of this matter to the
People's Court.

<div align="right">Kozhanov</div>

I/ Investigation of the complaint by com. Alexandrov who stated
that vodka was being drunk in the Red Corner when I started to
object I got only insults from them I as a member of the House
Committee was insulted and offended

Order

We the undersigned members of the House Committee coms. Vbrodov,
Yashin, Soloviev have verified cit. Kuznetsova's complaint that
com. Ser. Iv. Davydov is violating the common use rules he has
blocked literally the entire corridor with his things the bath-
room is in a very dirty state cit. Davydova washes kitchen uten-
sils, plates, forks, spoons, and whatever comes into her head
she puts a hose on the faucet and starts to work
The Committee confirms that the above is confirmed the corridor
is literally jammed there is a wardrobe, trunk, the corners are
cluttered a bicycle hangs on the wall there are crates with
pigeons hanging up the attic is completely cluttered unaccept-
ably The Committe asks the House Committe to review this matter.

signatures

Petition

We request the House Committee to review our complaint concern-
ing the repairs of the apartments. Major repairs are being done
on the fifth floors, it is indicated in the estimate that the
ceilings will be finished with wet plaster. Two rooms in apart-
ments 9 and 10 have already been done that way and a third is to
be finished. Shiryaeva's room was whitewashed with dry plaster,
since the repairs were dragging on, and they are going to do all
the floors in dry plaster. That room is still just a test room,
but if a committee of residents, the building manager and the
chief engineer all accept it, then it will be left that way.
Whether or not the committee accepts it, we are categorically
opposed to dry plaster. No matter how many times it was
repaired, there has always been a leak in our apartment, and the
Norenkovs' room is always damp, it is even leaking now. And the
roof has already been coated. We request the House Committe to
help us. Residents of other apartments are also against dry
plaster and they will also not refuse to sign our petition.

signatures

Fig. 12.5 Ilya Kabakov, text detail, from Ilya Kabakov and Joseph Kosuth, *The Corridor of Two
Banalities*, 1994, Centre for Contemporary Art, Ujazdowski Castle, Warsaw

13

The Terminology is in Crisis:
Postconceptual Art and New Music

What light does the idea of contemporary art as a generic and postconceptual art throw on the current musical situation, and the situation of New Music (*neue Musik*), in its historically established institutionalized sense in particular? I ask this question as an outsider to the musical field, as an act of problematization: a problematization of the concept of music by transformations in the concept of art – transformations to which, of course, music itself has contributed, significantly, since at least the mid-1950s. What is at stake, then, is as much a reclamation of the ongoing critical meaning of a particular musical history (John Cage, George Brecht and La Monte Young would be the emblematic names in the US context) – namely, its *own* problematization of 'music' in the direction of a collectively singular 'art' – as it is any current, externally driven transformations of the musical field by its positioning in relation to, or its prospective absorption within, 'contemporary art', critically or institutionally (and there remains a significant disjunction between those two domains); although one gets little sense of that from the historical self-consciousness exhibited by New Music's own institutional self-projections. What is primarily at stake, in fact, is the relations between the two movements.

The International Music Institute Darmstadt (IMD), with its famous Summer Course for New Music, which has positioned itself as the centre of New Music in Europe since its inception in 1946, continues to be representative of the field. That the theme of its seventieth-anniversary,

forty-eighth Summer Course (2016) should have been 'Music in the Expanded Field' (an allusion to Rosalind Krauss's 1979 essay 'Sculpture in the Expanded Field') is symptomatic of a contradictory double relation to the history of contemporary art: of identification and historical delay. Krauss's essay attempted to sum up the common, structural significance of a diverse body of work produced since the mid-1960s. However, 'Music in the Expanded Field' was not construed as a historical reflection, but as 'a motto for new and commissioned works'.[1] Even the moderate expansion of the 'field', while retaining a thereby transformed medium-specificity, proposed by Krauss in 1979 – prior to the critical theorization by others of a more radical, fully fledged 'generic' conception of contemporary art – appears here as an aspiration within the present, within the New Musical field. Despite the formative role in the construction of a generic concept of art played by Cage, Brecht and Young in the late 1950s, and the lingering if muted avant-garde aspirations of its own musical tradition, the institutional self-consciousness of New Music remains rigidly medium-specific. From its standpoint:

> theses on the postconceptual condition of art and the generic concept of art . . . seem odd when looked at from the perspective of music . . . Music (and others arts) are left out of this generic concept, which leads to the peculiar situation of a generic concept that has specific concepts next to it, with music stubbornly clinging to its medium in an age where this kind of *attachment* should be obsolete. It is not in a postconceptual state at all.[2]

But is music really 'left out'? Is it really 'not in a postconceptual state at all'? Or does this only appear to be so from the standpoint of an institutional self-consciousness which would define music in a medium-specific manner in such a way as to foreclose questions about the ontology of musical practices that insist on their relations to other practices that open on to the question of the ontology of 'art' as such? What, if any,

1 Rosalind Krauss, 'Sculpture in the Expanded Field', *October* 8, 1979, reprinted in *The Originality of the Avant-Garde and Other Modernist Myths*, MIT Press, Cambridge MA and London, 1985, pp. 276–90; Darmstad summer course statement, available at internationales-musikinstitut.de/en, accessed 5 January 2017.
2 Christian Grüny, 2 June 2015, letter of invitation to the 2016 Musical Interventions Conference, *Wirklichkeiten/Realities*, Academy of Music and Performing Arts, Stuttgart.

is the critical difference between sound art and various recent forms of New Music in non-musical, art-institutional spaces, for example? These questions throw doubt upon the continuing validity of the critical self-understanding of 'new musical' institutions. And they are by no means recent ones. It is over sixty years since Adorno raised the critical problem of 'The Aging of the New Music' (1955, a mere decade into IMD's existence) and fifty years since he began to probe the now well-worn problem of 'Art and the Arts' ('*Die Kunst und die Künste*', 1966/7), in a lecture of that name.[3] Yet, conversely, how are we to understand the results of a critical standpoint (that of a generic postconceptual art) that is so at odds with the institutional self-consciousness of its object, when institutional relations are themselves in part constitutive of 'what art is'?

Method

This chapter sketches a historical-philosophical narrative that starts out from the 'art and the arts' debates of the 1960s (and Adorno's position within them in particular) and ends with the idea of contemporary art as a generic and postconceptual art. This involves the claim not only that the generic idea of art historically constituted in practice since the 1960s, and critically consolidated as 'contemporary art' over the last twenty years, is in a certain sense 'postconceptual' in character, but that all of the practices associated with or derived from the arts, as historically received in modern systems of the arts (hence, also 'music'), find their *artistic* (and hence social) meanings today in relation to such an idea. Which may, of course, mean via a refusal, or some kind of passive negation, of that idea, since dialectically speaking that would still make the idea constitutive of the critical meaning of those practices, were one to accept its critical-historical predominance within the present.

Adorno is my starting point here, not only because he was my own theoretical starting point, thirty years ago, at the beginnings of what has become the general argument I reprise here; and not only because

3 Theodor W. Adorno, 'The Aging of the New Music' (1955), in *Essays on Music*, University of California Press, Berkeley, Los Angeles and London, 2002, pp. 181–202; 'Art and the Arts' (1966; published 1967), trans. Rodney Livingstone, in R. Tiedemann, ed., *Can One Live After Auschwitz? A Philosophical Reader*, pp. 368–87.

Adorno's is, in a certain sense, *the* philosophy of art of the twentieth century (for non-Heideggerians, at least); but also because the philosophy of art of *Aesthetic Theory* – the philosophical self-consciousness of the immanent crisis of modernist art as a historico-philosophical form – is to a great extent a generalization of Adorno's philosophy of music. This is a generalization mediated by the history of modernist literature, with minor references only to the now so-called 'visual' arts of painting, sculpture and architecture, as Adorno conventionally lists them in his lecture/essay, quite ignoring the existence of photography and film, despite their by-then-considerable histories and profound affects upon the other 'arts'. The critical extension and transformation of Adorno's argument via its engagement with the history of the so-called visual arts since the mid-1960s, which I have tried to construct elsewhere, is thus in certain respects already conditioned by Adorno's philosophy of music, from which many of his most basic general categories derive: his historical understanding of the concepts of 'artistic materials' and 'technique' in particular – which go back to his writings on music from the 1920s – and his understanding of the dialectics of mimesis and rationality (expression and construction), which is grounded in his reception of Weber's sociology of music, which became increasingly important to him once again in the post-serialist situation of the 1960s.

I conclude with some tentative remarks about the significance of all this for the concept of music as art and Adorno's inconsistency – and surprising lack of radicality – in following through the direction of his own argument.

First, though, it should emphasized that, methodologically, what is at stake here is the construction of a concept in the field of 'a historical philosophy of art' – indeed, a (re)construction of that field itself – since this is what the concept of art at stake must do. This is a concept that must function critically (this is part of its philosophical function) and not merely descriptively in relation to the totality of individual works competing for recognition as historical actualities (*Wirklichkeiten*). One of the main things at stake here is thus the determination of what constitutes historical actuality (*Wirklichkeit*) today, artistically, as opposed to mere reality (*Realität*) or existence (*Existenz*) – to borrow a crucial terminological distinction from Hegel. (In this respect, the *Wirklichkeiten* of the Stuttgart conference should be rendered as 'actualities', rather than 'realities', as it appears in the English version.) For Hegel, historical

actualities are *actualizations* of historical processes of social reason (forms of 'spirit'/*Geist*), which, as part of the real, share the 'reality' of the empirically real in general, but possess a historical intelligibility and significance lacking in the 'merely' existent.[4] The problem of post-Hegelianism, one might say, is how philosophically to register the existential significance of reality (*Realität*), in its contingency and lack of intelligibility, without entirely dissolving this distinction. Or to put it another way: how to maintain a conception of effective historical intelligibility that is of both critical and experiential significance without foreclosing the contingency of the future.

If this all sounds too orthodoxly Hegelian for twenty-first-century ears, it may be pointed out that the phrase, 'a historical philosophy of art' (*eine historische Philosophie der Kunst*) originates not in Hegel himself but in Friedrich Schlegel's 1798 review of Goethe's *Meister*. Indeed, it may be understood to sum up one side of the early Romantic philosophical project, from Friedrich Schlegel's *On the Study of Greek Poetry* (1795/7) onwards – a project that, in both its *historical* and *metaphysical* dimensions, is opposed to Kant's subjection of 'the arts' to the results of a transcendental analysis of the power of judgement, which effectively gave birth to that most confused of unifications of the field of the arts, commonly called 'aesthetics'. Schlegel's early project both anticipates and may retrospectively be seen to function as an anticipatory *critique* of Hegel's historical ontology of art – in the collective singular, a term that begins to be used in this manner at around the same time as that other great collective singularity, history (*Geschichte*). One of the things at stake here is thus the viability, under current (conjointly, artistically post-1960s and geopolitically post-1989) conditions, of a *proto-Romantic but post-Hegelian historical ontology of art*.

In its beginnings in early German Romanticism, the generic concept of art had a certain ambiguous relationship to philosophy: namely, a certain metaphysical universalization of what we would now call *literature* (poetry and the novel: the novel as universal poetry, in particular). But it has its *actuality* today in what is called 'contemporary art' – 'contemporary art' in its critical and theoretical sense, that is, as the designation for a selective but nonetheless radically diverse totality of

4 This is a terminological distinction that is paradigmatically displayed in Hegel's *Philosophy of Right*, but adhered to only occasionally elsewhere.

practices that are both; first, historically 'post-medium' (in the ontological sense that its mediums are not the *fundamental* basis of its meanings, because they are not the fundamental basis of its being); and, second, addressed in some way or other to the contemporaneities of the present (the 'lived' conjunctions and disjunctions between the times of different lives).

Such an art is often referred to as 'visual art' (again in the singular), or as embracing the totality of the 'visual arts' (plural); by which is meant an art that is practiced within the terms of the institutions devoted to what *used to be* the 'beautiful' or 'fine' arts (*beaux artes, schöne Künste*) – even though its visuality (or even on occasion its visibility) ceased to be its defining characteristic some time *before* the label 'visual art' became popularized. And the label was popularized, of course, not simply in order to institutionalize a certain late modernist, formalist stress on the visual/optical in the very wake of the historical passing of that framework as an effective medium for art practices (a kind of retrospective institutional revenge of the aesthetic, or at least, a comic delay), but primarily in order to include the popular arts of graphics, illustration, animation, video and, more recently, digital imaging of various kinds alongside the so-called beautiful arts of painting and sculpture. The visuality of all of these practices by no means exhausts their artistic significance – they may be temporal as well as spatial, sonic as well as silent, conceptual as well as aesthetic, poetic as well as iconographic – but they nonetheless coexist as gathered together under the generic term 'art' by a set of institutions (educational, curatorial and exhibitory) that have developed out of the institutions of 'fine' and 'applied' arts, *as distinct from* those of both 'literature' (the modern term for the totality of genres of writing that emerged in the wake of, and mirrors the 'infinite becoming' of, the novel) and music. However, this generic art, the art of 'contemporary art', only excludes literature '*qua* literature' in the latter's residual critically principled difference from 'art' (as the recent episode of conceptual writing, and artists' current fascination with writing, reveals), just as it only excludes music '*qua* music' in the same respect. In terms of the extension of the term 'art' within its own discourse, it *includes* it, in a critically recoded manner. More interestingly, the question arises: What is music *qua* art that is not music *qua* music? I hope we will be able to agree that this is neither an empty set nor an insignificant one.

In this dual post-Hegelian and post-1960s context (that is, after the various existential and materialist critiques of Hegel – which is to say, after the critique of the self-sufficiency of philosophy disciplinary as inherently idealist – and after the artistic transformations of the late 1950s and 1960s), the methodological problem of *constructing a concept in the field of 'a historical philosophy of art'* appears as part of the broader project of the transdisciplinary construction of general concepts; concepts which only subsequently (that is, as 'results' – another term with heavily Hegelian overtones) come to function as *quasi*-philosophical forms of universality. Such construction is at once 'transversal', in presenting conceptual relations across different fields of inquiry on a single plane, and 'vertical' in its subjection of the discourse of ontology to the distributive effects of a processual historical temporality.

In the first case, to 'construct' a concept transdisciplinarily is thus to 'work' that concept, in the sense of 'working a concept' to be found in the philosophical structuralism of Georges Canguilhem's famous methodological imperative, reprinted on the inside cover of all nine issues of the French journal *Cahiers pour l'analyse* (1966–9):

> to work a concept is to vary its extension and comprehension, to general-
> ize it through the incorporation of exceptional traits, to export it beyond
> its region of origin, to take it as a model or on the contrary to seek a
> model for it – to work a concept, in short, is progressively to confer upon
> it, through regulated transformations, the function of a form.[5]

This is the task set by the concept 'art' in the generic collective singular.

The second aspect is perhaps best summed up in one of the more explicitly methodological passages in Adorno's *Aesthetic Theory*, from its second paragraph (editorially entitled 'Against the Question of Origin' [*Gegen Ursprungsfrage*]), to which reference has already been made in two other essays in this book:

> The definition of art is at every point indicated by what art once was,
> but it is legitimated only by what art became with regard to what it

5 Georges Canguilhem, 'Dialectique et philosophie du non chez Gaston Bachelard', *Revue Internationale de Philosophie* 66, 1963, p. 452; extracted quotation as translated in Peter Hallward and Knox Peden, eds, *Concept and Form. Volume 1*, p. 70.

wants to be, and perhaps can, become . . . Because art is what it has become, its concept refers to what it does not contain . . . *Art can be understood only by its laws of movement*, not according to any set of invariants. It is defined by its relation to what it is not . . . Art acquires its specificity by separating itself from what it developed out of; *its law of movement is its law of form.*[6]

We need to conjoin these two – transversal and temporal – standpoints to construct the relations between the concepts of 'art' and 'music'. For the notion of construction shows that there is far less distance between post-Hegelian philosophy and French philosophical structuralism than is generally believed.

Adorno's Problematic

Adorno essay 'Art and the Arts' is emblematic of the suspended, transitional character of his historical ontology of art in the mid-1960s, corresponding to that transitional moment in the history of art ('crisis of the modern') with which it was concerned. This position is pushed closer to the point of dialectical clarification in *Aesthetic Theory* itself, where the contradictory structure of the situation is presented both more sharply, through its extremes, and in more conceptual detail. Yet it remains there, philosophically, characteristically aporetic and (for us, today) perceptibly restricted by the moment of its composition. The main difference between the two texts is that whereas in 'Art and the Arts' Adorno claimed that 'art exists only in the arts, whose discontinuous relation to one another is laid down by reality beyond the world of art' – *despite* the increasing 'erosion of the lines of demarcation' between the different arts, with which the essay is primarily concerned;[7] in *Aesthetic Theory* it is the increasing individuation of individual works of modern art that comes to the fore, raising the prospect of a *nominalistic dissolution of the arts into the totality of individual works.* These two tendencies

6 Adorno, *Aesthetic Theory*, pp. 2–3, emphases added; *Ästhetische Theorie*, pp. 11–12. Cf. Chapter 1, note 38 and Chapter 11, note 5, above.

7 Adorno, 'Art and the Arts', pp. 383, 368; Theodor W. Adorno, '*Die Kunst und die Künste*', *Gesammelte Schriften* 10: 1, Suhrkamp, Frankfurt am Main, 1977, pp. 448, 432.

of the erosion of the borders between the arts and a growing nominal-
ism across each of the arts reinforce one another, but have rather differ-
ent bases. The erosion of the boundaries of the arts is taken to derive
from motives 'intrinsic' to those arts themselves (in particular the search
for new materials), taking the form of borrowings and mixing. Adorno
notes the effect of the graphic arts on musical notation, for example, and
of musical serialism on literature. 'Whatever tears down the boundary
markers is motivated by historical forces that sprang into life inside the
existing boundaries', Adorno writes, 'and then ended up overwhelming
them,'[8] while nominalism has a deeper historical basis in bourgeois
culture as the artistic refraction of its concept of individual freedom.

With regard to the individual arts, Adorno argued in 'Art and the
Arts', the erosion of borders led them to 'aspire to their concrete gener-
alizations, to an idea of art as such'. This is explained with reference to
the principle of coherence (*Zusammenhang*), characteristically via
Schoenberg, and its increasing independence from the traditional mate-
rials of the particular arts. 'The more the coherence creating methods of
the individual arts spread their tentacles over the traditional stock of
forms and become formalized, as it were, the more the different arts are
subjected to a principle of uniformity'. Adorno here thus comes to asso-
ciate the idea of art as such with a uniformity, which must be countered
within individual works by the extra-artistic elements of heterogeneity
in their materials: 'the extra-musical meaning without which music
cannot exist', for example. 'This introduces an element of irreducible
qualitative plurality', Adorno writes, since although such materials must
be subjectively mediated to produce artistic meaning, they must also
ultimately resist such mediation if they are to maintain their objectivity.
'Art' and 'the arts' are thus seen to enter into an irresolvable 'conflict',
which is, once again characteristically, expressed by Adorno in the form
of a 'neither/nor' – the basic grammatical form of a negative dialectic.
'Art can be distilled neither into the pure multiplicity of the different arts
nor into a pure unity'. Nor do the (now 'so-called') arts 'form a contin-
uum that would allow us to provide the entire complex of phenomena
with a single unifying label'. Rather, art 'can carry out its movement
toward unity simply and *solely by passing through multiplicity*'. A multi-
plicity that is figured as that of a 'constellation of art and the arts'

8 Ibid., p. 370; *GS* 10: 1, p. 434

dwelling 'within art itself'. The concept of art is thus judged to be essentially negative, to reside in the negativity of the relations not just between the arts (which are, after all, dissolving into one another) but more importantly between both each of those arts and their totality, on the one side, and 'the idea of art as such', on the other.[9]

This is a picture that is overdetermined by the general structure of negative dialectics in a manner that fails to grasp some of the more concrete aspects of the historical tendencies to which Adorno is reacting. In particular, the continuing conceptual necessity of the mediation of 'art as such' by 'the arts' (as conventionally received) is overplayed, while both the radical nominalism of avant-garde art – eroding all structurally mediating categories – and the emergence of new kinds of mediating categories are underplayed. *Aesthetic Theory* goes some way to making good these omissions – in particular, in its discussion of the 'preponderance of art' over the individual artwork (jumping over the mediating role of any particular art) and of the mediating role of isms. However, it continues to equivocate regarding, on the one hand, the necessity of 'arts' as 'mediums' providing the ontological basis of the art-character of individual works and, on the other, the dissolution of all 'authoritative' mediations by medium or genre.

There are two main issues here: (1) the lack of theorization of the *logical form* of the ongoing disintegration of the objectivity of mediating categories and the movement of reunification of individual works, internal to the category of 'art', and in relation to the speculative idea of 'art as such'; and (2) the peculiar failure to acknowledge the growing conceptuality of the artistic practices he describes. They are related insofar as they both derive from a reductively Kantian conception of concepts as forms of subsumption. In the first case, Adorno has no concept of 'distributive', as opposed to 'collective', unity as a logical form – to use Kant's own term, taken up and transformed by Deleuze in an explicitly nominalistic fashion, as the unity of the process of production of a totality of individuals.[10] Here (albeit not in Deleuze), there is a historical process governed by the logic of retrospective intelligibility, as set out in

9 Ibid., pp. 373, 374, 377, 375, 382, 383; *GS* 10: 1, pp. 438, 439, 441, 440, 447, 448.
10 Immanuel Kant, *Critique of Pure Reason*, A644/B672; Gilles Deleuze, *Difference and Repetition* (1968), trans. Paul Patton, Minnesota University Press, Minneapolis, 1994, ch. 2.

my opening quotation from Adorno. In the second instance, his thought remains plagued by the abstract Kantian opposition of conceptuality to sensation (as given matter of intuition), logic to aesthetic, which is mediated only by an equally Kantian aesthetic of form, or *reduction of form to an aesthetic of reflective judgement*. Such is the ambiguous double-coding passed down by Kant to 'aesthetics' (the combination of its distinct senses in the first and third *Critiques*, respectively), which made it such a powerfully Janus-faced resource.

Adorno is enough of a Hegelian to be aware of the dangers of thinking the unity of art as a generalized aesthetic, always insisting on the historical state of artistic materials as being constitutive of the art-status and character of works. But he restricts the conceptual content of the increasingly logical or rational structure of artistic production to interpretative discourse, denying it to practices themselves; presumably because he considers it *too much* of a negation of the aesthetics of form. Yet both the rational structure of construction and the relational character of meaning (figured by Adorno always as a multiplicity of negations) exhibit a conceptuality internal to the structure of experience of *all* modern art.

It is here that a consideration of the historical role played by conceptual art within the so-called 'visual' arts contains lessons of a general significance for all 'art', art music included.

Contemporary Art Is a Generic and Postconceptual Art

Let us briefly take each of the components of this proposition in turn: the generic, the postconceptual and the contemporary.

The generic

As has already been expounded in Adorno's account of 'art', the generic concept of art in the collective singular is constituted by a double determination. It is determined (1) historically and negative-dialectically, as the ongoing retrospective totalization, from the standpoint of the present ('the latest art'), of the multiplicity of individual works making up the system of negations of previous works which *is* the history of art: negations of the ontological significance of (especially, conventionally

received) mediums standing to the fore within this multiplicity, since the mid-to-late 1950s. It is determined (2) by the speculative 'idea of art as such' – in its opposition to empirical reality – as the regulative conceptual unity of the aforementioned permanently ongoing process of retrospective unification; a process that is governed by 'laws of movement', rather than a simple selective aggregation, the laws of movement of a *multiple collective singularity*.

What stops this generic 'art' from functioning as a bad abstraction is an emphasis on its collective, internally differentiated, relational and concretely historical characteristics. This unity is 'not abstract', because as Adorno put it, it 'presupposes concrete analyses, not as proofs and examples but as its own condition'.[11] In this respect, the *idea* of art is given through each work, but no individual work is adequate to this idea, however 'preponderant' that idea may have become over individual works themselves. The ongoing retrospective and reflective totalization of distributive unity is necessarily open, fractured, incomplete and therefore inherently speculative. It must include the afterlife of mediums within a post-medium condition.

It is the conceptual component of this process that determines the character of such art as (paradoxically) 'postconceptual', by which is meant: *necessarily but not exclusively conceptual*. This usage of the 'post' marks a difference from the project of the self-nominated 'conceptual art' of the mid-1960s to become *absolutely* anti-aesthetic.

Postconceptual art, postconceptual music

The aspiration to an absolutization of the negation of the aesthetic was the main respect in which Conceptual art – in the various 'strong' or analytical, heroic self-understandings through which it was constituted, critically, as a 'movement' – was subsequently seen to have 'failed', and failed *necessarily*, since for all its experimental artistic productivity, the absolutization of anti-aesthetic was philosophically incoherent as an artistic project. Aesthetic refuses to remain 'indifferent' in art spaces; 'pictorialism' (as Charles Harrison would have it) was inevitable, in one form or another. The aesthetic as such could not be annihilated, or absolutely removed from art, but rather had to be increasingly strategically

11 Adorno, *Aesthetic Theory*, p. 263; *GS* 7, p. 392.

incorporated or 'contained' through the ongoing negation of various of its specific modes and the instrumental refunctioning of others. Hence the need for the awkward and confusing term 'postconceptual' to designate an art that reflectively incorporates relations between its equally necessary conceptual and aesthetic aspects into its internal structures. The term is awkward, because the banality and formal emptiness of the 'post-' fails in itself adequately to convey the complicated, temporally dialectical semantic content to which to refers. It is confusing because it appears to denote an art 'after' Conceptual art, while actually retrospectively *including* all of the canonical works of Conceptual art itself at the level of their artistic structure – against the hegemonic historical self-understandings through which the periodizing category of Conceptual art as a movement was constructed and, to a large extent, continues to be understood. That is to say, postconceptual art is a category of *historical ontology*, rather than of a merely empirical art-historical periodization, constructed at the level of movement, aesthetic form, or style. Such is the retroactive ontology of certain critical categories. The term remains necessary, though (despite being awkward and confusing), insofar as it registers the critique of the self-understanding of canonical Conceptual art (in however theoretical or practical a manner) as being constitutive of the historical position and ontological structure of such art. That is to say, the history of criticism retroactively overdetermines the history of art in such instances.

As I have argued elsewhere, the critical legacy of conceptual art consists in the combination of six main insights, which collectively make up the condition of possibility of a postconceptual art.[12] These are:

1. Art's necessary conceptuality. (Art is constituted by concepts, their relations and their instantiation in practices of discrimination: art/ non-art.)
2. Art's ineliminable – but radically insufficient – aesthetic dimension. (All art requires *some* form of materialization; that is to say, aesthetic (felt, spatio-temporal) presentation.)
3. The critical necessity of an anti-aesthetic*ist* use of aesthetic materials. (This is a critical consequence of art's necessary conceptuality.)

12 The list that follows is reproduced from Osborne, *Anywhere or Not At All*, p. 48.

4. An expansion to infinity of the possible material forms of art.
5. A radically distributive – that is, irreducibly relational – unity of the individual artwork across the totality of its multiple material instantiations, at any particular time.
6. A historical malleability of the borders of this unity.

The conjunction of the first two features leads to the third; together they imply the fourth; while the fifth and sixth are expressions of the logical and temporal consequences of the fourth, respectively.

We can see the same thing happening in music, I believe, to the extent to which, on Adorno's analysis, serialism and post-serialism are characterized by a dislocation of the relationship between compositional logic (= the conceptual) and what is heard (= the aesthetic aspect). I am thinking here in particular of Adorno's 1964 essay 'Difficulties. I. In Composing' (*Schwierigkeiten beim Komponieren*).[13] In this account, the objective developments in musical material have 'outrun' the subjective forces of production that are supposed to produce their aesthetic mediation. A gap opens up between compositional intelligibility and the experience of listening. 'Music' *is* this split across these two non-communicating components; and its social meaning resides in its enactment of the split itself. This allows for the two components to be developed separately. *Music thus stages its own postconceptual structure as the crisis and disintegration of the concept of music itself.*

This is not to say that, institutionally, music does not continue to be composed and performed according to its classical concept, of which New Music is in various respects the dialectical continuation. It is to say that the *artistic meaning* of those practices derives from their place within the continually developing concept of art, the generic and anti-medium character of which has become established in the domain of the 'formerly visual' or no-longer-very-visual arts and also in literature, especially through the respective extremes of the DVD/online streaming mini-series format, on the one hand, and the recoding of poetry as conceptual writing, on the other.

13 Theodor W. Adorno, 'Difficulties. I. In Composing', in *Essays on Music*, University of California Press, Berkeley, Los Angeles and London, 2002, pp. 644–60; *GS* 17, pp. 253–73.

The actuality of the contemporary

Returning to actualities/*Wirklichkeiten*: the main form in which actuality imposes itself on art today is as the new historical-temporal form of contemporaneity. 'Contemporaneity' is understand here as a category of the philosophy of history; more specifically, of the *philosophy of historical time*. A historical philosophy of art is a regional domain of the critical philosophy of history, a regional domain of the philosophy of historical time.

I have expounded this concept of the contemporary in a number of places.[14] Here, it may suffice to summarize three aspects: (1) it is a disjunctive conjunctive of coeval but differential temporal forms (not a 'shared time' but a coming together of socially and historically different times); (2) it is geopolitically global in its spatial scope; (3) it has a particular relevance for music insofar as music is an art of time, indeed a particularly 'pure' type of temporal art. As Adorno put it,

> the serial composers took as their starting point the thesis that because all musical phenomena, including pitch and tonal colour, are, in their acoustical regularity, ultimately temporal relations, they must all be able to be reduced, compositionally to a single common denominator – time.[15]

It arguing thus, Adorno returned music to its Hegelian philosophical definition, as an art of time, in its conceptually privileged difference from painting. And, for Hegel – and it is interesting that this fundamental philosophical proposition appears only in his *Lectures on the Philosophy of Art*: 'time is the being of the subject itself' ('*die Zeit ist das Seyn des Subjekts selber*').[16] Yet it is no longer possible to maintain Lessing's transcendental distinction between arts of time and space. All artworks are articulations of complicated spatio-temporal relations, of which the 'no-time' of the image is but one *temporal* aspect and variant, occurring always in *internal* relations to other temporalities. And as our

14 See for example, Chapters 1–3, above.

15 Adorno, 'Difficulties. I. In Composing', p. 656; *GS* 17, p. 268.

16 G.W.F. Hegel, *Aesthetics: Lectures on Fine Art, Volume 2*, trans. T.M. Knox, Clarendon Press, Oxford, 1975, p. 908. The sentence appears in the section entitled 'Effect of Music' in the chapter on music.

understanding of the fate of all of the 'arts' is temporalized, so the trans-formative extensions of their practices enter into new relations to the 'musical' as previously understood.

The question becomes: How can the global temporality of the actuality of the contemporary today be translated into music? How does it sound?

14

The Image is the Subject: Once More on the Temporalities of Image and Act

How to say something new about the place of stasis within the temporalities of image and act?[1] Something that is more than a mere repetition of the structure of novelty, which is itself the main cultural form of stasis in capitalist modernity: the *stasis of the new*. For to speak of stasis under the conditions of capitalist modernity is necessarily to speak of that 'ever-selfsame' that Benjamin detected as the structure of the new, the longing for which, Adorno argued, 'represses duration'.[2] Adorno famously described the new as the 'aesthetic seal of expanded reproduction' (*das ästhetische Signum der erweiternen Reproduktion*), using the latter phrase in the sense intended by Marx in *Capital*, with respect to capital as self-expanding value.[3] The *restless stasis* of the reproduction of the social relation of capital within expanded reproduction – philosophically prefigured by Hegel in the 'restlessness of the absolute concept's infinity', 'the real being of

1 This is a revised version of a paper presented at the conference, Aesthetics of Standstill: Stasis and Latency, Kunstakademie Düsseldorf, 28–30 January 2016.

2 Walter Benjamin, 'Central Park' (1939), in *Selected Writings, Volume 4: 1938–1940*, p. 175; Adorno, *Aesthetic Theory*, p. 27. It was Baudelaire's poetry, Benjamin argued, that revealed 'the new in the ever-selfsame, the ever-selfsame in the new'. As a result, 'now, there is only one radical novelty – and always the same one: death.' 'Central Park' , p. 171.

3 Adorno, *Aesthetic Theory*, p. 21; Marx, *Capital, Volume 1*, ch. 24, pt 1, p. 732 and *Volume 2*, ch.2, pt 2, pp. 158–62.

absolute subjectivity'[4] – lies at the heart of the problem of stasis. For theoretical forms and motifs – here, theoretical forms and motifs of *image* and *action* in which stasis plays a central role – are in no way exempt from the problems posed by the temporal structures that they theorize.

In the present context, with regard to stasis, it is the danger of the simple (but perhaps also the *merely* expanded) repetition of the Benjamin–Adorno nexus that is the greatest threat. The idea of an 'aesthetics of standstill' positions itself as a displaced repetition of Benjamin's famous motif of 'dialectics at a standstill'. More specifically, in Benjamin's proposition: 'image is dialectics at a standstill'.[5] To speak of an 'aesthetics of standstill' is thus to speak about the aesthetics of the image. However, this displacement of the standstill motif within the study of the image, from dialectical form to 'aesthetics', is a critical-historical *retreat* from the standpoints of philosophy and art alike. For it is a movement *away* from both the intelligibility and the historical character of art – the question of the *historical temporality of the dialectical form of the image* – back towards the *feelings* (today many would say 'affects') associated with experiences of standstill or stasis; a movement *away* from a concern with the experiential effects of the conceptual structure of an imagistic freezing of the movement of a particular, determinate set of historical relations (the relationship between a 'specific now' and a 'specific then', to use Benjamin's language); a movement *away* from that relationship coded by Benjamin as one of recognizability (*Erkennbarkeit*) and hence of conceptual form.

The synthesis of recognition, it is helpful to recall, is the third part of Kant's threefold synthesis, in the first edition of the *Critique of Pure Reason*, constituting pure concepts. In the famous temporal coding of the three parts by the early Heidegger, it appears as the synthesis of the *formation of the future*. For recognizability is the futural possibility of identifying sameness in cognition. This grounds its reproducability through memory, and hence it grounds the second synthesis, that of reproduction. *Recognition, pure concept* and *futurity* are bound together

4 G.W.F. Hegel, *System of Ethical Life*, in G.W.F. Hegel, *System of Ethical Life (1802/3) and First Philosophy of Spirit*, ed. and trans. H.S. Harris and T.M. Knox, SUNY Press, Albany NY, 1979, p. 134.

5 Benjamin, *The Arcades Project*, [N2a, 3], p. 462.

here in Heidegger's Kant interpretation, as they are also, within a differ-
ent structure, in Benjamin's dialectical image.[6] It is the conceptuality of
historical recognizability that makes contemporary art, with its self-
consciously conceptual dimension, a privileged vehicle of its experience
– rather than any kind of aesthetic art, or aesthetics of standstill, which
cannot grasp such conceptuality, in principle.

From this point of view, the movement back to aesthetics – to an
aesthetic appropriation of the image – appears as part of a broader
retreat from the historical-philosophical criticism of art and other
cultural forms; a retreat currently associated with an (at least rhetori-
cally) exclusive focus on force, sensation and affect to be found in certain
French philosophies of difference, Deleuze's in particular. This includes
a certain *aestheticization of theoretical terminology*, from which
Benjamin's own famously crystalline prose has not been exempt; a
certain aestheticization of theoretical terminology that is especially
prevalent within those currents of Deleuze*ism* flowing through the
artworld. This is the conventionally 'bad' side of reification, which
Benjaminians sometimes forget, to which Adorno referred in his 1965
Lectures on Negative Dialectic when he wrote of the

> tendency on the part of a reified consciousness to bring all the
> concepts of the world to a standstill simultaneously and to fetishize
> them, much as happens with the headlines in advertisements . . . [a]
> tendency [that] is all the more damaging as its universal prevalence
> prevents people from becoming properly aware of it.[7]

Certain oft-repeated citations of Benjamin, for example ('seizing hold of
a memory as it flashes up in a moment of danger'; 'there is no document
of civilization which is not at the same time . . . ') run the risk of becom-
ing advertisements for the position of tragic intellectuality, a leftism
marooned by history, instead of enactments of that latently dynamic,
action-generating stasis to which their imagistic form aspires. One thus
needs to ask: when is the stasis of reification just a commodified

6 Kant, *Critique of Pure Reason*, A98–111, pp. 228–34; Martin Heidegger, *Kant and
the Problem of Metaphysics*, trans. Richard Tuft, Indiana University Press, Bloomington
and Indianapolis, 1990, p. 127.

7 Adorno, *Lectures on Negative Dialectics*, trans. Rodney Livingstone, Polity Press,
Cambridge, 2008, p. 24.

negation of process and relation, and when is it a critical interruption of the already reified process a naturalizing historicism? There is a tendency – shared by Benjamin himself – to see these as clear alternatives, yet the integration of the formal strategies of critical art into advertising and the so-called 'creative industries', and the social sources of these forms themselves in specifically capitalistic forms of technological experience, can produce both an ambiguously contradictory coexistence and a certain indifference between them. This is especially so since the temporality of capitalism as an economic system can no longer be plausibly reduced to a simple combination of that of the commodity form (the stasis of the thing) and of capital as self-expanding value (the stasis of the new). There is a tendency – shared at times by Adornians – to think of standstill or stasis (especially in the work of art) as necessarily 'resistant', 'emancipatory' or 'utopian' – holding off the catastrophe of 'progress' – but this can no longer be straightforwardly maintained. Artistically, it derived from the formal dominance of photography within twentieth-century Western art (including film), technologically transcoding the theological structure of the icon. But the technological basis of that dominance has been fundamentally transformed over the last two decades, however vivid its *aesthetic* may remain within both our imaginations and some of the new artistic materials themselves.

Yet even the association of standstill or stasis with the 'bad' reification of the negation of temporal process in favour of the ontological fullness of the fixed position of a thing, carries hidden within it a certain critical position, lurking in the etymology that connects the ancient Greek word *stasis* to the concept of position itself. *Stasis*, we are told, initially referred to the simple 'posture of standing' (its core choreographic sense); then by extension to 'position, post or station'; and thereafter, extending metaphorically outwards, by virtue of the sense of *taking* a position – a position within a field of social conflict, a position that, in the particularity of its fixity, opposes itself to some status quo, to the meaning, finally, of 'a party formed for seditious purposes'.[8] On this basis, Agamben characteristically polemically *reduces* the Greek *stasis* to the single tendentious translation of 'civil war', in his short text,

8 Liddell and Scott, *Greek–English Lexicon*, 7th edition, Oxford University Press, Oxford, 1999, p. 742.

Stasis: Civil War as a Political Paradigm – extrapolating from Schmitt.[9] However, while reminding us that stasis has a semantic potentiality that is more than just latent, and possibly ever-present, this eliminates all complexity from the concept, along with its actual (non-etymological) historical content. In particular, in stressing the ancient etymological link of stasis to the space-time of the body, Agamben's move extracts the concept from the philosophical history of temporality since Kant. Yet it is on the basis of that history that so many of the claims for the radicality of standstill or stasis with regard to action are grounded – as temporal markers of a 'cut' with ontology in the classical sense; recovering theological structures of argumentation in post-transcendental and proto-materialist forms.

With his invention of the transcendental, Kant inadvertently gave an ontological priority to time over being and thereby transformed the meaning of ontology itself. This was a transformation that was further radicalized (in its non-Heideggerian forms) – and further problematized – by the pressure to render it consistent with a philosophical concept of history. On first sight, the shift within the focus on standstill from dialectics to aesthetics might be thought to sustain this modern philosophical coding of stasis, at the centre of the structure of relations between the faculties of the subject. Yet the connection of stasis to the image fractures – or at least mediates – such a transcendental aesthetic appropriation. For while the image carries with it an inevitable aesthetic charge, as a condition of being experienced, it nonetheless exceeds the domain of the aesthetic, in principle, because of its fundamental withdrawal of that which it presents from the domain of presentation itself. This is its inherent virtuality.[10] This is so even in Kant, in the *Third Critique*, if we understand the image to be 'those representations of the imagination' that are the means of actualization of the paradoxically named 'aesthetic ideas'. There, the image (like the power by which it is produced, transcendental imagination) is not itself aesthetic as such, strictly speaking, in the sense of the *First Critique*. Rather, architectonically, it is suspended midway between logic

9 Giorgio Agamben, *Stasis: Civil War as a Political Paradigm*, Homo Sacer, II, 2, Edinburgh University Press, Edinburgh, 2015. This is the text of a 2001 seminar at Princeton.
10 See chapters 8 and 10.

and aesthetic, as a *non-conceptual but more-than-sensible* form of synthesis, *through* which concepts may be rendered sensible, but *in* which they are not sensible (that is, spatio-temporally given) as such.[11] The virtuality of the image remains distinct from the infinite multiplicity of its possible manifestations or visualizations (and hence from its aesthetics) even in Kant's transcendental version – and much more so, categorially, in Benjamin's work, of course.

The attempt to shift the locus of 'standstill' from being a moment in the *dialectical structure of the experience of the historical recognizability of an image* – that is, to quote Benjamin, of 'the relation of what-has-been to the now' – into the field of a generalized 'aesthetics' is thus a *reversal* of the original Benjaminian philosophical meaning of the 'standstill' motif, insofar as dialectical images (and, Benjamin writes, '*only* dialectical images') are 'genuinely historical',[12] while aesthetics, in principle, is not. This is where Friedrich Schlegel's early, proto-Romantic 'historical philosophy of art', in whose wake Benjamin follows, breaks decisively with *any* Kantian aesthetic.[13]

Displacement of 'standstill' from a concern with the dialectical form of the historico-philosophical character of the image to its aesthetics cannot avoid either its re-transcendentalization or positivization, or more likely both, insofar as the transcendental always manifests itself as a part of what Foucault called a 'transcendental-empirical' doublet. Kant's 'aesthetic' may be temporal, but this does not make it historical. To court the danger of another Benjamin citation: 'while the relation of the present to the past is purely temporal, the relation of what-has-been to the now is dialectical; not temporal in nature but figural [*bildlich* – imagistic]'.[14]

Yet this '*not* temporal in nature' is only so in a very particular, polemical sense, of course, which associates temporality exclusively with temporal *continuity* – a linear conception of past–present–future – and hence, ultimately, with the famous 'empty homogeneous time' of

11 Immanuel Kant, *Critique of the Aesthetic Power of Judgment* (1790; 1793), trans. Paul Guyer and Eric Matthews, Cambridge University Press, Cambridge, 2000, 5: 314–6, pp. 192–5; *Critique of Pure Reason*, A140–43/B179–82, pp. 273–4.
12 Benjamin, *Arcades Project*, [N3, 1], p. 463.
13 Friedrich Schlegel, 'On Goethe's *Meister*' (1798), in J.M. Bernstein, ed., *Classic and Romantic German Aesthetics*, pp. 269–86, 274.
14 Benjamin, *Arcades Project*, [N3, 1], p. 463.

historicism. In contrast, the dialectical image famously has a temporal-
ity of its own (so-called 'now-time'/*Jeztzeit*), which, in its specific *nega-
tion* of temporality in the everyday sense of temporal continuity – hence
as itself an instance of 'standstill/stasis' – associates it with a series of
apparently 'atemporal' figures: *messianic exteriority, nature* (in its messi-
anic aspect) and *political action*, in its creatively 'revolutionary', affirma-
tively nihilistic sense of willed acts of destruction and construction.

This is the third main critical meaning of stasis at stake in the
Frankfurt tradition: the *stasis of now-time*. There is (i) stasis of the thing
– imaginary fixity; (ii) stasis of the ever-same structure of the produc-
tion of the new – repression of duration; (iii) stasis of now-time – atem-
poral rupture of temporal continuity. The Benjaminian conversion of
the stasis of the dialectical image into now-time famously aspires to
break through the continuity of historicism and the abstract structure
of the new alike, to produce something 'genuinely' historically new;
that is, some non-capitalistic form of social practice; or at least, some
purportedly 'revolutionary' action. However, this is a paradoxically
temporalized atemporality, since it gains meaning (and supposedly
force) from its negation of temporal continuity, phenomenologically
figured as interruption, flash, explosion, etc., creating a caesura that is
coded as that of a new beginning: the radically originary temporaliza-
tion of a 'revolutionary' act. Yet, of course, an *act* is not in itself a *prac-
tice* – however much there might be a tendency in certain crucial texts
(Marx's 'On Feuerbach', for example) to use the terms as synonyms. The
stasis in the 'empty place' at the centre of an *action* is part of a quite
different structure from the necessary sociality and narrativity that
structure *practices*, in which each production is at the same time a
reproduction of the social relations constituting the practice in
question.

It is in the structural homology here between the (a)temporality of
the image *qua* image (as opposed to the particularity of its materializa-
tions) and the (a)temporality at the source of so-called 'revolutionary'
action as a cut in being (at least, according to a classical ontological
conception of being, or its modern mathematical revival) that the poli-
tics of Benjamin's philosophy of history is taken to reside. The 'substitu-
tion of a political for a historical view of the past' is the way it appears in
the language of Benjamin's 'Surrealism' essay – where historical still
meant historicist – before the term 'historical' was recoded by Benjamin

as itself a political category in *opposition* to the temporal continuity and ahistoricality of historicism.[15]

We might call this speculative exploitation of the structural homology between the temporalities of the image and the 'revolutionary political act', within the terms of the coding of standstill or stasis as a kind of latency – in the sense of a position of possibility from which decisive action is produced, rather than the standpoint of any kind of Aristotelian potentiality – Benjaminian orthodoxy. In its fixity as an orthodoxy, its citationality and its generalized transferability between different contexts, it is itself imagistic (*bildlich*). Therein lies the danger of its own 'bad' reification: discursive repetition of an idealized structure of rupture routinizes it, robbing it of the singularity it in each instance rhetorically proclaims. Benjaminian orthodoxy wants to form dialectical images out of our present relations to Benjamin's 'then', via Benjamin's own discourse. Yet in so doing, as a wholly discursive manoeuvre, it reproduces the *aporia of action* long detected at the heart of Benjamin's conception.[16] The ontological basis of this aporia resides in the gap between the experience of the stasis of the dialectical image and the necessarily *narrative* temporality of meaningful action, insofar as action gains its meaning as *event*: an irreducibly narrative category, which articulates the relations between past, present and future, transcendentally, from the standpoint of human agency.[17] Now, what is interesting about this existential-ontological gap between stasis and narrativity is that it has the very same structure as the existential-ontological gap or 'empty place' that constitutes *the temporality of the subject*, on its

15 Walter Benjamin, 'Surrealism: The Last Snapshot of the European Intelligensia', p. 210.

16 See Jürgen Habermas, 'Walter Benjamin: Consciousness-Raising or Rescuing Critique' (1972), in *Philosophical-Political Profiles*, trans. Frederick G. Lawrence, MIT Press, Cambridge MA and London, 1983, pp. 129–63. Cf. Peter Osborne, *The Politics of Time*, pp. 152–5.

Underlying this aporia is the old, unanswered question of Russian formalism: how can we make a politics out of formalist poetics? Benjamin's answer: by giving determinate historical content to Shklovsky's idea of literature as a 'device of estrangement', imagistically. Viktor Shklovsky, 'Art as Device', in *Theory of Prose*, trans. Benjamin Sher, Dalkey Archive Press, Champaign, London and Dublin, 1990, pp. 1–14.

17 Paul Ricœur, 'The Circle of Narrative and Temporality', Part 1 of *Time and Narrative, Volume 1*, pp. 3–87. Cf. Osborne, *The Politics of Time*, pp. 155–9. See also, Peter Osborne, 'Neo-Classic: Alain Badiou's *Being and Event*', *Radical Philosophy* 142, March/April 2007, pp. 19–29.

structuralist construal, as summed up in, for example, Jacques-Alain Miller's 'Action of the Structure' (1964/8) and elaborated at some length in Badiou's 1982 *Theory of the Subject*.[18]

Subject

As Étienne Balibar has put it: 'structuralism is one of the few philosophical movements to have tried not only to *name* the subject, assign it a founding function, or *situate* it but, properly speaking, to conceptualize it (which may simply mean to conceptualize the preceding "operations" as operations)'.[19] Interestingly, the idea of an 'empty place' at the heart of the structure of the subject, characteristic of the structuralist concept of the subject, has its origins where one might least expect it, in Hegel's *Phenomenology of Spirit*: 'it is for the most the name as a name, which denotes the pure subject, the empty, conceptless "one"' (*ist es vornehmlich der Name als Name, der das reine Subjekt, das leere begrifflose Eins bezeichnet*), Hegel wrote.[20] It is also in Hegel that we find the most explicit formulation of the ontological reduction of the being of the subject to time: 'time is the being of the subject itself'.[21] Miller's idea that his analyses of structure and subject are 'in open conflict with Hegel'[22] may thus require some modification, although it may be more plausibly maintained of the French phenomenological tradition of 'neo-Hegelianism'.

On this reading, then, we may say: *the image is (has the structure of) the subject*. Let us explore this idea in a little more detail. It is made up of two main elements: (i) the 'empty place' of the effectivity of the structure as the place of the name of the subject, that is, stasis as the (a)temporality of the figural (*bildlich*), imagistic, topological or 'imaginary unity';

18 Jacques-Alain Miller, 'Action of the Structure'; Alain Badiou, *Theory of the Subject*, Part V, section 2.

19 Étienne Balibar, 'Structuralism: A Destitution of the Subject?', *Differences* 14(1), 2005, pp. 11–12.

20 G.W.F. Hegel, *Phenomenology of Spirit* (1807), trans. Terry Pinkard, 2012, Preface, para. 66; *Phänomenologie des Geistes*, Suhrkamp, Frankfurt am Main, 1986, p. 48.

21 Hegel, *Aesthetics: Lectures on Fine Art, Vol. 2*, p. 908. Cf. Chapter 13, note 16, this volume.

22 Miller, 'Action of the Structure', p. 76.

and (ii) temporalization as the activation of the division. The first of these sets up an equation of subject and image based on the claim for the solely 'imaginary' unity of the subject (in the Lacanian sense of imaginary'). As Miller put it: 'the imaginary subject-agent of the structured, the subject-support, element, of the structuring ... only appears as a subject in the real by misrecognizing itself in the imaginary as element in the structuring'.[23] 'The image is the subject', then, is a consequence of the proposition that not only is the subject imaginary, but the subject both grounds and exhausts the imaginary itself, as the domain of the production of the effective unity of a process.

Interestingly, Benjamin himself abstracts wholly from the question of the subject, bridging the gap between the present and the future (or better, the what-has-been and the what-will-be) with a generic conception of force, which is figured as acting simultaneously at the level of individual and collective experience, but within which it is the experience of 'the dreaming collective' that is privileged. He is thereby, ironically, in danger of reproducing the structure of the very same fallacy of modelling a transcendental subject on an individual subject that his project began by diagnosing, in his 1917 'Programme of the Coming Philosophy'.[24]

In contrast, in the second section of Part V of *Theory of the Subject*, Badiou gives determinate temporal form to the aporia of action, in his account of the relationship between the *anticipatory* structure of 'subjectivization' and the *retroaction* of what he calls there the 'subjective process'. It is a formalization of Kierkegaard's modified Hegelian insight that whereas 'life can only be understood backwards ... it must be lived forwards'. For Kierkegaard, the consequence is famously that 'life in temporality never becomes properly understandable, simply because never at any one time does one get perfect repose to take a stance – backward'.[25] (This is to say, the standpoint of 'the philosopher' has no living existential actuality for Kierkegaard.) For Badiou, however, this contradiction between the temporalities of life and its comprehension is

23 Ibid.
24 Walter Benjamin, 'Programme of the Coming Philosophy' (1917), in *Selected Writings, Volume 1: 1913–1926*, Belknap Press of Harvard University Press, Cambridge MA and London, 1996, pp. 100–10.
25 Søren Kierkegaard, 'Early Journal Entries', in *The Essential Kierkegaard*, Howard V. Hong and Edna H. Hong, eds, Princeton University Press, Princeton NJ, 2000, p. 12.

itself the key to the problem, since it articulates the temporality of the subject itself. The crucial formulation (formalizing a Heideggerian-Lacanian modification of Kierkegaard's insight) is as follows:

> In subjectivation, certainty is anticipated.
> In the subjective process, consistency is retroactive.

What Badiou calls 'the subjective process' thus 'amounts to the retroactive grounding of the subjectivation in an element of certainty that the subjectivation alone has made possible'.[26] Or in Benjaminian terms, we might say: now-time is the time of subjectivation, and what Benjamin calls the 'afterlife' (*Nachleben*) is the time of the subjective process.[27] However, what Badiou terms the anticipatory 'haste of the cause' remains, and must remain, mysterious. '*To put into consistency the haste of the cause*, therein lies the whole enigma of the subject', Badiou writes. He then goes on to posit a 'heterogeneity of forces' as the 'supplement' necessary to cross the gap between 'the temporal topology and the algebra of calculation' that gives retroactive consistency (one might say, intelligibility) to the act.[28] But there is equally necessarily no account of the determinacy of this element of force – not just causally (which must remain so), but at the level of the intelligibility of the act, which is crucial if we are to connect image to act. 'Subjectivation operates according to the element of force by which the place . . . finds itself altered', Badiou writes, more or less tautologically, from the standpoint of the subjective process – since there is no other standpoint from which to *think*, as opposed to act. Or again, very similarly to the structure of Benjamin's now-time: 'The act takes precedence over the reasoning . . . interruption [is the ground of] . . . subjectivizing effect'.[29] The existential-ontological enigma of the subject, within which a certain interruptive detemporalizing or atemporal stasis is the ground of all action, can be formalized but it cannot be 'solved', or developed much further, at the level of abstraction of the subject as such.

It is at this point that questions about more complex structures of narrativity that incorporate a recognition of these homologies between

26 Badiou, *Theory of the Subject*, p. 251.
27 'Historical "understanding" is to be grasped, in principle, as an afterlife of that which is to be understood.' Benjamin, *Arcades Project*, [N2, 3], p. 460.
28 Badiou, *Theory of the Subject*, p. 253.
29 Ibid., p. 255.

the stasis of the image and the 'event-like' structure of subjectivation become germane, since it is such structures that render historical life intelligible, in its determinate social content rather than just at the level of the messianic exteriority of history as a whole, compacted, imaginarily, into each dialectical image of a relation between a specific 'now' and a specific 'then'; which are the only two levels at which history appears in Benjamin's thought. These structures are best constructed on the basis of an account of the effect on the concept of the image of the new digital technologies of image production (what I have elsewhere called 'the distributed image'),[30] on the one hand, and the new geospatial forms of social relations through which they circulate (under the conditions of globalization), on the other. One might speculate that the place of stasis within such a culture of images is neither fundamentally choreographic (bodily), nor is it located at the level of the image as a whole, in its wholeness as a fragment of reality (Benjamin's early Romantic photographic model), but rather at the much lower level of *the pixel* as the basic unit of the image. This suggests a fundamental alteration – dissolution, even – in the whole problematic of reification, both 'bad' and 'good'.

30 See the second part of Chapter 9.

Acknowledgements

Earlier versions of the following chapters appeared in the publications listed below, most having initially been presented as talks.

Chapter 1: *Radical Philosophy* 184, March/April 2014.

Chapter 2: Chris Lorenz and Berber Bevernage, eds, *Breaking Up Time: Negotiating the Borders between the Present, the Past and the Future*, Vandenhoeck & Ruprecht, Göttingen, 2013.

Chapter 3: *Nordic Journal of Aesthetics*, 44–5, 2013.

Chapter 4: *Open: Cahier on Art and the Public Domain* 23, 2012, special issue on 'Autonomy: New Forms of Freedom and Independence in Art and Culture', Skor, Amsterdam, 2012.

Chapter 5: *Radical Philosophy* 174, July/August 2012.

Chapter 6: Aurélie Bouvart et al., eds, *French Theory in American Art*, SIC/Sternberg Press, Berlin and New York, 2013.

Chapter 7: *Nordic Journal of Aesthetics* 49–50, 2015.

Chapter 8: In Spanish, as 'El archivo como vida después de la vida', *Concreta* 6, October 2015.

Chapter 9: Combines two short texts from *Texte zur Kunst* 95, September 2014, and 99, September 2015.

Chapter 11: Bojana Cvjevic, ed., *'Retrospective' by Xavier Le Roy*, les presses du réel, Paris, 2014.

Chapter 12: *Afterall: A Journal of Art, Context and Enquiry* 42, Autumn/ Winter 2016.

Chapter 13: In German, as 'Die Idee der Konzeptkunst (und Musik)', in *MusikTexte: Zeitschrift für neue Musik* 151, November 2016. Published here in revised form.

For their roles in stimulating the production of these texts through invitations to speak at their institutions and commissions for publication, I would like to thank: Chris Lorenz, Pablo Lafuente, Charles Esche, Nina Möntmann, Aurélie Bouvart, Nuria Enguita Mayo, Isabelle Graw, Dirk Snauwaert, Bojana Cvjevic, Maria Mkrtycheva and Christian Grüny. I am grateful to Francis Mulhern for his editorial suggestions regarding what has become the title chapter of this volume. Thanks to Marta Kuzma for her continuing struggles to build institutional spaces where critical thought might be put into relation with contemporary art, and vice versa – recently, at the Royal Institute of Art, Stockholm (where we collaborated on the graduate programme Philosophy in the Context of Art, 2014–16) and now at the Yale University School of Art; and to Éric Alliez for thinking the postconceptual in a different way. Finally, as always, thanks to Stella, Ilya and Felix for everything else.

Image Credits

5.1 Günther Brus, *Clear Madness – Urination*, 1970. Photo courtesy of Peter Weibel.

5.2 Günther Brus, *Clear Madness – Excretion*, 1970. Photo courtesy of Peter Weibel.

5.3 Valie Export Society, *From the Portfolio of Doggedness, Remake*, 2000, video still. With kind permission of the artists.

5.4 Valie Export Society, *From the Portfolio of Doggedness, Remake*, 2000, video still. With kind permission of the artists.

5.5 Ines Doujak, *Untitled*, work-in-progress, studio photo, 2010. Subsequently titled, 'Not Dressed for Conquering'. With kind permission of the artist.

5.6 Ines Doujak, *Untitled*, work-in-progress, studio photo, 2010. Subsequently titled, 'Not Dressed for Conquering'. With kind permission of the artist.

7.1 Biennial Foundation website map (July 2017): biennialfoundation.org/home/biennial-map/

7.2 Museum Rietberg Symposium Sign. Photo: Peter Osborne.

10. 1–4 Akram Zaatari, *In this House*, 2005. Digital video, 30 minutes, stills. With kind permission of the artist.

10. 5–8 Akram Zaatari, *Letter to a Refusing Pilot*, 2013. Digital film, 34 minutes, stills. With kind permission of the artist.

12.1 Robert Barry, Douglas Huebler, Joseph Kosuth and Lawrence Weiner, 1969. Photo: Seth Siegelaub. Courtesy Stichting Egress Foundation, Amsterdam.

12.2 Collective Actions, *The Russian World 1985*, performance

documentation. Annotation by Margarita Tupitsyn from the Russian Pavilion, 56th Venice Biennial, 2015, indicating the four participants to have had solo exhibitions in the Russian Pavilion in the post-Soviet period. Photo:Peter Osborne.

12.3 Ilya Kabakov, Concept drawing for *The Corridor of Two Banalities*, not dated, watercolor, colored pencil and lead pencil, 40.4 x 2.6 cm, signed on the back. With kind permission of the artist.

12.4 Ilya Kabakov in the installation of *The Corridor of Two Banalities*, Centre for Contemporary Art, Ujazdowski Castle, Warsaw, 1994. Photo: Emilia Kabakov. With kind permission of Emilia Kabakov.

12.5 Ilya Kabakov, text detail, from Ilya Kabakov and Joseph Kosuth, *The Corridor of Two Banalities*, 1994, Centre for Contemporary Art, Ujazdowski Castle, Warsaw. With kind permission of Ilya and Emilia Kabakov.

Index